Helen Drew

The Fundamentals of Photography

AVA Publishing SA
Switzerland

An AVA Book

Published by AVA Publishing SA
Rue des Fontenailles 16, Case postale
1000 Lausanne 6, Switzerland
Tel: +41 786 005 109 Email: enquiries@avabooks.ch

Distributed by Thames & Hudson (ex-North America)
181a High Holborn, London WC1V 7QX, United Kingdom
Tel: +44 20 7845 5000 Fax: +44 20 7845 5055
Email: sales@thameshudson.co.uk
www.thamesandhudson.com

For distribution in the USA & Canada please contact:
English Language Support Office
AVA Publishing (UK) Ltd.
Tel: + 44 1903 204 455 Email: sales@avabooks.co.uk

English Language Support Office
AVA Publishing (UK) Ltd.
Tel: +44 1903 204 455 Email: enquiries@avabooks.co.uk

Copyright © AVA Publishing SA 2005

ISBN 2-88479-050-0
10 9 8 7 6 5 4 3 2 1

Book design by Gavin Ambrose
www.gavinambrose.co.uk

Production and separations by AVA Book Production Pte. Ltd.,
Singapore

Tel: +65 6334 8173 Fax: +65 6334 0752
Email: production@avabooks.com.sg

Acknowledgements

With special thanks to the following people for making this
book possible:

Helena Kovac; Matthew Butson @ Hulton Archive / Getty Images;
Brian Doherty and the darkroom team at Getty Images; Melvin
Cambellie-Davies @ Master Mono; Alex Timms; Matthew Timms;
James Finlay; Adrian Mott and David Carpenter @ L.C.C.; Rachael
Elliston and Charlie Devereux @ Untitled; Paul Cousins and Martin
Reed @ Silverprint; Amy Timbrell @ Corbis; Ty Wheatcroft; Ben Part
and Joanna Sykes; Carl Inder; Brian Morris, Natalia Price-Cabrera,
Caroline Walmsley, Renée Last and Laura Owen @ AVA; Gavin
Ambrose; J.P. Kernot @The Bill Brandt Archive; Andy Rumball;
STYLE and thefamilytunes magazine, Germany; Ben Elwes; Danny
Elwes. Special thanks to Alan Morris and Duncan Evans for their
comments and contributions to the content and the structure, and also
with very special thanks to Patrick William and Theresa Joyce Drew.

This book is for Alex.

contents

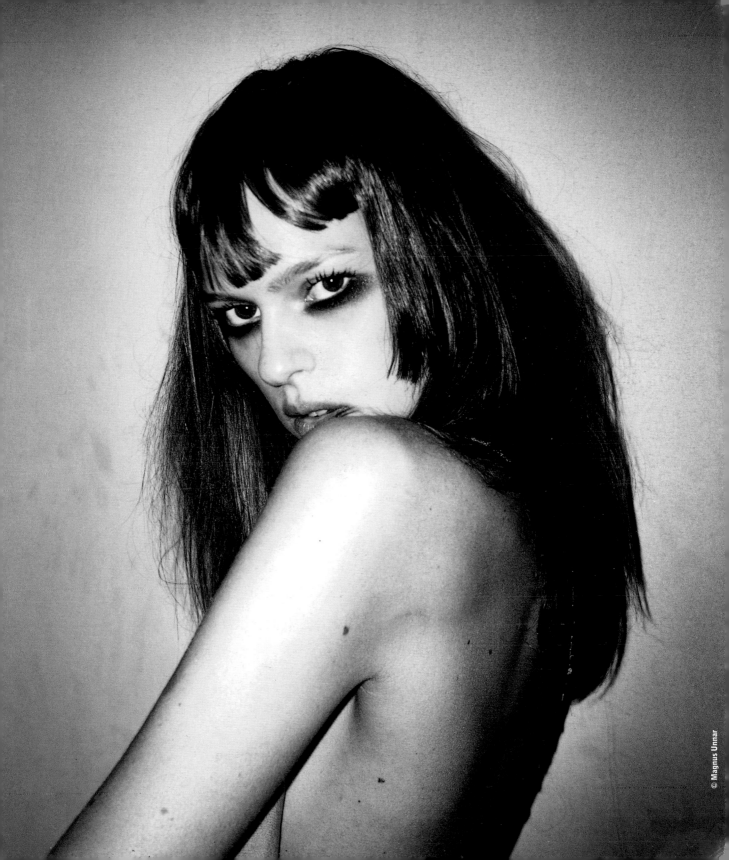

how to get the most out of this book

Section 3
Composition

Composition *(n.)* **1a)** The act of putting together; formation or construction. **b)** something so comprised; a mixture. **c)** the construction of such a mixture; the nature of its ingredients.

Primer introductory sections

Each element of photography works as part of an overall whole that comprises the job or assignment. The effectiveness of any single element is determined by its relation and appropriateness to that whole. Prior to embarking on a discussion of the fundamental elements of photography each chapter begins with a primer that identifies key developments and debates surrounding each of the six sections of the book. This discussion establishes the context for the fundamental principles to be addressed and their importance within this context.

Fundamentals

Getting the fundamentals correct is the first step towards successful photography, but to do so requires an understanding of why they are important. The fundamental rules pages outline the key principles of contemporary photography. Each rule is concisely explained and illustrated with a detailed diagrammatic illustration enabling the reader to understand, both theoretically and visually, the principles discussed. Through the use of examples, the reader will see the fundamental principles in action and the visual impact that they can achieve.

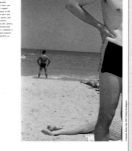

Examples

There is no better way to acquire an understanding of the fundamental principles of photography than to see them at work in a real life application. The examples that follow the fundamentals are taken from projects undertaken by contemporary photographers and have been chosen to highlight the practical application of the fundamental principles discussed in this book. The choices and decisions made by the photographers are discussed to give the reader an insight into the creative process of professional photographers and why they make the decisions they do.

introduction

IN OUR ERA OF SOPHISTICATED REPRODUCTION, INSTANT SEAMLESS IMAGE PRODUCTION AND DIGITAL PERFECTION, MORE AND MORE PEOPLE ARE DRAWN TO PICTURE MAKING AND USE OF THE BASIC PROCESSES OF PHOTOGRAPHY TO DO SO. THE FUNDAMENTALS OF PHOTOGRAPHY IS INTENDED AS A GUIDE FOR THE STUDENT, OR ANY INDIVIDUAL WITH AN INTEREST IN DEVELOPING THEIR PHOTOGRAPHIC SKILLS AND KNOWLEDGE. PHOTOGRAPHY, PARTICULARLY OVER THE LAST 20 YEARS, HAS EVOLVED DRAMATICALLY AND IT IS EASY TO GET LOST IN THE COMPLEXITIES AND POLITICS OF IT ALL, LET ALONE THE CHOICE OF EQUIPMENT AND TECHNIQUE.

WITH THIS BOOK I AM GOING BACK TO BASICS, KEEPING THINGS SIMPLE AND GUIDING YOU THROUGH COMPLEX TECHNICAL AND CREATIVE ISSUES. SIMPLE STEP-BY-STEP EXPLANATIONS AND PRACTICAL EXAMPLES WILL ASSIST YOU IN CREATING PHOTOGRAPHS IN A CLEAR AND ACCESSIBLE WAY. THE POSSIBILITIES, ONCE YOU HAVE LEARNED THE BASICS, ARE ENDLESS. YOU CAN LEARN THE TECHNIQUES PRACTISED BY SOME OF THE WORLD'S FINEST PHOTOGRAPHERS, FROM THE MANY GENRES WITHIN PHOTOGRAPHY, TO CREATE YOUR OWN UNIQUE AND EXCITING IMAGES – THIS CONCISE GUIDE TAKES YOU FROM YOUR INITIAL IDEA RIGHT THROUGH TO DEVELOPING AND PRINTING YOUR ARTWORK.

THE FUNDAMENTALS OF PHOTOGRAPHY IS PACKED WITH REFERENCE INFORMATION AND ESSENTIAL TIPS THAT COVER ALL THE FREQUENTLY ASKED QUESTIONS, AS WELL AS PHOTO ASSIGNMENTS TO PUT YOU TO THE TEST. THIS IS A DEFINITIVE GUIDE, WITH CLEAR INSTRUCTIONS AND INSPIRING PRACTICAL EXAMPLES OF METHOD AND STYLE , WHICH IS DESIGNED TO GIVE YOU ALL THE NECESSARY INFORMATION YOU NEED TO BECOME CONFIDENT WITH THE CAMERA.

The Fundamentals of Photography Introduction

WE LIVE IN A WORLD COMPLETELY SATURATED BY THE PHOTOGRAPHIC
IMAGE, WHICH SHAPES AND INFORMS EVERY ASPECT OF OUR DAILY LIVES.
THE PHOTOGRAPH FUNCTIONS AS THE RECORDER, THE NARRATOR, THE INFORMER,
THE SEDUCER AND THE COMMUNICATOR.

WITHOUT QUESTION, THE ART, SKILL AND TECHNICAL CAPABILITY OF
PHOTOGRAPHY HAS DEVELOPED ENORMOUSLY OVER THE PAST 150 YEARS,
FROM THE EARLIEST VICTORIAN PLATES TO THE SOPHISTICATED DIGITAL
HYPERREALISM THAT CAN BE SHOT BY ANYONE TODAY. WE HAVE A VAST AND
VARIED VISUAL PALETTE AT OUR DISPOSAL FOR CREATING PHOTOGRAPHS, AND
THIS GUIDE PROVIDES THE OPPORTUNITY TO STUDY DIFFERENT TECHNIQUES
AND APPROACHES IN A MANAGEABLE AND INSPIRING WAY.

STUDYING PHOTOGRAPHY CAN BE A LIFELONG EXERCISE AND LEARNING
TO UNDERSTAND HOW A PHOTOGRAPH WORKS EMOTIONALLY REACHES BEYOND
SIMPLE COMPOSITION AND TECHNIQUE PRINCIPLES. SOMETIMES THE
MEANING IN A PHOTOGRAPH IS INSTANTLY OBVIOUS, BUT IMAGES CAN ALSO
BE WONDERFULLY LAYERED AND COMPLEX. AS YOU LOOK AT DIFFERENT
METHODS AND APPROACHES, BOTH IN A HISTORICAL AND A CONTEMPORARY
CONTEXT, YOU WILL DEVELOP YOUR VISUAL AWARENESS AND UNDERSTANDING
OF THE POWER OF THE PHOTOGRAPH AND ACQUIRE A GREATER APPRECIATION
OF THE DIFFERENT GENRES.

Section 2
Equipment and getting started

Photography *(n.)* The science that relates to the action of light on sensitive bodies in the production of pictures, the fixation of images and the like.

'There are many teachers who could ruin you. Before you know it you could be a pale copy of this teacher or that teacher. You have to evolve on your own.'
Berenice Abbott

Cameras

The film camera

These come in many styles and formats, but a basic 35mm Single Lens Reflex (SLR) is a good accessible camera from which you can learn and achieve a great deal when starting out. Although the range of equipment available is daunting, a camera is still essentially a light-tight box holding light-sensitive film. It has a lens to focus the image on to the film, and this lens has an aperture, which is basically an adjustable opening. The shutter is an internal 'curtain' that allows the light in. The length of time that the shutter is open during the exposure is called the shutter speed. The combination of aperture and shutter speed lets in a specific volume of light, which causes the photographic image to form on the film.

The 35mm SLR is a very versatile camera that 'sees' what you see through the viewfinder, and an array of lenses and accessories are available to help you create powerful and interesting photographs. In order to capture an image, light comes through the lens and hits an angled mirror that is positioned in front of the film plane. This mirror reflects the light up to the viewfinder. While you view and compose your photograph the diaphragm within the lens remains open, allowing you to see as truthful and bright an image as possible. Then, when the fire button is pressed, the lens diaphragm closes down to the size set by the aperture value, the mirror is raised and the shutter opens to allow the light to hit the film.

Try to visualise the workings of a theatre stage: the curtains as the focal plane shutter, the stage as the subject and the lighting creating the mood as the source of your exposure, the change of scenes and the closing of the curtains is another frame. In the theatre the term 'Lights! Camera! Action!' is often used, and although taking a photograph is a rather more complex affair it is essentially these three functions coming together when you take focus, expose and shoot!

The digital camera

The exposure principles of the digital camera are essentially the same as the film camera, even if the actual processes are very different. Quite simply it is a 'filmless' camera with a lens, aperture and shutter speed and most of the principles we will look at in this book can be applied to making images with a digital camera. However, instead of recording on a roll of film, the digital camera has a silicon chip called a CCD (Charge Coupled Device). This chip has a surface layer of light-sensitive diodes, which record the volume of light arriving during the exposure, then convert that value into an electronic charge that is sent to the processing firmware. This works against a scale set by the digital ISO rating and gives a luminance value to each picture element, or pixel that goes to form the digital image. The more pixels an image is made up of, the higher the resolution and the better the quality. The colour in a digital image is generated by the placement of a colour matrix over the CCD diodes. This matrix usually consists of a red, blue and two green elements for each block of four diodes. The firmware in the camera has the job of identifying the image type and correctly sorting out the colours from the samples it has taken. As camera technology progresses, you can expect colour accuracy and resolution to improve to pixel accuracy.

There is little doubt that the immediacy of feedback from the digital camera LCD has helped beginners adopt digital technology en masse, leading to a dramatic slump in sales of compact film cameras. The APS format of film cameras has all but been abandoned as digital technology has advanced. The fact that each capture with digital is essentially free and that the user can check the exposure and compensation makes digital a good choice for anyone starting out in photography.

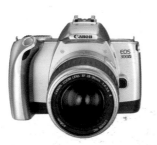

Above: The Canon EOS 300V SLR camera.

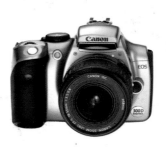

Above: The Canon EOS 300D digital SLR camera.

lenses

The lens is as important to the camera's ability to record images as our eyes are to our ability to navigate the world around us. The look of your image can be greatly affected by the lens you use and you should think of it as the photographic unison between your subject, your vision and the mechanics of the camera.

There are hundreds of lenses available that create all kinds of effects, and the sharp increase in the number of people taking photographs and buying equipment means that prices have dropped and lens optical quality is of a very high standard. You may start off with a standard 50mm lens then wish to progress to lenses of different focal lengths as your skill and understanding improve.

There are three basic types of lens: the wide-angle, the standard and the zoom. The the standard lens is the closest view to the vision of the naked eye; the wide-angle lens gives you a broader field of vision; and the zoom lens acts like a telescope, bringing a subject in the distance closer to you. There are only few differences between the basic components they contain. Multiple glass optical elements and a mechanical system work in conjunction to bring the image in the viewfinder into sharp focus. These glass elements are ground and coated with the utmost precision and transmit the light hitting your camera. The lens is attached to the camera by a lens mount, which is found at the rear of the lens. The lens also has a diaphragm, which can be altered in size and controls the amount of light hitting the film plane. The size of this diaphragm is controlled on manual lenses by setting the aperture ring, which is marked with f-stops. Autofocus film SLRs and digital SLRs usually set the aperture on the lens to the maximum value mechanically, and then the camera controls the aperture electronically. An important element of the lens is the manual focus ring. By adjusting this, you can adjust the optical mechanisms of the lens and select which part of your subject will be in focus.

One point to remember about lenses on current consumer digital SLRs is that because the CCD chip is smaller than a piece of film, yet occupies the same position in the camera as the film would, the focal length of the lens is effectively shifted by a ratio set by the relative size of the chip. This is typically around 1.5x so that a 50mm lens gives the field of view and telephoto effect of a 75mm lens, when used on a digital SLR.

Standard 50mm lens

A standard 50mm lens functions along the lines of 'what you see is what you get'. This lens is used for standard recording of your subject as you see it through your viewfinder. This is probably the first lens you will use on a 35mm SLR and it is a great way to get to grips with how your camera works and how to look at the world through it.

Wide-angle lens

A wide-angle lens has the advantage of allowing you to record a broader view and a greater depth of field. Subjects can therefore be photographed close to the lens with much of the background still in focus. The wider the angle however, the greater the possibility of some distortion and care should be taken when photographing people too close to the lens.

Zoom lens

The modern zoom lens is a popular choice. It has a multiple focal length built in to a single unit, which means you can select from multiple focal lengths without having to change the actual lens. This basically allows you to increase your focal length, and keep your wider view.

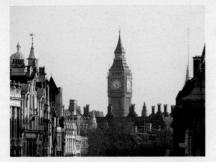
Focal length of 200mm

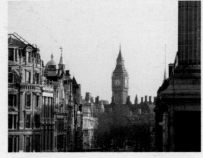
Focal length of 135mm

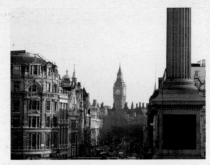
Focal length of 105mm

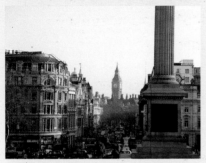
Focal length of 85mm

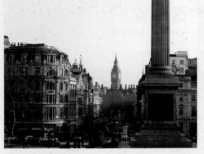
Focal length of 80mm

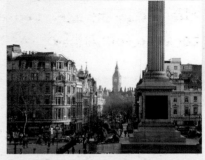
Focal length of 70mm

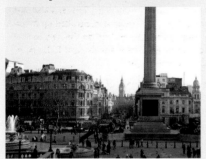
Focal length of 50mm

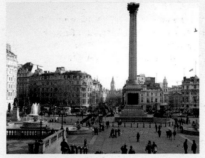
Focal length of 35mm

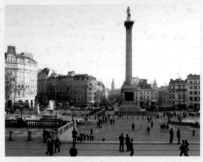
Focal length of 28mm

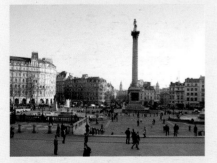
Focal length of 24mm

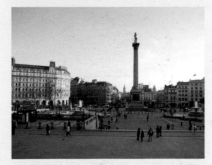
Focal length of 20mm

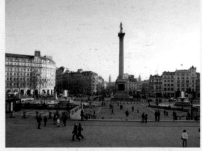
Focal length of 10mm

© James Finlay

Above: If we look at this sequence of shots taken from the same position and of the same view (on the northern side of London's Trafalgar Square, looking across to Whitehall and Big Ben), but using different lenses to provide a range of focal lengths, we can see that the field of view and magnification reduces in proportion to the focal length.

These images of the crumbling West Pier in Brighton were shot on a Nikon F3 35mm SLR using a combination of standard, wide-angle and zoom lenses, ranging from 28 – 105mm. Each of these pictures clearly illustrate the dramatic difference achieved by varying focal length.

50mm lens / regular shot of the West Pier in Brighton.

Zoom lens / close-up image of the West Pier in Brighton.

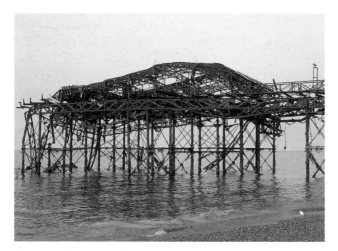

Wide angle lens / long view of the West Pier in Brighton.

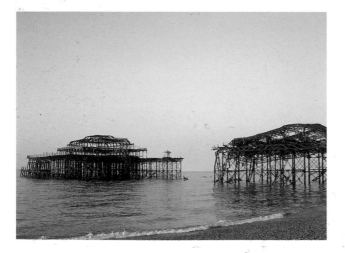

© Helen Drew

Tips

When you buy your camera it is a good idea to purchase a lens hood. This stops stray light creeping into the lens and causing flare; this is what happens when too much light enters the lens at the wrong angle.

When choosing your camera ensure that the brand and model has other accessories and lenses readily available as you advance your skills and techniques. Choose the lens that best suits your need and budget.

Right: This vast, rusting steel zinc-storage container was deliberately photographed facing the harsh sunlight in the High Canadian Arctic. The shot was taken at an oblique angle and without a lens hood. The effects of flare caused by too much light entering the lens and distorting the light levels can clearly be seen in the foreground of the image, though in this particular instance it has been used deliberately to create an interesting photograph.

lens filters

Filters are glass attachments that are fixed on to the front of the lens. Essentially they block, or filter, colours in the spectrum of white light to change the look of a photograph. They range from the extremely creative filters, which are great for special effects, to the popular 'skylight' filters, which have little effect beyond the removal of ultraviolet light and protecting the lens from dirt and scratches. It is advisable to always have one of these filters attached on to the front of your camera. Polarising filters are very popular and an incredibly useful tool to enhance a huge variety of everyday scenes, as they help to minimise or remove reflections, haze and bright light.

© James Finlay

Filters work by diluting specific colours of the light spectrum and so intensifying the hues of others. This may seem quite strange when thinking in terms of colour, but remember that white light is made up of a colour spectrum and this colour spectrum is measured by temperature. You can think of some filters as turning the heat up or down and others will enhance particular colours and contrast. A point to note for digital cameras is that they use Automatic White Balance (AWB), to take out any colour casts caused by differing colour temperatures. If you use a filter to warm an image up, the AWB will most likely see the colour shift and remove it. When using warm up, cool down or colour filters on a digital camera, the White Balance must be set to a manual setting. Filters are also particularly useful for enhancing the contrast of skies and stretches of landscape as they can change the tonal range of large areas of a similar quality such as skies, clouds or landscapes.

Tip

Care is needed with exposure when using certain filters. Just as they can block the colours filtering through, they can also alter the amount of light the camera is actually reading so you may need to recalculate and compensate for this if using a manual camera. Check the packaging to assist with the calculation.

Tip

There are many filters to choose from for creative and corrective use. The packaging is a good guide to help you decide which filter is best suited to your needs, or talk to the staff at your local supplier for tips and guidance. Experiment to see the great range of effects that are possible.

There is no great magic in the proper application of filters in photography. You just have to know what they do, when to use them to enhance your photographs and what effect they will have on exposure settings and tones. It's that simple and it's even easier if you have an auto-exposure camera, since the camera's exposure meter reads the amount of light available and adjusts exposure automatically; all you are required to do is attach the filter. If you have a manual camera, simply refer to the specification sheet supplied with the filter to learn its filter factor, and change exposure in accordance with the instructions.

Daylight filters,
This image (below), was taken with a daylight filter, which protects the lens from dust, moisture, scratches and breakage.

Polarising filter
These filters reduce or eliminate glare and reflections. The filter is rotated until its angle blocks certain lightwaves; usually the reflections. The polarising filter also deepens and darkens skies making them more contrasting. On digital cameras it tends to make skies blacker, as well as a deeper shade of blue. This is an essential filter for landscape and general outdoor photography, but note that its light blocking properties mean that it will be necessary to reduce exposure by one or two stops when using it.

Diffusing filter
Also known as a soft filter, this gives a smooth look to textured surfaces, evens out facial blemishes and softens wrinkles whilst maintaining a good, clear subject image. This type of filter is useful for portraiture or subjects with an overbearing texture.

Filters for use with black-and-white film

These coloured filters absorb specified lightwaves and transmit any remaining unabsorbed light. For example a yellow filter absorbs red and green light, and allows yellow light to pass through it.

Yellow filter
Yellow filters provide the most natural tonal correction and so improves contrast. This filter is ideal for landscapes.

Orange filter
Orange filters are great for enhancing dramatic natural landscapes as they increase the contrast in the sky and the surroundings.

Red filter
These filters are especially useful if you want to create dramatic skies, especially if the weather is overcast, as they can really produce stunning results.

Warm-up filter

These filters are specifically used to warm-up and complement skin tones and enhance scenic views.

Right: Filters for colour film

The type of light (daylight or artificial), which strikes your subject will affect the way in which colour is rendered on the film. Conversion filters will change the colour balance of light for any given colour film. Tungsten films, for example, are designed and balanced for the colour temperature of amber tungsten light. Exposed in daylight they will produce pictures with a bluish cast, but a series 85 conversion filter can correct this. Daylight film, on the other hand, is balanced for sunlight at midday. Daylight has a greater concentration of blue wavelengths than tungsten light, and therefore will have a yellow-amber cast when exposed under tungsten light. Again, a series 80 conversion filter can correct this problem.

Left: Filters for digital cameras

Filters are very useful for digital cameras as they can give a more subtle effect than simply manipulating the white balance to warm up or cool down an image. As mentioned, the Automatic White Balance must be set accurately to the current conditions for the filter to work.

camera support

One of the advantages of the modern SLR camera is that it is light and portable, enabling you to take photographs virtually anywhere. The best way to stop any camera-shake or blurred shots is to learn how to hold a camera properly. Practice steadying the camera with your left hand while you get the image focused with your right, and learn how to release the shutter without taking your eye away from the viewfinder. This will soon become second nature to you, and the confidence with which you hold your camera and shoot will mean that you will sometimes get the shot you might have missed by hesitating with your equipment.

© Helen Drew

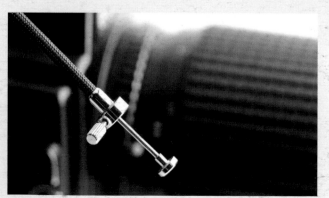

Cable release

The cable release is a valuable accessory to add to your basic kit, especially if you are in poor lighting conditions or situations that require a longer exposure. Used in conjunction with a tripod this simple device can reduce and control camera shake or vibrations. It is an essential tool for many landscape photographers.

© Helen Drew

A guaranteed method for capturing a pin-sharp and well-exposed image is to use a tripod, especially when photographing landscape in low light. Tripods can vary in size and strength and it is worth spending a little more of your budget on a good, sturdy model; a flimsy tripod can do more harm than good and will ultimately be a waste of money. Most tripods will come with the attachments required to secure it to the camera. The head of the tripod screws into the thread at the bottom of the camera. The head can rotate 360 degrees and also tilt vertically backwards and forwards so you can position the camera precisely. If you are likely to mix and match tripod photography with more mobile use it is worth getting a tripod with a quick-release plate so it can be detached and reattached easily. When purchasing your tripod consider how often and where you will be using it, as these factors will influence your selection.

Tip

Photography can be fairly expensive but it's a far better idea to invest in the best equipment you can afford rather than go for cheaper options that will let your photography, and your pocket, down in the end.

film

Film is light-sensitive and is purchased in a light-proof canister. Your roll of film will be primed and ready with just a short piece at the tip to pull out and load into your camera, or wind back in ready for processing (see page 132). The film packaging contains a great deal of information about the film and its development, and this is worth keeping for quick and accurate reference. When choosing film it helps to know what effect and look you wish to achieve in your end result; as colour and tonal ranges do vary slightly with each brand. There are three types of film to choose from: black-and-white (or negative) film, which will provide you with a black-and-white negative to print from; colour-print film, so called as the colour negative produces prints, and colour-positive (or reversal) film. Colour-positive film is commonly known as slide film (as the slides you process are positive), this is the film of choice for many professional photographers and their term for slide film is 'transparency'.

Photographic-print film consists of a polyester base that is coated in a gelatin emulsion. This emulsion contains tiny particles of silver halides that convert to metallic silver when processed, creating the highlights in a negative. These particles (that look like black specs), also create the grain in the image. The more of these particles that accumulate on the film, the more density there will be in the negative. Therefore a dense negative appears dark because of the high silver content and a thin negative appears almost clear because it holds very little information. This content level informs the processes involved in making your print, so it is vital that the exposure is correct in order to convert the particles into sufficient metallic silver, so that you have a balanced negative to 'read'.

Tips

Loading film is not difficult. Most cameras now have an automatic film-advancing program; you simply have to drop the film in, pull and lay the film-leader over the toothed sprocket and close the back; the camera will recognise the film, grab it and advance it on to your first frame.

To load film manually, open the back of the camera and drop the film into the left-hand hollow with the spool facing the base of the camera and the film leader face-down ready to pull over the shutter and feed into the spool. The sprocket holes in the film should line up with the teeth in the spool. Slide the film tip into the spool and begin to advance a few frames with the camera back open to ensure that the film is winding on properly, is taut and is not popping back out of the spool. Close the back and release the shutter about three more times. Each time you shoot a frame check that the frame counter is indeed moving on and advancing the film.

Right and below: Black-and-white (or monochrome) film is also known as negative film. When the film has been developed (see page 132) it forms an exact opposite image, in terms of tonal range, of the original view. For example, white objects appear dark (these are called the highlights of the negative), while lighter objects will appear in a range of greys (these are called the shadows), and black objects will appear clear. It is literally a negative record of your positive view.

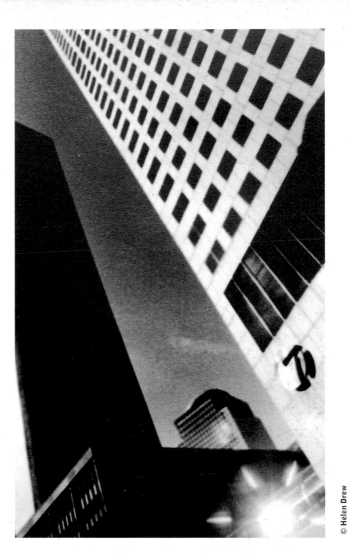

© Helen Drew

© James Finlay

Left: Colour print film works in a similar way; the colours of the original view or object are reversed on the film. The film itself has three layers that are sensitive to the primary colours of light when processed. The colour print film developing process is called C41.

An advantage that colour-print film has over colour-positive film is its exposure latitude. This means the range of exposure can be as much as two stops under or over the accurate setting and still produce a decent print. Colour-print film is also far more tolerant of light, for example less cast will appear in a mixed lighting situation than if using colour-positive film. There are many great films on the market that can offer you a range of warm, rich colours or a cooler look to your prints; try experimenting with different films to achieve the right look for your chosen subjects.

Colour-positive (or slide) film works in much the same way as colour-print film in the way it records colour; the difference between the two is in the processing technique, which is called E6. Digital cameras tend to offer a similar latitude to colour-positive film. Colour-positive film is processed as a normal negative, which is then 'bleached' and replaced by a positive at a further stage in the developing process (hence the alternative term 'reversal'). This film produces the ultimate in colour reproduction and there is nothing quite like seeing your first set of brightly coloured transparencies in all their glory. However, although colour-positive film produces excellent results if exposed and processed correctly, it does not have the latitude of colour-print film – while slight underexposure is not a problem, overexposure is and bleached out areas can be irredeemable in the print process. To accommodate this many professionals ask the processing lab to do a 'clip test', this is when a short piece of the film is 'clipped' and processed. You can then determine the perfect exposure required by looking at the test result to ascertain whether it is too dark or too light.

It is also a good idea when shooting with colour-positive film or with a digital camera, especially if the subject is important, to 'bracket' your shots. Bracketing describes the process of photographing the same subject at different exposures, so you know you will definitely get at least one at a perfect exposure. Your meter should read the correct exposure, then you shoot several frames both under and over this. It is of course not always possible to bracket given time and circumstances, but it is ideal in difficult low lighting or unusual circumstances when you really are not sure what you will capture. A digital image that is underexposed is relatively easy to correct, whereas an overexposed one with lost highlights is harder, or often impossible, to remedy. Even when shooting digital where you can check the exposure on the LCD – easily the most significant advantage of digital cameras – it is worth bracketing when you are faced with difficult conditions.

Tips

If you are shooting portraits or people on colour-positive film, do not use a warm-tone film as they can look a little too magenta; cooler films deliver a more accurate balance.

If you are shooting indoors without flash and under tungsten lights, you can buy colour-balanced film suited to this purpose.

Manually set your white balance on digital cameras when shooting indoors as low light conditions can often fool the automatic setting.

film speeds

As well as variation in type, film also has a variety of speed ratings; these values are determined by the film's sensitivity to light. The packaging of any roll of film contains a good deal of useful information, and will specify the ISO (International Organization for Standardization) rating, or film speed. These range from slow film such as 25 ISO to fast film, which is rated at 3200 ISO.

The higher the ISO number, the faster the film is and the greater its sensitivity to light. Fast film requires less light to render an image because it is so light-sensitive, a slow film is less sensitive and therefore great for use in brighter light. Ultimately the higher the ISO number is, the better chance you have of recording an image in poor lighting. Conversely the lower the ISO number, the better the film is for use in bright, well-lit conditions and / or subjects. Remember, film with a low ISO rating will produce a finer grain and a sharper image and is often a better option if you wish to enlarge your picture. Some photographers hate grain, others love it and deliberately use it to enhance an image.

An advantage of digital cameras is that they can change the ISO rating for any individual shot, rather than for an entire film. Obviously there is no film grain for light to react to, so digital ISO works by changing the level at which light from the CCD diodes trigger a charge, which is turned into a pixel. However, the higher the ISO, the greater the chance for an inaccurate reading from the CCD, which translates into the appearance of random colour noise. Unlike large-grain film, which can be attractive, colour digital noise can make a picture unusable. Many compact digital cameras have an ISO 800 mode, but the results are only suitable for black-and-white images.

Tips

Don't forget, the ISO setting on your camera should match the ISO rating of the film. Never change this setting or your film will be processed under- or over-developed at some stage.

When lighting conditions are poor (and instead of using a flash), use fast film with a rating of 400 ISO or higher, as this film is very light-sensitive.

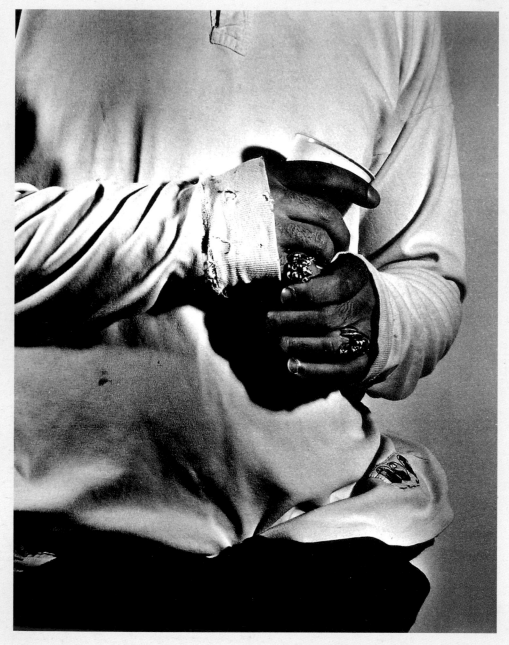

Left: This photograph was taken using a slow film, rated at 100 ISO, which produces a very fine grain. The resulting image shows the fine detail in the hands and shirt of the subject.

Right: Using a fast film, rated at 400 ISO, has lent this image of a young man, cycling through London's Soho in the spring sunshine, a grainy, almost abstract quality.

© Helen Drew

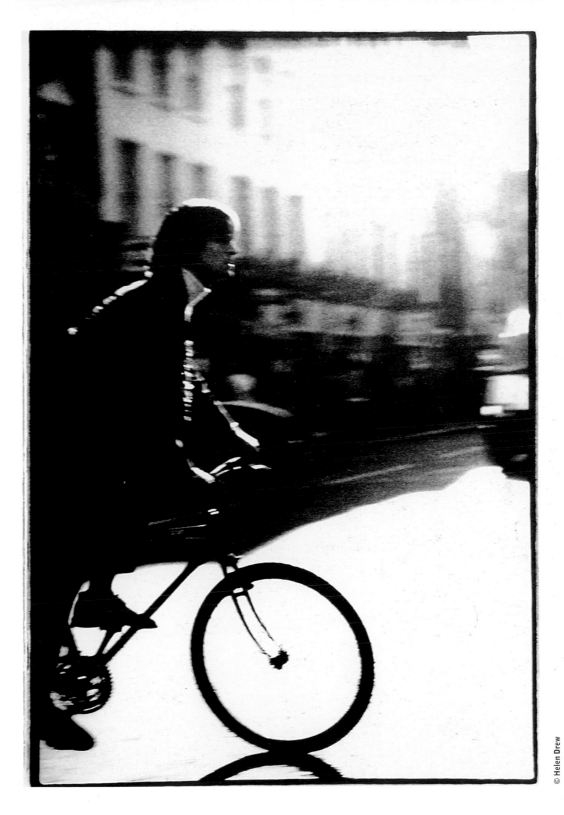

© Helen Drew

digital formats

Whether you use a digital camera to capture photos or choose to scan film in at a later stage, the resulting file has to be stored somewhere, somehow. Initially it may be on a computer, where it can be tweaked, enhanced or corrected, or later on to a back-up medium like DVD, CD or ZIP disk. The format used to save the image will determine the amount of storage space it consumes and whether the file will degrade in quality as it is used further. The choice of file format, then, is a trade off between size and quality. RAW, JPEG and TIFF are the more common and useful digital file formats.

RAW

RAW files are taken directly from a digital camera. They are unprocessed and the nearest digital equivalent to a film negative. The advantage of the RAW file over a TIFF file is that it is about 30% smaller in terms of file size, so more shots can be stored on a memory card. The disadvantage is that the RAW file is unusable on its own. Each camera manufacturer uses a proprietary format for its RAW files so the file needs to be processed before saving in a more general format. Some computer software applications – stand-alone or Photoshop plug-ins – allow the RAW data file to be extensively manipulated before being saved, which can provide a more accurate and desirable result than the automatic operation carried out in-camera. Other programs simply perform a conversion process and turn the image into a TIFF, thus the original file's lower size is the only advantage.

JPEG

The Joint Photographic Experts Group file is the most common compressed file format, used by both digital cameras and computer software. The JPEG file is user configurable so that the amount of compression can be set before saving. This allows the needs of smaller file sizes to be offset against quality considerations. JPEG files are typically 75% smaller than uncompressed TIFFs. The primary disadvantage of a JPEG file is that the higher the level of compression used, the more visual artefacts of the process begin to become noticeable in the image. If a picture is going to be printed at larger than A4 it is strongly recommended that JPEG is not used. A further consideration is that each time a JPEG file is resaved, the quality will worsen, though the size will remain the same.

TIFF

The Tagged Image File Format is the most common quality format in use, both in-camera in the case of digital, or on the computer. TIFF files are usually not compressed, so can be very large, but this means that they retain maximum quality. It is possible to use the LZW compression option, which reduces file sizes by up to 50%, but preserves quality. The only drawback to this is that some software applications do not support LZW compression so files that were usable on one computer might not be usable on another.

Size impact of different file formats

The file size of the same 6Mp picture will vary quite dramatically depending on which file format you chose to save the image in.

RAW = 12.6Mb
Uncompressed TIFF = 17.4Mb
Compressed TIFF = 10Mb
Maximum quality JPEG = 5.19Mb
Medium (6/12) quality JPEG = 626k
16-bit PICT = 8.94Mb
32-bit PICT = 16.6Mb
24-bit BMP = 17.4Mb
256 colour GIF = 2.86Mb

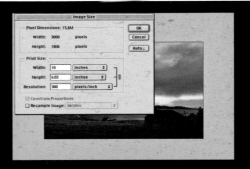

If you want to check the size and resolution of your image, it is easy to do so in Photoshop. Go to Image and click on the image size. The table featured above will appear and will show the picture's dimensions and the number of pixels per inch (PPI).

There are however, alternative file formats available:

GIF
Graphics Interchange Format. The GIF file is now almost exclusively used for simple web graphics as, with only 256 colours, it is unsuitable for photographs. GIF files can be very small.

BMP
A Windows picture system file. BMP files are usually large and uncompressed, though high quality when they are saved as 24-bit or 32-bit colour images. However, BMPs can also be saved as 4-bit and 8-bit, at which point run length encoding (RLE) compression can be used to make them smaller. BMP files are not usually used for photographic purposes.

PICT
An Apple Mac format offering high quality as either 16-bit or 32-bit colour files. Used mainly in page layout applications for sharing between applications.

JPEG 2000
Latest version of the JPEG standard, though still unsupported by many applications. It is possible to specify standard JPEG compatibility in the saving options though.

PCX
An old 24-bit picture format, common on PCs ten years ago but now outdated.

PDF
The Portable Document Format is used for designed layouts of text with embedded pictures. It is invaluable for print production but not a good choice for single photographs.

digital storage

Storage media for digital cameras is sometimes referred to as digital film. The similarity being that both are something that you put into the camera, and without which you won't get any pictures. This is of course, entirely erroneous. Digital cameras create the image in the camera, which then needs to be saved or output. There are a number of ways to save or output your digital image; ranging from removable digital media cards, to wireless network transmission and direct connection to computer. Indeed this latter option, bypassing storage in-camera, is standard practice in professional studios.

What is common to all methods of processing digital images is that they have to be saved, stored and archived somewhere. This process usually starts with the removable media card, commonly referred to as a memory card, which slots into the camera offering over 1Gb of storage. As digital camera resolution increases, the need for larger capacity memory cards grows with it. Producing a TIFF file on a current 6MP camera occupies around 17Mb of storage space per picture. This increased demand on storage capacity is one reason why the SmartMedia format card has been discontinued in favour of the x-D Picture Card format.

Confusingly, there are a host of additional formats, many proprietary, designed by digital equipment manufacturers. The common formats are CompactFlash, x-D Picture Card, SecureData and Memory Stick. These are solid state devices with no moving parts, but there is also the IBM MicroDrive to consider. This is CompactFlash II compatible and is a miniature hard drive. As such, when introduced, it offered higher capacities but was more susceptible to impact damage. There is however, debate over how much capacity can be stored in such a device against the increasing capacity, and simpler electronics, of a regular CompactFlash card.

Once past the immediate stage of in-camera storage, the digital image needs to be stored somewhere off-camera and this is where CDs, DVDs and Zip disks come into play. Zip disks are less popular than they once were, as CDs have dominated the storage market. Although the latest Zip disks offer up to 750Mb storage, they are limited because anyone receiving such a disk must also have the same capacity (or higher) Zip drive in order to access it.

Regular CDs, whether CD-R where areas of the disc can only be written to once, or CD-RW where data can be erased and rewritten, offer a stable and reliable platform for capacities up to 700Mb. Digital Versatile Disc, or DVD, is still in a state of flux offering two competing formats known as DVD-R and DVD+R. It seems likely that the DVD-R format will become the dominant one but this is by no means assured. A single sided DVD disc though offers up to 4.7Gb of data storage, making it ideal for mass, high-resolution image storage. There are also DVD-RW and DVD+ReWritable formats where the data can be erased and rewritten.

Card speed
Some memory cards are little more than strips of storage with a few wires – the interface electronics to access them are stored in the camera, not on the card. This means that the card can be accessed at whatever speed the interface in the camera runs at. An old camera makes this a disadvantage, but a new camera with faster electronics makes it an advantage. The other types, like CompactFlash, have the interface electronics built into the memory card itself. This means that newer cards, with faster speed ratings can be used to their full potential, no matter what the age of the camera using it. The disadvantage is that old, slow cards will be just as slow in a new camera.

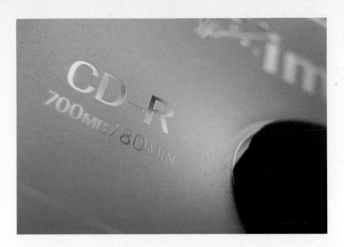

Right: Buying CDs in bulk on spindles reduces the cost per unit considerably.

Below: The Zip disk offers 100Mb, 250Mb and 750Mb storage options. IBM MicroDrives can be used in-camera to offer gigabytes of immediate digital image storage.

aperture

The aperture opening on a camera works in the same way as the pupil of an eye. If there is too much light coming in then the size of the aperture will be reduced, and if the light is dim then it needs to be increased in order to let more light in. This calculation is determined by the f-stop. The f-stop values displayed on the lens are fractions of its focal length. The terms 'open up' and 'stop down' are used to increase or decrease the diameter of the aperture. The size of the aperture will also dictate the depth of field.

Depth of field (or depth of focus) is the total distance in front of and behind your picture's main subject whilst it remains in sharp focus. This depth (or length) of field is not what you are focusing on, but it does create a sense of distance in the final image. Understanding and controlling depth of field is a great creative tool to consider and apply when creating interesting images.

If you observe the f-stop numbers on your lens they will tell you the focal length of the lens. This length is always measured in millimetres and denotes the enlarging power afforded by a particular lens: the higher the number, the greater the magnification. The shorter the focal length, the greater the depth of field, which means the lens cannot travel and focus a great distance, but the range within which it can will be in focus. The longer the focal length (for example a close-up shot of a distant subject), the smaller the depth of field, which probably means only the subject will be in focus.

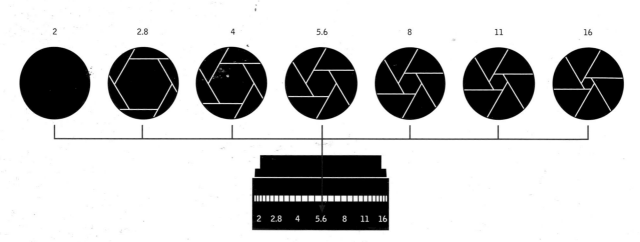

Above: The f-stop values on the lens are fractions of the focal length. You can determine how much light will enter the lens by increasing or decreasing the diameter of the aperture.

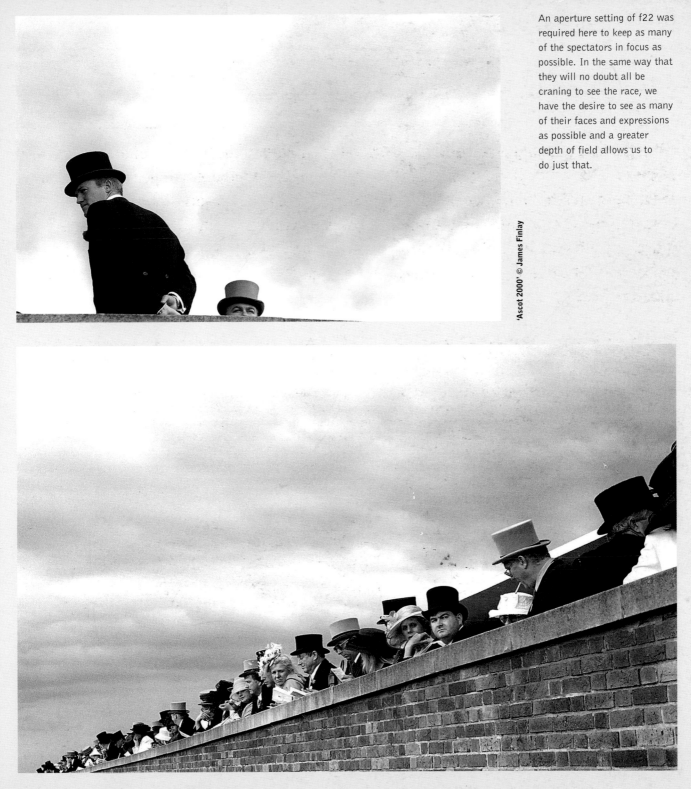

An aperture setting of f22 was required here to keep as many of the spectators in focus as possible. In the same way that they will no doubt all be craning to see the race, we have the desire to see as many of their faces and expressions as possible and a greater depth of field allows us to do just that.

'Ascot 2000' © James Finlay

'Down the Line, Ascot 2000' © James Finlay

The Fundamentals of Photography Aperture

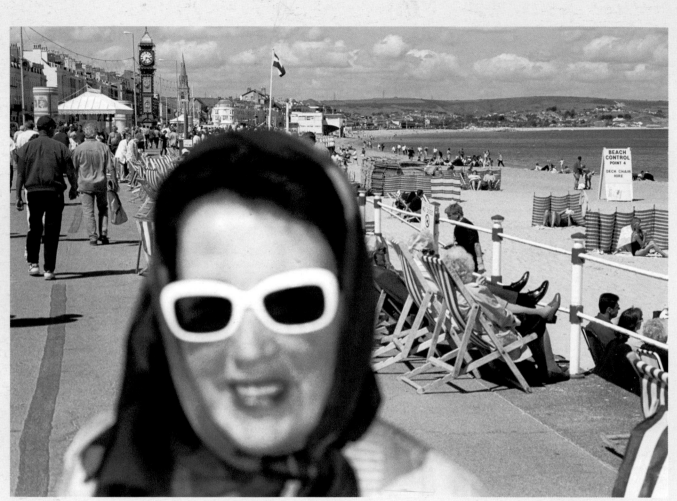

'Weymouth, England, 2000' © Martin Parr/Magnum

Above: This image uses focal length for impact in a way you might not usually expect to see. The woman in white sunglasses is deliberately thrown out of focus although the beach is sharp. The photograph works very well as it mixes humour, colour and a real sense of a crowded summer seafront, without following the rules.

Right: This image of Eastbourne's crowded beach demonstrates very different aperture principles to those of the photograph on the facing page. In this image only the unsuspecting sunbather's foot remains in sharp focus whilst the rest of the beach becomes a blur; yet the image still manages to create a great feeling of a lazy, hazy summer's day at the beach, with the radio buzzing away in the background and the owner of the foot relaxing.

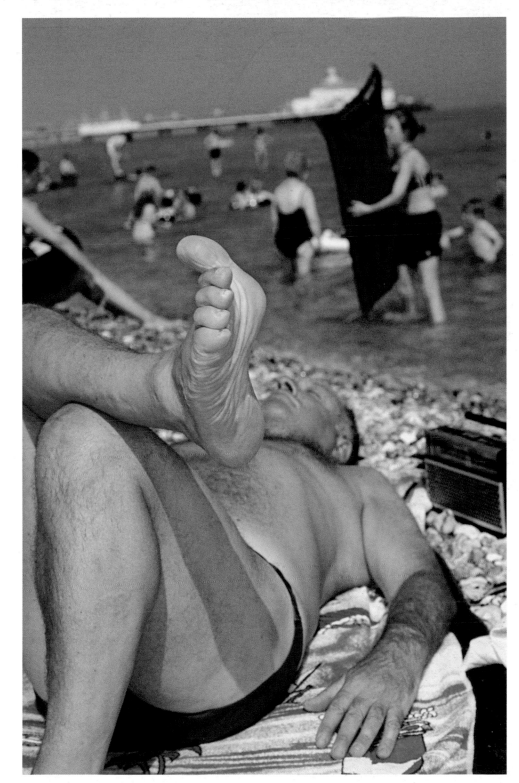

'Eastbourne, England, 2000' © Martin Parr/Magnum

shutter speed

Cameras have an adjustable shutter, which is essentially a 'curtain' inside the camera that opens for a certain amount of time when a picture is taken. The shutter is the mechanism that controls the amount of light entering the camera and the speed at which it does so. The range of shutter speeds varies among different cameras; a modern electronic SLR (digital or film), will be typically between eight seconds and 1/4000th sec. Some camera may have faster speeds; many digital models can offer 16- or 30-second exposures. There may also be a 'bulb' function that allows you to keep the shutter open for as long as you wish. Although these speeds are fractions of seconds they can have a great bearing on your photograph, achieving fantastic results if employed with the right subject. Try to think of the shutter and the aperture as a winning combination: quite simply one cannot function properly without the other.

© Helen Drew

Left: This dancer was caught by flash using a shutter speed setting of 1/60th sec to capture the moment.

Above: This speeding beach buggy was deliberately shot on a slow shutter speed to create the effect of fast motion.

STA Travel © Andy Rumball

Tip

To freeze a moving subject, select a fast shutter speed such as 1/500th sec that will literally 'freeze' the frame. To increase the sense of motion and speed in an image select a slower shutter speed to heighten the sense of movement by producing a dynamic blur.

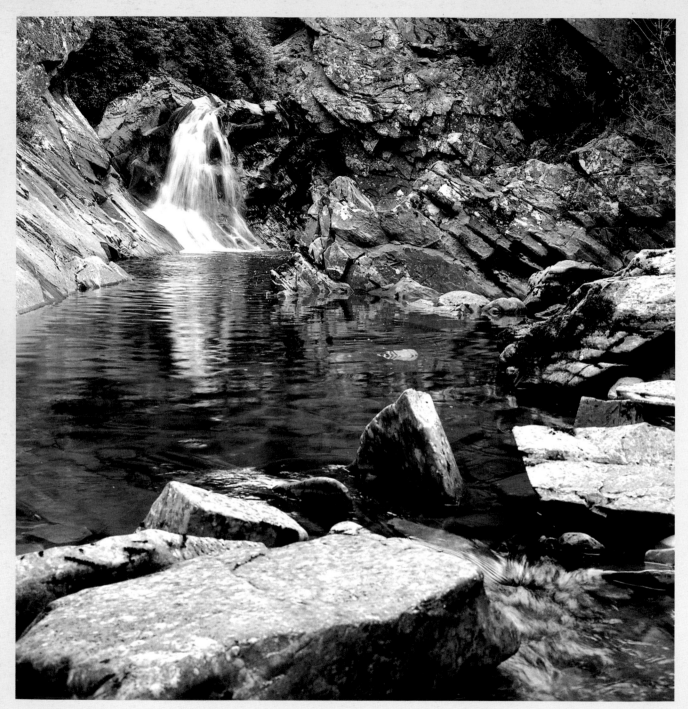

Above and right: The photographer's vantage point for both of these shots was actually standing in the rippling and rushing falls respectively. This image (above), was shot in late spring on a Hasselblad 503CW, with a CFE 80mm lens, at f8/60 and using Kodak Tri-X 400 film. On his return to the same spot in the winter, the photographer wanted to capture a similar image with higher water (right). This shot was taken with a Hasselblad 503CW, with a CFE 80mm lens, at f8/8 and using Kodak Tri-X 400 film. The breaking falls in the winter shot were 'placed' in the top right of the image to accentuate the blurred effect of running water.

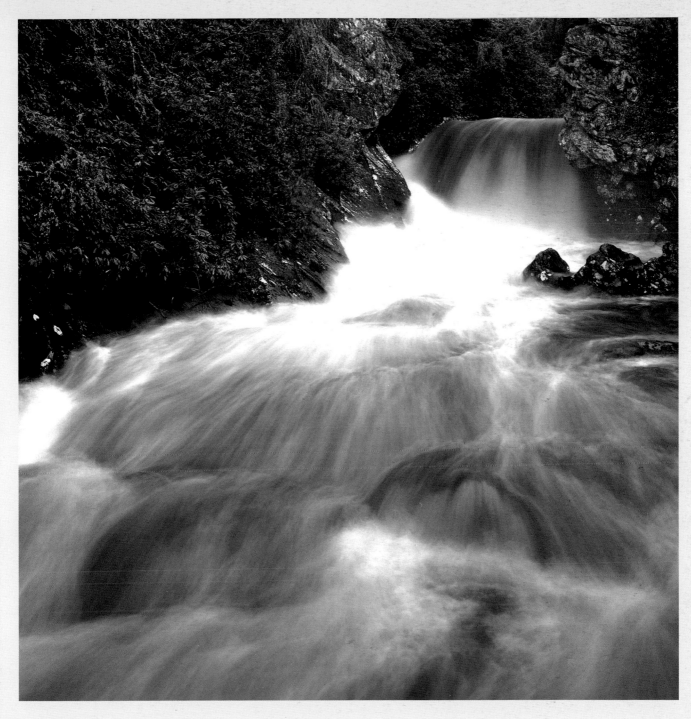

The Fundamentals of Photography Shutter speed

exposure metering

So far we have discussed how the camera operates and the fundamentals of shutter speed, aperture and ISO rating, but of course the essential aspect to develop an understanding of in order to take a good photograph is light. The amount of light that reaches the film or CCD, and for how long, is determined by the light meter, a device that measures light and converts it into electricity. This electricity is then converted into the appropriate aperture and shutter speed required by your camera to make the correct exposure; this process is called exposure metering. Separate hand-held light meters are used most often with manual or medium format cameras, however, modern SLRs have built-in light meters, which offer a number of options for measuring the available light for your shot.

© James Finlay

Above: Using Fuji Velvia shot at shutter speed 1/125 sec and aperture 2.8

Left and opposite: These images of the British Airways London Eye were shot on a fairly average day and perfect exposure would not have been difficult to achieve with one shot. However, another way of getting at least one perfectly exposed shot is to bracket the image (see page 26), by taking a sequence of shots. This is advisable in particularly difficult circumstances where there is too much light or darkness, by under- and over-exposing the subject. Bracketing a shot is also a really good way to develop an understanding of how to read light and gauge probable exposure if you are caught in a situation where you don't have time to think or test.

Above: Using Fuji Velvia shot at shutter speed 1/125th sec and aperture 4.

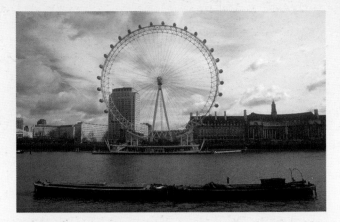

Above: Using Fuji Velvia shot at shutter speed 1/125th sec and aperture 5.6.

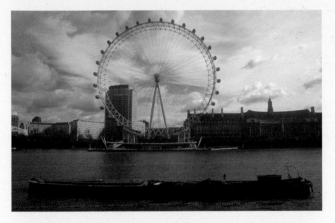

Above: Using Fuji Velvia shot at shutter speed 1/125th sec and aperture 8.

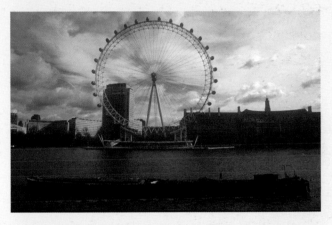

Above: Using Fuji Velvia shot at shutter speed 1/125th sec and aperture 11.

Above: Using Fuji Velvia shot at shutter speed 1/125th sec and aperture 16.

Above: Using Fuji Velvia shot at shutter speed 1/125th sec and aperture 22.

© James Finlay

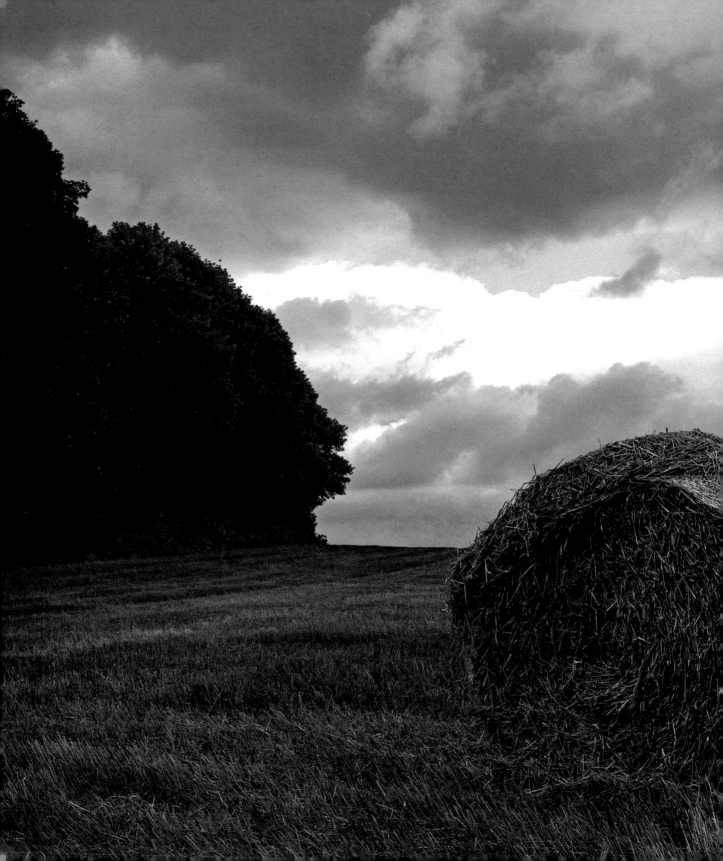

Light metering and ISO rating go hand-in-hand in exactly the same way as exposure and shutter speed are welded together. Always set your film camera to the ISO rating of the film you are working with before you do anything else, as this will affect the compensation the camera makes when 'reading' the light to give you the best exposure. Most modern film SLRs have a built-in system that can automatically read the film ISO speed, thus removing the chance for mistakes. Manual cameras do not have an ISO setting at all because the light meter is where the ISO setting needs to be specified when it is used to gauge the exposure.

Your camera probably has a pretty good built-in exposure meter, which works by reading the light reflected off your subject or across the whole frame. From this reading the camera will determine, and tell you, how much exposure is required to create the image and what levels to set the speed and aperture at. The meter will produce its reading when it has found a suitable 'mid-grey or middle-tone grey'. This mid-grey is half white and half black, 82% absorbed light and 18% reflected back, which, when the camera is set accordingly, will produce the average exposure for the mid-tones of the subject. A good way to get an average mid-grey reading is to purchase a 'grey card' (available from good photographic supply shops). Through your viewfinder you can look for scenes that have many black, white and grey tones. Learn to look for mid-grey as this is the best part to expose for as an average. The grey card is this same mid-grey and should be held over the most important part of the image to be exposed in order to take a good average reading. Unfortunately, taking an average meter reading will not always be enough for an even exposure. This is due to the extreme nature of actual light and the difference between the way in which our eyes see it and how the film sees and records it, which is simply not in as much range and detail.

'Fields Near Castle Howard, Yorkshire, England' © James Finlay

Left: An overcast day with stormy skies lends itself well to this typical pastoral scene. The straw bales provide a sense of proportion, and a greater depth of field keeps the fore and background sharp. Look for shapes that create balance and interest naturally.

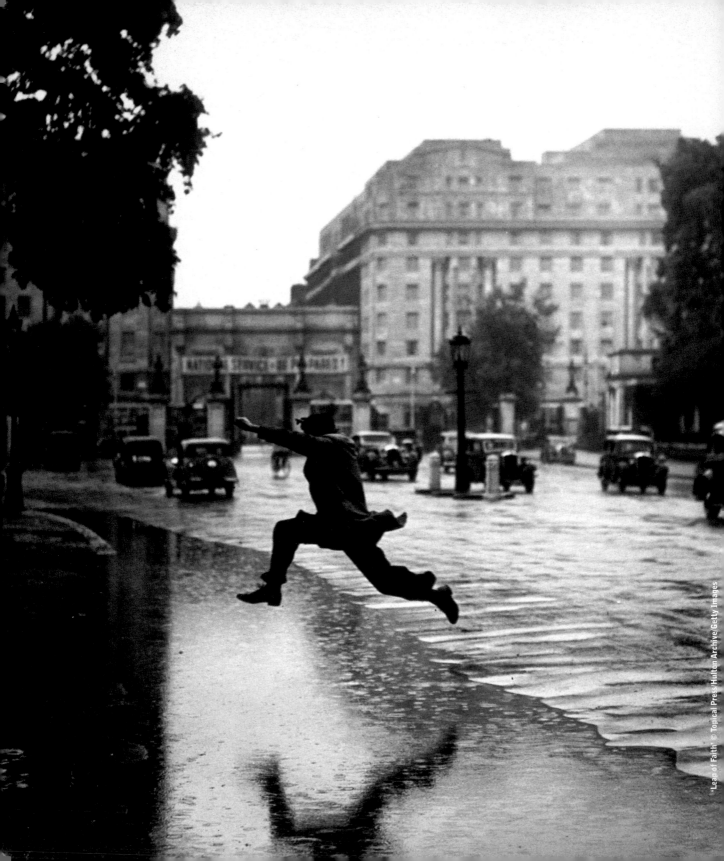

Section 3
Composition

Composition *(n.)* **1a)** The act of putting together; formation or construction. **b)** something so comprised; a mixture. **c)** the construction of such a mixture; the nature of its ingredients.

arranging key elements

Think of watching a film, listening to a piece of music or going to view a painting at an art gallery, and consider how each of these creative experiences is constructed or composed. Careful decisions are made when arranging the key elements of any creative piece in order to create a particular dynamic to the final result; the same care should be taken when composing a photograph. Exquisite composition is all around you but you must learn to look, and look again. Many people when walking along an ordinary street or battling through a crowd are doing just that; walking or battling and probably paying little attention to their surroundings. A photographer's eye, however, will see the peeling paint of a door they happen to pass, or capture the energy of a crowd while freezing the point of interest in a split second.

© Helen Drew

The photographer analyses and mentally composes the world around them at all times; it is a good skill to perfect and you will find it second nature the more you develop as a photographer. A strong photographic composition will hold, and emotionally reach, the viewer beyond the subject matter and they probably won't even notice the deliberate structure that makes the image work so well. Composing your images well can create the difference between a good picture and a great photograph. Sometimes this is purely in the visual sense, but at other times a well-composed photograph has the ability to convey a little of what you felt at the time rather than simply replicating the image as you saw it through the viewfinder.

For much of the early history of photography compositional methods were borrowed from fine art painters; nowadays though, many painters borrow compositional techniques from photographs in an attempt to recreate the illusion and symbolism of an image.

Above: Using 50 ISO transparency film and shooting with a large format camera set at 5.6/125 the clarity of this frozen moment was preserved. Although the red hull of the ship dominates the top half of this image, the rope anchoring the ship is the focal point and creates balance and a symmetrical composition.

Right: This image is composed very simply and yet tells us a great deal. We know that the primary subjects are lifeguards, even though their faces are obscured, one is cropped and one has his back to the camera. They are alert and assertive in their poses, and cover the whole stretch of beach by filling the camera frame from the foreground to the seashore. A sunbather's legs are visible and unaware of the vigilant watchers on the shore.

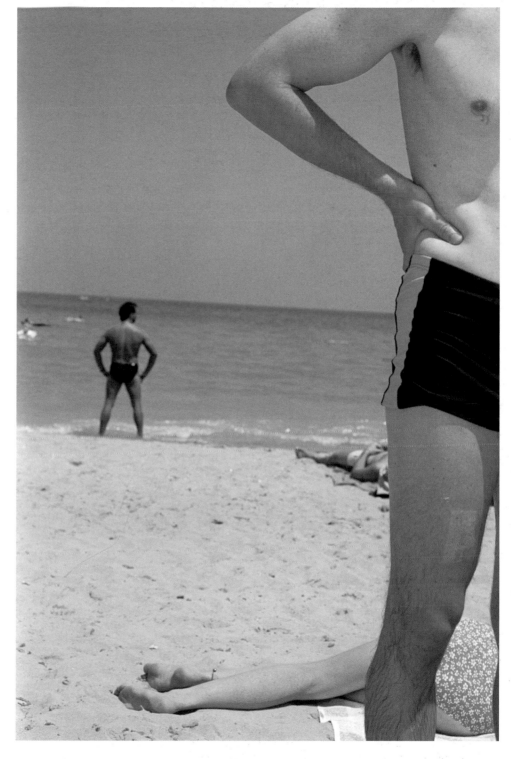

'Lifeguards, Rimini, Italy, 1999' © Martin Parr/Magnum

A well-composed photograph will possess visual simplicity. As you train your eyes to understand the structure of a photograph you will begin to see and understand, that even those apparently busy scenes – such as the work of press photographers covering often chaotic and crowded situations – will be well composed using a series of key elements. These elements are the foundations upon which we can create images due to the way in which they are combined, organised and arranged.

Formal or informal balance in a photograph can bestow very different interpretations of an image. Experiment by placing lines within your frame and explore the results; from the serenity and mystery of a calm sea or a road stretching to infinity, to the dynamism and energy of rows upon rows of people at a rock concert, these lines, by their placement, implication or obvious absence can hold the picture together.

Below: A typical suburban scene is turned into an ordered riot of colour: this abstract arrangement hints at the 'behind closed doors' nature of suburban life by the clever placing of the hedgerow right through the centre of the image. Rather than obscure what is happening here, the absence of a full view stimulates the imagination to tell its own story.

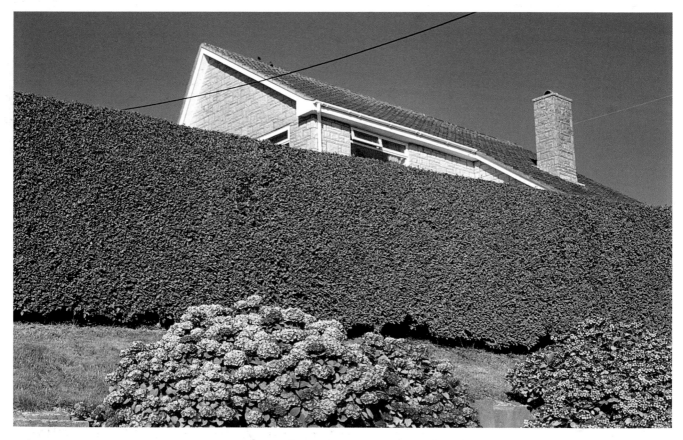

'West Bay, England, 1996' © Martin Parr/Magnum

Tip

Don't forget to look on your own doorstep for inspirational and challenging photographic opportunities. It is often the most familiar places, people and objects that we overlook and yet these can be a rich source to plunder for unexpected and complex images.

Below: These serene images of Venice are, at first glance, full of clean lines and reflections, but the choice of steps leading over the bridge and the row of gondolas give a sense of harmonious shape and line. There is also a slight sense of unease as the steps lead over a bridge we can't follow, and neither the gondolas nor the steps on the left tell us where we can alight or where they go. You can infuse your compositions with narrative or leave them wide open to suggestion if you choose the arrangement of elements carefully.

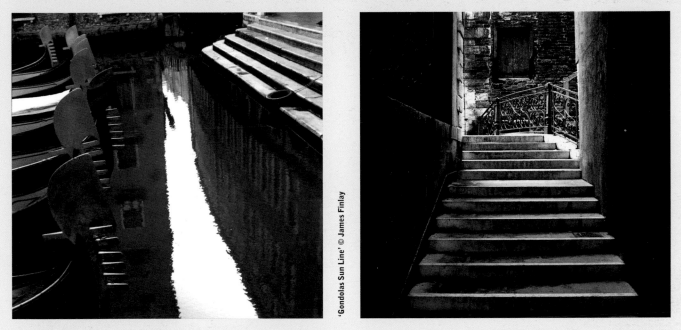

'Gondolas Sun Line' © James Finlay

'Venice Steps' © James Finlay

As a rule there should be one main subject in a composition, which all the other elements contribute to. This main subject can be in the foreground or further back in the middle ground, as these visual reference points create a sense of scale and perspective depending on where you place different components of your view and from what vantage point you choose to compose your shot.

Over the last 20 years we have seen a revolution in photography and it may seem as if there are no rules or boundaries to adhere to; however, there is a method to the composition of a great photograph regardless of what the subject is, and once you are comfortable with this, you can then go out, get creative and break the rules.

Whilst you are developing your compositional skills, it is a good idea to study magazine images, read about photographers you admire and go to as many exhibitions as you can to absorb the style and messages of the thousands of great photographers. You will develop your own style with the influence of others in the same way you might choose your clothes influenced by certain individuals or eras; it's really no different.

'Venice Steps' © James Finlay

Left: The rule of thirds is a technique employed successfully by many photographers. Mentally divide your frame into nine equal parts by creating a grid that is composed of both horizontal and vertical lines. Then place the key feature of your shot at any of the four points where the lines of the grid converge. Experiment with this principle, as different subjects work at different points. A number of digital cameras come with the option to place a grid over the LCD view, which beginners can utilise to gain an even better grasp of basic composition skills.

Right: This image was taken from a low viewpoint allowing the sky to fill most of the frame – with the exception of an iceberg creeping in – creating a sense of the vastness of the Arctic. A knowledge of the actual size of a key element within a photograph means that we can gauge just how big (or small), the scene we are looking at really is.

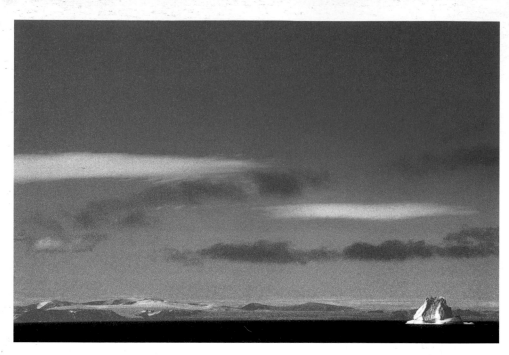

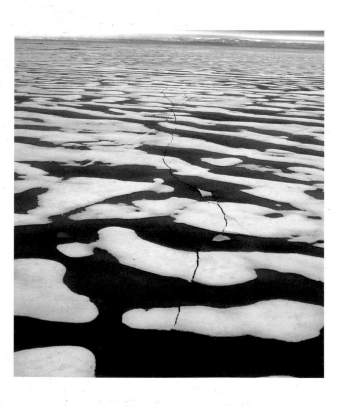

Left: This is another example of a photographic composition with a strong sense of scale. By almost filling the entire frame with the frozen sea, the eye is drawn to the natural fissure running through this photograph, which was taken in the Arctic. The diminishing ice-melt leads the eye up until it meets the horizon, giving a strong sense of distance.

Right: The brilliantly original and renowned British photographer Bill Brandt, had an almost surreal approach to composition (he was at one time an apprentice to the surrealist photographer Man Ray). In this beautiful, stark photograph the model's ear is clearly the focal point of the image, yet the vast, stony beach that is devoid of any other human life claims equal interest and has balance specifically because Brandt has contrasted a tiny human feature against the grandeur of a cliff face and expanse of natural space.

The Fundamentals of Photography Composition

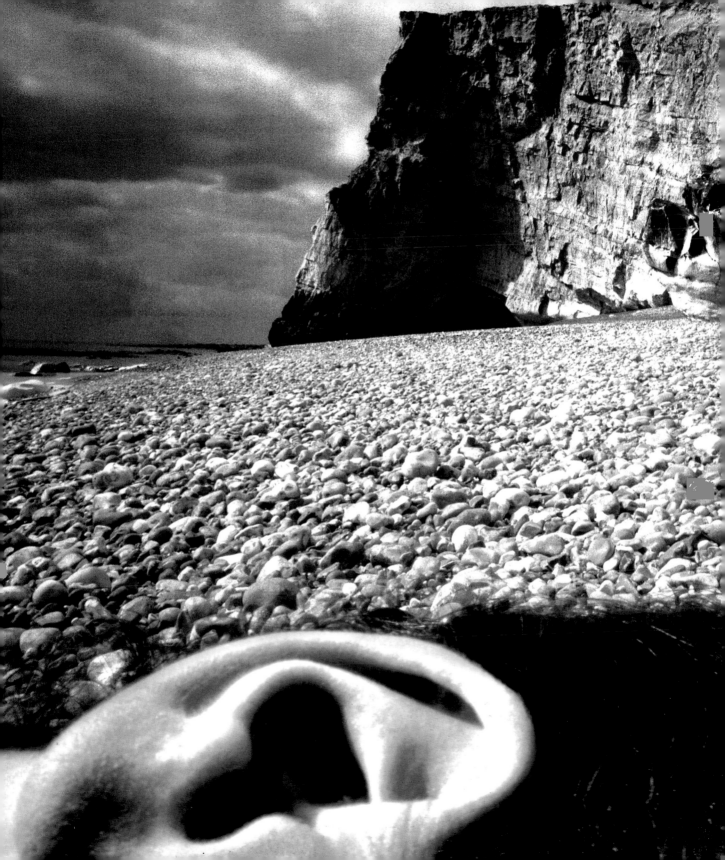

format

When you have decided on your subject matter and the importance of your key elements and their arrangement, you must then consider your composition's format. The format you choose will greatly affect the strength of your composition and message of your photograph. In this context, format means either a horizontal or a vertical image, known respectively as landscape and portrait.

Right: This landscape image, taken on a typically wet London night, depicts a solitary figure standing alone in the rain. At first glance it may appear as if that is all there is to it, but look again, as the photographer did when he composed the shot. He has chosen a strong linear perspective, in the form of the tree trunks diminishing in scale and the reflections of the rain on the wall of the river bank, which draw your eye to the centre of the photograph. This is a strong compositional tool that you can look for in all sorts of everyday situations and places to create a sense of perspective and distance, and lead the eye to the horizon. On taking a good second look, we can see the ship, moored in the gloom of the evening, which introduces a sense of depth and distance to the shot. The solitary figure is another focal point that lends a sense of scale to this photograph.

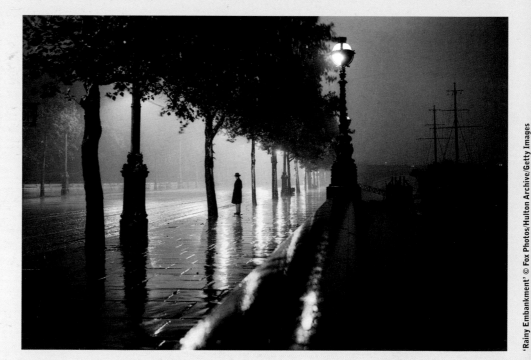

'Rainy Embankment' © Fox Photos/Hulton Archive/Getty Images

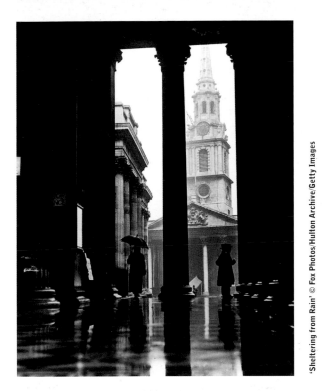

Left: This 'portrait' image demonstrates a strong use of shadow, reflection and linear perspective, which is contrasted with the scale of people to create a memorable composition.

'Sheltering from Rain' © Fox Photos/Hulton Archive/Getty Images

Below: A good example of selecting a point of interest, or focus, to centre your composition can be seen in this photograph of Brigitte Bardot at the Cannes Film Festival. Bardot is surrounded by an autograph-hungry crowd, but she remains the central focus of the photograph. The image retains the energy and fervour of the event, but everything is about her and this moment in time.

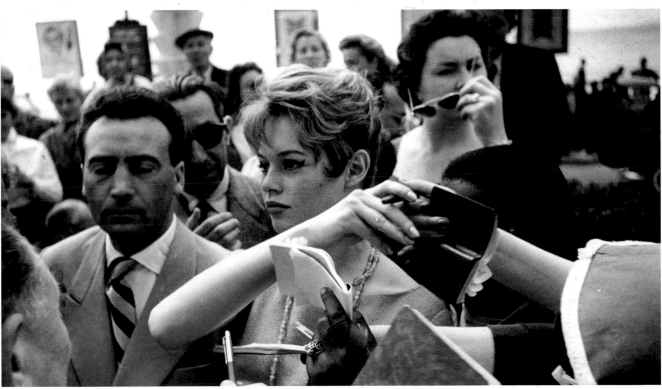

'Brigitte Bardot in Cannes' © Haywood Magee/Hulton Archive/Getty Images

framing and boundaries

Framing your chosen subject within an image can add a great deal of impact. If the subject you are photographing does not provide a natural sense of frame through your viewfinder, but instead has a particularly strong shape, then consider this carefully as you compose your shot and utilise the space around it.

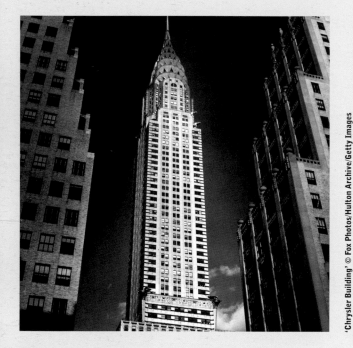

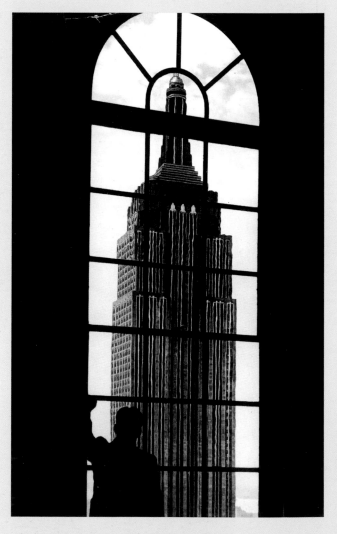

'Chrysler Building' © Fox Photos/Hulton Archive/Getty Images

'Empire State Silhouette' © General Photographic Agency/Hulton Archive/Getty Images

Above: The imposing Chrysler Building in New York is clearly framed here by two adjacent buildings; the low-angle vantage point that the photographer has chosen truly conveys the size and scale of the building.

Right: Simple but stunning framing has been used in this shot of the Empire State Building in New York, which is seen through an arched window. The silhouette of a man provides us a reference of scale but also lends the whole image a wonderfully graphic feel due to the grid of the window. Look out for bridges and buildings or opportunities presented by the fabric of cities that will work as powerful visual structures for your photographs.

Right: This crowded photograph of musicians leaves very little room for anything else, but the wire fence that the photographer has skillfully used as a grid contains them and makes an interesting shot of the band.

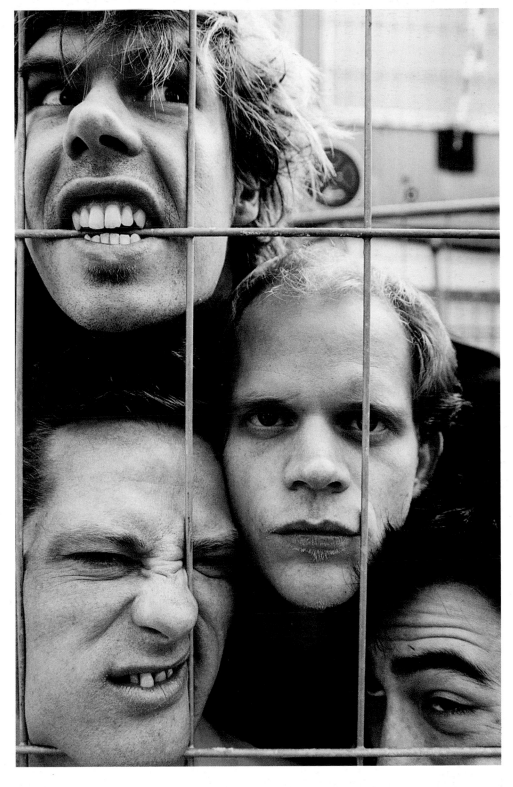

The Liars © Andy Rumball

judging the moment

Sometimes you may be lucky and just happen to catch that 'moment', and taking snaps, with no particular thought beyond the pointing and shooting is all well and good to a certain extent. However, if you wish to create a true feeling of spontaneity and dynamism, which also looks considered, then you will need to do a little homework on the location and people you plan to photograph.

Right: Look for a particular spot where the surroundings contain natural framing and potential focal points and then wait. There is no guarantee, but you might just get that character, capture a moment or some other wonderful thing that you had not anticipated happening. This unlikely kiss came about by chance, but was caught by being ready with the camera set and the expectation that this particular area would hold such characters who would no doubt emerge at some point. In this instance London's Soho, with its infamous mix of café society characters, provided the perfect setting for this odd pair to meet; the shot captures the split second in which a beautiful young Italian model spontaneously gave this old Italian gentleman a kiss.

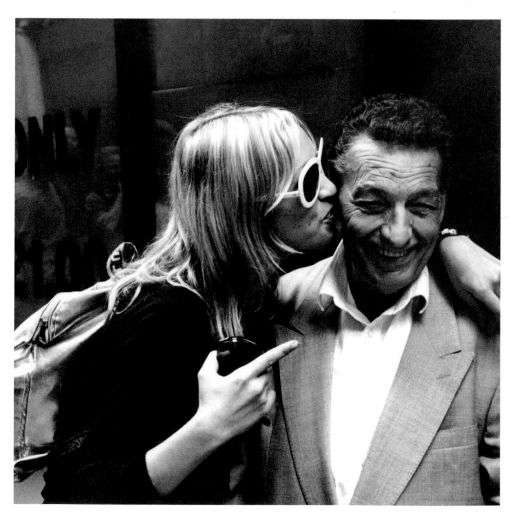

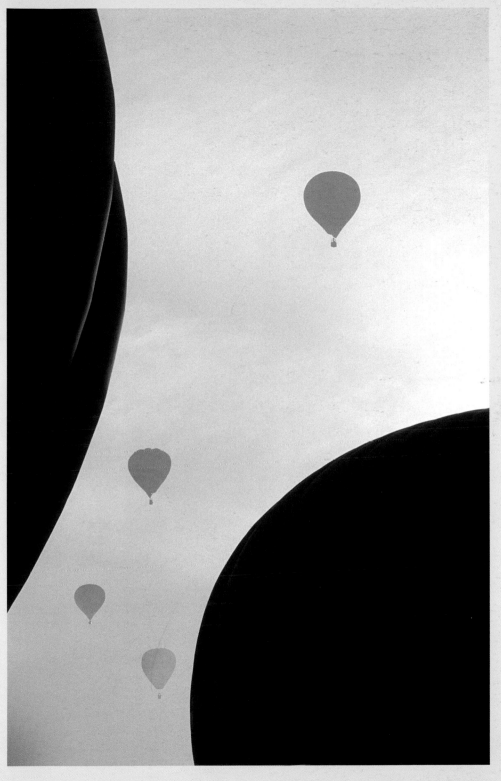

'4 in a Mist' © James Finlay

Left: This picture was shot with a Nikon F5, with a 28 – 70mm lens, at f4/12 and using Fuji Provia 100 film. The shot was taken whilst the photographer was running towards a balloon chase vehicle and glancing back at the balloons moments after take-off. Two balloons are still on the ground as can be seen in the top left and bottom right of the picture. These two also serve to naturally frame the four balloons that are rising in the morning mist. The image captures both a fleeting and exciting visual moment.

texture, pattern and form

We often miss the smaller details that make our surroundings so visually rich and diverse, and learning to look for these using a photographer's eye will open up a whole new world to explore. Isolating elements or focusing on patterns and shapes can be a highly creative way to express your vision, catch the mood of an occasion or simply illustrate the beauty of something that has caught your eye.

When considering texture, pattern or form, think about how the light falls on to your subject. The simple swell of a lily, the rich layers of a rose or the peppered details of the back of a sunflower head (shown on the facing page), have great depth and complexity when simply lit and photographed. If texture is an important element, angle your light or change your vantage point to make the most of the surface of your subject.

Travel often presents some great opportunities to exploit texture, shape and patterns. Look out for the layout of traders and their wares in market places or the town squares. You may want to think in terms of multiple shots and aim to create a collage.

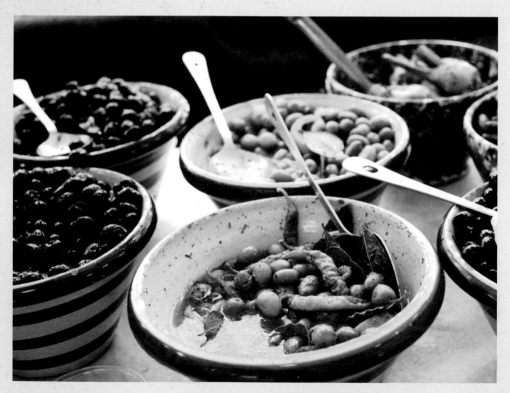

© Helen Drew

Left: Look for the simplicity in everyday objects and life forms around you. Separating a natural shape and photographing it alone can be highly effective – a technique that has been used in fine-art photography since the birth of the medium. However, an equally effective approach is to see the beauty of simplicity in multiples. The simple circles formed by these bowls of olives, with their gleaming oily surfaces bunched together, becomes a strong, yet simple study of shape and form.

© Peter Dazeley

Tip
Try experimenting with black-and-white film. This will help you separate shapes and patterns more easily. For digital images, convert those shots with particularly interesting detail to monochrome (see page 162), and see how different it looks.

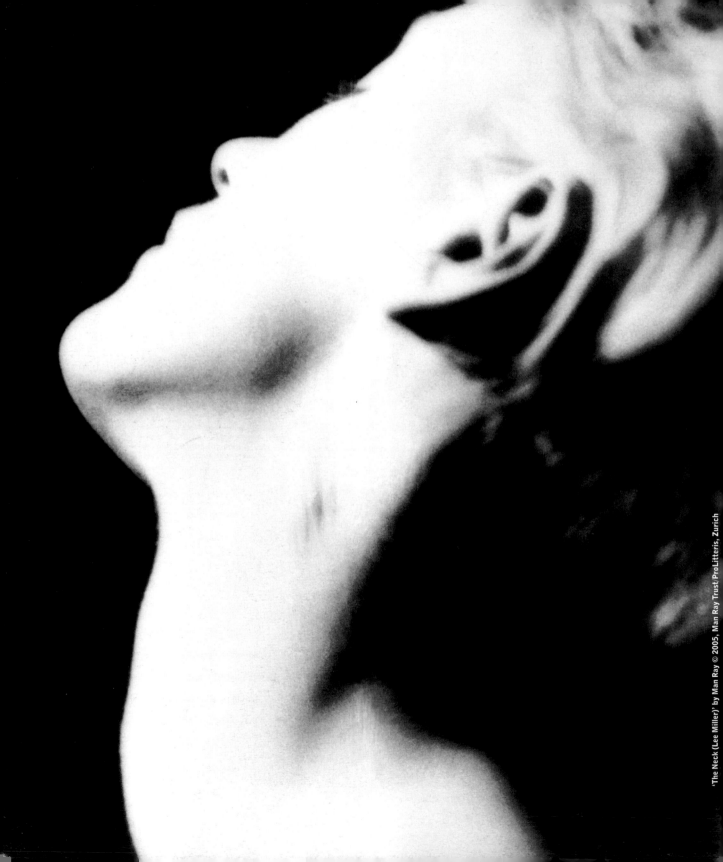

Section 4
Genre

Genre *(n.)* **1.** A type or class. **2a)** A category of artistic composition, as in music or literature, marked by a distinctive style, form, or content. **b)** a realistic style of painting that depicts scenes from everyday life.

documentary

Documentary photography shows us exactly what our world looks like at any given moment in time. Whether the pictures are bleak, playful, angering or astounding, they all serve a historically significant purpose.

The camera is a powerful tool for finding and communicating visual information to others, describing the world in which we all live but cannot wholly see. This might explain the popularity of magazines and pictorial editorial. The photographs transport the viewers to places and times far removed from their own situations. They give us great insight into recent history and the world around us. Quite simply, documentary photography records the impressive wealth of imagery in our everyday lives.

In our world of film, television and technological excess, a tangible photograph somehow captures reality, and allows us to enter and examine it, taking our time and trying to experience or understand what we see before us.

Of all the genres, documentary photography is perhaps the most prominent in our collective minds. This is partly due to many iconic images serving as visualisations of events and people brought to us via the media images delivered to us all day, everyday, on global activities worthy of public interest. Documentary and reportage photography record the reality of a situation in order for us to piece together the bigger picture, so that we understand more than a single frame can say. Both documentary and reportage photography require the photographer to be at the scene of the action and work using a small-format camera with a wide-angle lens to record an image that will successfully communicate the essence of a situation.

Tip

If you are interested in recording people in their personal environments and places, invest your time in them. Spend time talking to them, hanging out, include them in your project plans and show them your pictures if you have any. You will gain their trust and they will reveal more of themselves to you as they really are. If you are really lucky, they may tell you about places and people that they would not disclose to other strangers, offering you an opportunity to capture some unique pictures.

Ty Wheatcroft is a photographer and artist living and working in London.

'Around 2003 I became determined to make photographs about my own visual and personal consequences – dismissing my past photo-journalistic pursuits and reacting against notions of high technology and blindingly-sharp focus that has never really appealed to me. Consequently, I seldom focus, and this gives me the "not of this world" effect I delight in – a more spontaneous, personal documentation of whatever I encounter.'

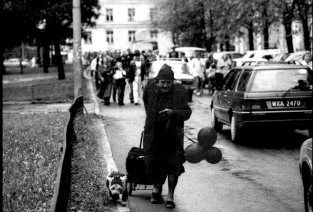

The Sprinter. It reflects well on you.

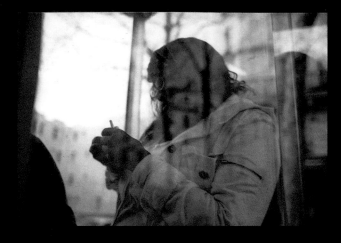

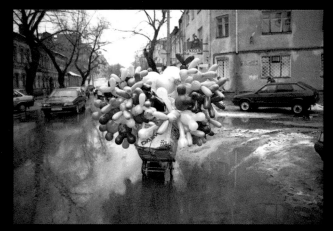
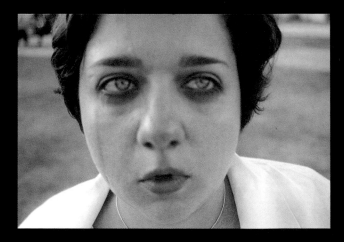
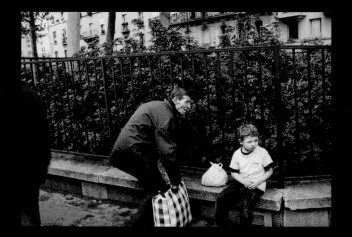
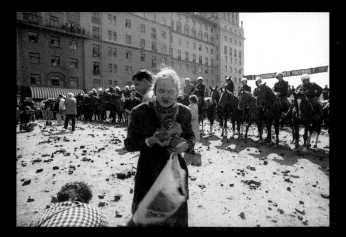

© Ty Wheatcroft

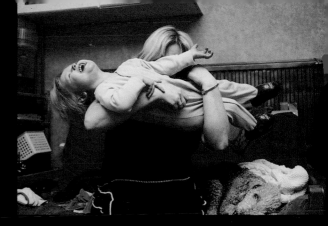
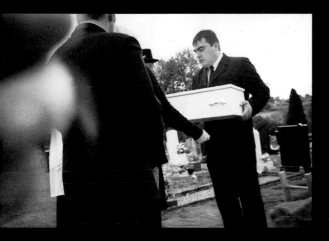
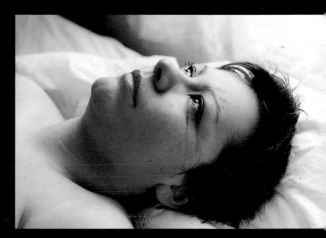
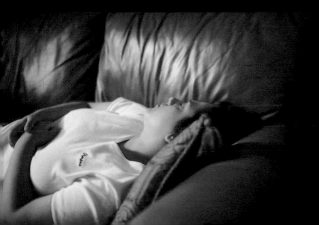
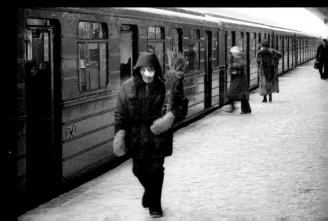

Born in Epsom, Surrey, Martin Parr studied photography at Manchester Polytechnic (1970–73), and gained early recognition in Europe and abroad as he won three successive awards from the Arts Council of Great Britain in the late 1970s.
To support his career as a freelance photographer, he took on various teaching assignments between 1975 and the early 1990s. Then, after much heated debate because of his provocative photographic style, he became a Magnum member in 1994 and his work has been widely exhibited in Europe and the United States, and acquired by a large number of public collections. His subject matter continues to be the study of the idiocies of mass tourism as well as the spiritual crisis of the lower and middle classes. He shows us an environmentally destroyed world in which the major saving grace is a gritty, very British sense of humour. He has shot several film documentaries and a TV documentary: 'Think of England'.

Below: New Brighton is a British seaside resort on the Wirral Peninsula, three miles from Liverpool. Originally a watering place for the wealthy merchants of Liverpool, New Brighton hit the peak of its popularity in the first two decades of this century. Parr's photograph documents a more contemporary New Brighton: an urban seaside resort, which is very much alive and kicking.

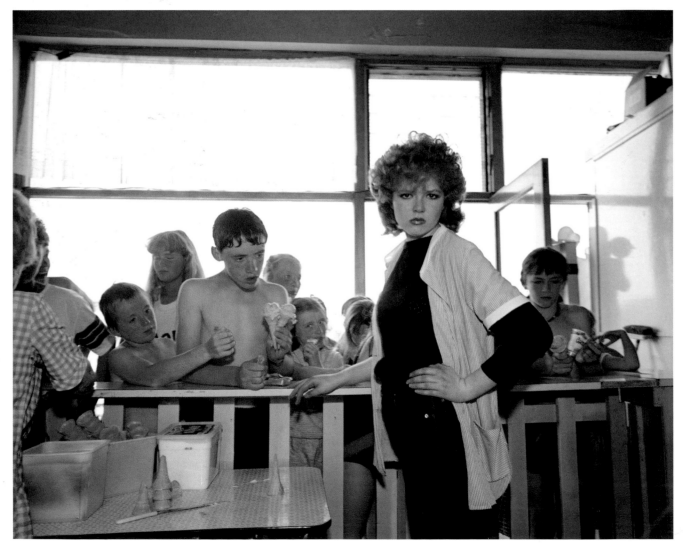

'New Brighton, England, 1985' © Martin Parr/Magnum

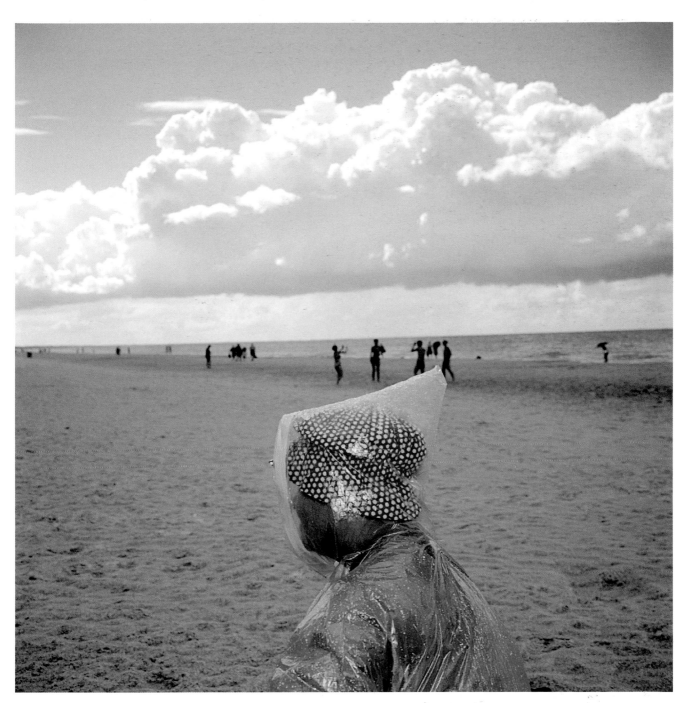

'Jurmula, Latvia, 1999' © Martin Parr/Magnum

Above: 'This is Jurmula a beach resort near Riga, capital of Latvia. I love seasides, particularly old communist seasides. I've got a mental image of a vast number of people being forced to enjoy themselves. This was a Sunday in July, and it had started to rain.'

photo-journalism

Photo-journalism is the act of gathering, evaluating and disseminating facts of current interest via photographic and literary media. A photo-journalist (or press photographer), while working in a similar style to that of a documentary photographer, may convey a particular point of view through an acute understanding of the power of a certain camera angle, point of interest, or cropping technique in order to produce a shot that will intensify the drama of the moment.

A successful photo-journalist will grab the attention of the viewer through his or her ability to express the drama of an event or extract the meaning of a situation within a single photograph. It's a very tough and competitive job as you may be on call 24 hours a day, in all kinds of conditions, waiting for your moment, covering the action, or preparing to capture the shot.

Whether displayed in an exhibition, published in newspapers or books or broadcast on television, photographs provide powerful visual records that undoubtedly shape our memory and historical recollection. Photo-journalists capture images of history, whether candid or posed, which can sometimes speak to us on behalf of the people they portray and the places in which they were taken. Photo-journalism has been a recognised genre for the last 150 years, and throughout that time photo-journalists have been on the front lines, not only in times of war but in times of peace, recording the important events of contemporary social and world history.

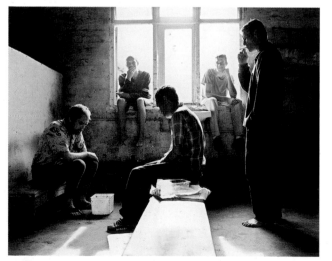

© Tom Craig

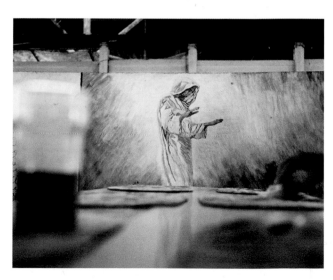

© Tom Craig

Tom Craig is one of Europe's most innovative and original young photographers. He is renowned for his unique approach to contemporary photo-journalism, believing that 'every strong image must begin with an in-depth understanding of the subject matter.' His sensitive and resourceful manner has earned him a respected reputation amongst both editorial and advertising clients and a plethora of deserved award nominations, including the prestigious Citibank Prize for Photography and, for three consecutive years, Magazine Photographer of the Year – an award he has subsequently won, alongside nationwide recognition as Arts and Entertainment Photographer of the Year.

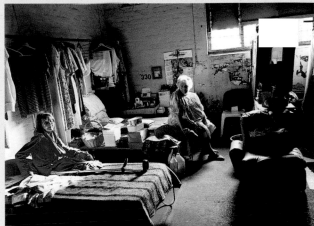

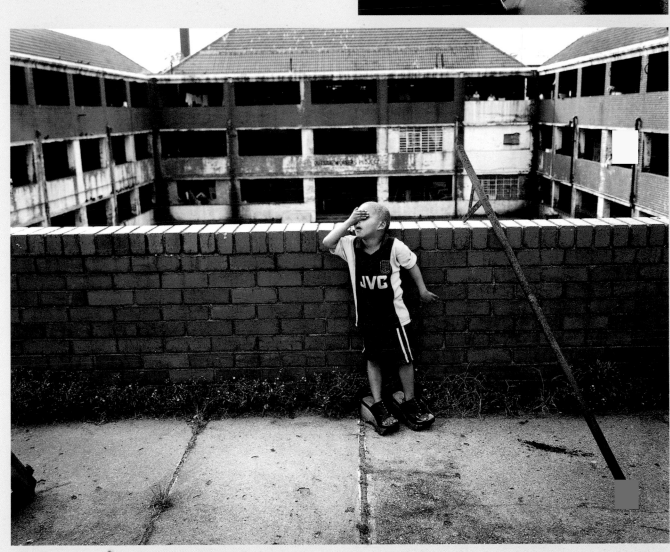

Situated in one of Durban's most dangerous districts is The Ark. It is the most extraordinary place and is home to some of South Africa's most unfortunate individuals. So stripped are the inhabitants of material wealth that blatant racial divides, so apparent elsewhere in South Africa, cease to exist in The Ark. This is a community that has very little, each person having been reduced to their lowest level at some point. This alone dissolves the ethnic tension and replaces it with a community spirit that brings individuals together; regardless of their colour or creed. Tom points out that 'individuals who make their living from photography are somewhat at the mercy of their commissioning editors. Assignments, briefs and the content of work can have a great deal to do with the source and whilst on one hand this can be rewarding it can also be a very limiting thing. There comes a point when photographers must express themselves, free of the shackles of fee-paying influence and this is the simple reason why so many photographers involve themselves in personal work. Such work can allow for complete artistic freedom and is often an opportunity for a working photographer to get back to their original reasons for pursuing a career in photography. In my case 'The Ark' was the place that I explored, as it is very much on the periphery of conventional society, and as such it is a space where much of my work comes from. There were countless reasons for me to return, how indeed one could exist in a place where people believed miracles could happen on a regular basis, yet you were regularly in the company of convicted murderers. I had no social or political agenda, I wanted a place unique in itself, where I could simply wander around in, meet people, drink tea, listen to life stories, but ultimately photograph at will. After a few visits no door was closed to me, I could get on and photograph the people and the life they lived.'

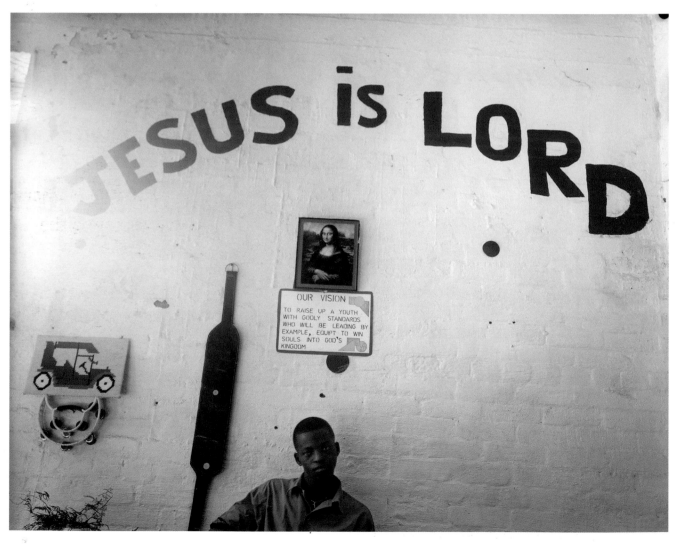

The Fundamentals of Photography Genre

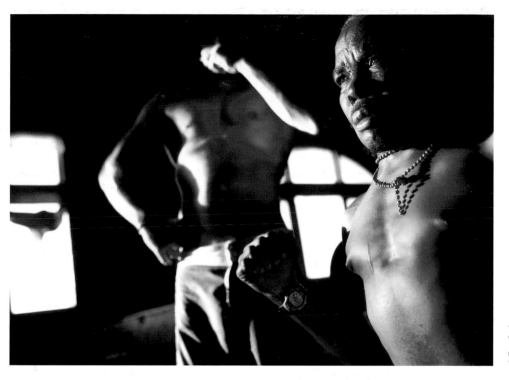

© Tom Craig

'It is one thing to photograph
people. It is another to make others
care about them by revealing the
core of their humanness.'
Paul Strand

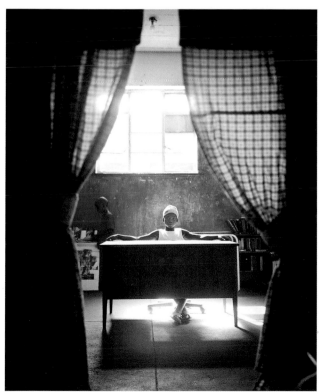

© Tom Craig

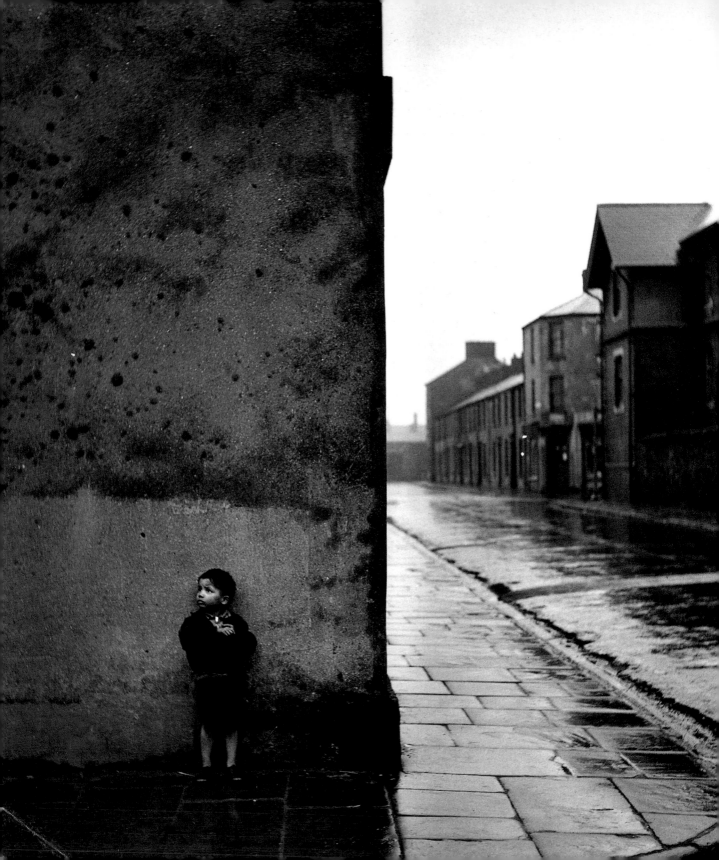

Once upon a time, *Picture Post* was the most accessible, exciting, up-to-date form of news available. Nowadays, replaced by the multi media of television, newspapers and the internet, this important publication no longer exists, but the incredible work of the photo-journalists working for the *Picture Post* remains just as powerful and inspiring as it was more than 50 years ago.

Matthew Butson from the Hulton Archive, a division of Getty Images, explains its importance: 'when the *Picture Post* was born on 1st October 1938 – under the genius editorship of Stefan Lorant – it arguably revolutionised the picture magazine market in the UK overnight. Its primary appeal, unlike many of its competitors on the news stands at that time, was that it spoke directly to the common man. The marriage between words and pictures contributed hugely to the success of the magazine and effectively defined the term photo-journalism. *Picture Post* was very much a pioneering publication and all but introduced the small format camera to Britain with photographers such as Bert Hardy, Kurt Hutton, Humphrey Spender and Bill Brandt converts to the revolutionary 35mm camera. The idea of depicting ordinary people going about their daily business was not necessarily new but the way in which *Picture Post* staff photographers captured the very essence of being British is still fondly remembered today. The instinctive use of natural light together with a genius for composition marked out the *Picture Post* "staffers" from the run-of-the-mill press photographers of the day. However it was also their uncanny ability to get close to their subjects that allowed them to consistently capture the raw emotion of the moment. The legacy left behind by these pioneering spirits is truly extraordinary and, without question, defined an era often referred to as "the golden age of photo-journalism"'.

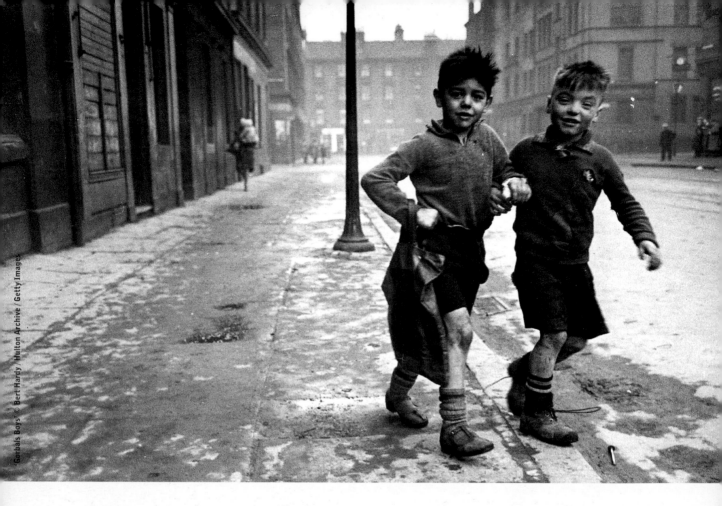

'It is simple. I tried to use photographs as a composer uses notes. Those that fit into the composition are taken, the others discarded.'
Stefan Lorant

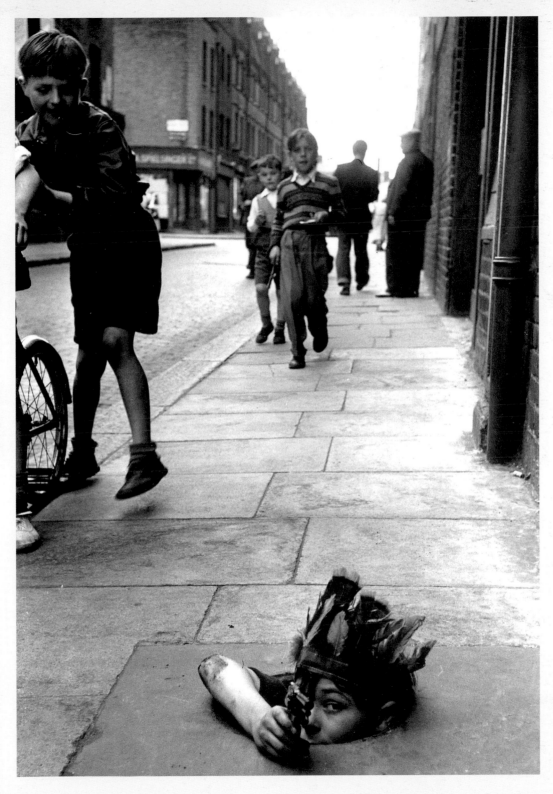

The Fundamentals of Photography Photo-journalism

landscape

Landscape photography is a hugely popular genre; capturing the mood and aesthetic dynamics of a scene that inspires will undoubtedly present a unique challenge to the photographer. Developing both your technique and an eye for lighting conditions will help you to confidently record memorable landscapes in any season.

A landscape does not move, but this makes it no less difficult a subject to shoot. Often the sheer vastness of a view may seem daunting and just too great to translate through the lens, but there are simple techniques that can be applied to make the whole experience more manageable and enjoyable and produce the results that you are aiming for. Light changes both with the seasons and throughout the day, and a good photographer will learn that different lighting conditions will provide different effects. Early morning and late in the afternoon are generally thought to be the best times to shoot as bright, midday light can wash out an image and create harsh shadows.

Landscape photography isn't just limited to shots of rolling hills and rugged mountains; the urban landscape provides a rich and complex visual experience, and a source of great inspiration to create stunning photographs. Recording the urban landscape through photography has advanced with the industrial growth of the cities themselves. Cities are a tapestry of dynamic shapes, iconic buildings, throngs of people, signs, transport and the bustle and energy of life. As such, cities do have a look and feel of their own; think of Paris, with its soft, grey rooftops, winding alleyways and cobbled streets; Venice with its canals, doorways and faded grandeur, and of course the vibrancy of London and New York City, with their respective trademark skyscrapers, bridges and riverfronts. It is easy to disappear in a city and get caught up in the frenetic pace, but choosing your viewpoint carefully and considering the scale and format of your image can isolate the powerful angles of buildings, and through a number of frames you can create a series of strong urban landscapes or isolated shots that stand alone. The mystery of what you cannot see in a city will always remain locked up in the streets and buildings that are too numerous to photograph, but you can create the essence of the urban space you are in with metaphors and dynamic lines.

You must rely on natural light when photographing landscapes and cityscapes. If you take the time to carefully consider what you are trying to capture and what light will create the most effective image you will see an improvement in your work. Early in the morning might provide mist, fluid skies and climatic changes that will affect the landscape before the day settles. The late afternoon often brings wonderful strong light that creates long shadows, which can be used to dramatic effect. Walk around and find the best vantage spot for your subject, and have your camera ready to shoot, then wait. The light can change continuously and a sudden cloud that appears over the sun or the mist evaporating may create exactly the right mood you want, so be ready. You cannot underestimate the importance of considering and selecting your vantage point carefully as this can change a mediocre landscape shot to a good, dramatic photograph with a strong sense of scale. An elevated vantage point often records the vastness of a view far better than an eye-level shot. This works particularly well when shooting urban landscapes that are often reflective of an architectural sprawl. Juxtaposing buildings of different periods or natural and man-made elements can also be a very effective way to add new and different dimensions to an image.

© James Finlay

Above and right: These beautiful landscape photographs were taken from different sides of the same valley and at different times of the day. Both shots perfectly illustrate the changing mood of the weather. The first shot (above), was taken at 5 a.m., from a low angle so the early morning mist prevails. The brighter scene (right), taken two hours later reveals more of the valley, but from a different vantage point.

© James Finlay

The Fundamentals of Photography Landscape

A landscape is an expanse that often contains a great deal of information, which will usually be difficult to capture and express, so focus on key elements within your range and work on those. Good composition is vital to the shot working, so consider the three structural layers in your viewfinder: a foreground, middle and background. Aim to build in a foreground with a strong visual element, which will act as an initial point of reference for the viewer and lend the image vital high- and lowlights for contrast. Middle-ground elements create a sense of depth that lead the eye into the photograph; these elements might be trees, a path or a river. The background of a typical landscape photograph will often comprise about a third of the image; it may consist of skies or mountains but, again, these elements create a sense of scale and space whilst framing the scene, so use them carefully when positioning your shot.

Most professional landscape photographers use medium- or large-format cameras that capture an enormous amount of detail; the disadvantages of using these are that they are expensive, the lenses particularly so, and heavy to carry around. The good news is that even if you only have a 35mm camera, it is possible to achieve great landscape results with the help of a tripod and a cable release to prevent camera shake (see page 22).

Unfortunately most digital SLRs do not generate enough pixels for professional landscape photographs, but because of the increasing interest in digital imagery, more and more book and magazine publishers are interested in digital landscape shots.

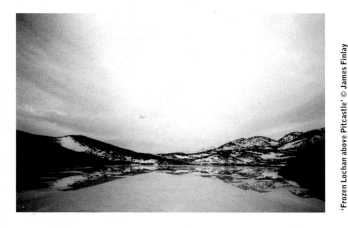

'Frozen Lochan above Pitcastle' © James Finlay

Left: Shooting low to the ground from a high vantage point captures the vastness of the sky, and the reflections in the lake create a bleak and yet beautiful symmetrical frozen landscape.

Right: For architectural scenes and urban landscapes, a long or telephoto lens (see page 14), will give you greater freedom and bring aspects of buildings closer to you. These neon signs are vibrant and colourful, typical elements of an American city. Be ready with several types of film, or plentiful memory cards, when you plan to capture cityscapes in order to do them justice.

'Progress St and 16th St Bridge, Pittsburgh' © James Finlay

Above: You may want to experiment with the format of your photograph – an atypical format in landscape photography makes for a more unusual image. Overcast skies can work to great advantage, as they provide an opportunity to capture muted colours and tonal ranges that can create a specific mood. Look out for breaks in stormy skies, when the sun is able to break through and highlight certain areas, as this will dramatically alter the feel of the whole shot.

Tips

There are a number of accessories that are considered sound investments for the landscape photographer. A selection of filters will help to separate and accentuate tonal range, depth and clarity, and a lens hood is also really useful for cutting out unwanted glare.

Countryside landscape photography is all about sharpness of image and depth of field. Use the smallest aperture available on your lens – usually f22 or f32, to create the maximum amount of depth of field.

Right: When shooting urban landscapes, remember to look at the shapes and lines in architecture and man-made structures. Use the archways, the reflections of windows and unexpected framing opportunities that occur to construct your picture. Also remember to look for figures that may provide a sense of scale, particularly in a dense urban scene.

You may want to experiment with formatting your shot as a portrait image (see page 54). In some ways this may compromise your photograph, but in others it may enhance the foreground and the use of an atypical format in landscape photography does make for a more unusual image. Digital compacts are particularly good for urban landscapes in a portrait format thanks to their 4:3 aspect ratio. Traditionally 35mm and most digital SLRs use a 3:2 ratio, which does not suit landscape photography in a portrait format because it is too long and thin. Digital compacts produce an image that is wider, and therefore looks better in portrait format.

(see page 54)

Tip

Look around you for interesting reflections that catch the light and distort the shapes of buildings.

'Downtown Pittsburgh' © James Finlay

The Fundamentals of Photography Genre

© Andy Rumball

Above: This image was taken from a low angle, which creates an interesting dynamic as the lines lead the eye up. A great depth of field was needed to keep as much of the clock and background in focus as possible.

Right: The crumbling façade of this building in Berlin dwarfs the modern house on the left. This not only creates a sense of scale, but also captures a mood of time and place.

© Andy Rumball

Tip
For architectural scenes and urban landscapes, a long or telephoto lens will give you greater freedom and bring elements closer to you. Don't forget that a detailed close-up of a particular aspect of a building can often create a more interesting shot than one that captures the whole building.

portraiture

What exactly is a portrait? When we describe a photograph of a person as a 'portrait' we tend to think of it as being a truthful visual representation of that individual – next best to the real thing. If the eyes are deemed to be the windows to the soul, then does the lens function as the recorder of that soul? Photographic portraiture can, particularly when employing a formal approach, not only record how a person looks, but also capture the essence and nature of the sitter.

Many photographers have commented that the purpose of a portrait goes beyond the obvious simplicity of functioning as a physical description of a person, and that it should capture an inner 'something' of that person, a sense of the character that this individual possesses, which sets him or her apart from others, or indeed joins them with a certain 'type'. An exemplary portrait can capture a frozen moment that reveals the inner world of a person, to the gaze of the outer world in the hope that we might somehow understand the essence of that person. There are portraits to portray the soul, and portraits to admire the aesthetic appeal of an individual; the approach toward portraiture is hugely varied.

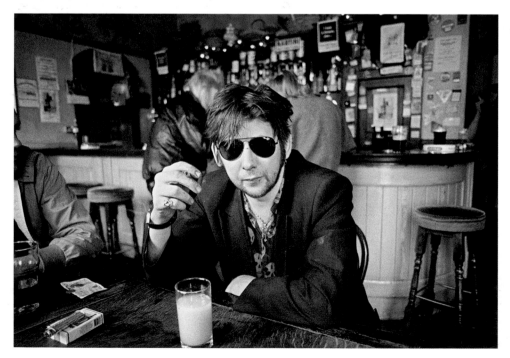

© Danny Elwes

Left: What are you aiming to achieve with your portrait? It may be that you decide to shoot your subject doing what they prefer to do with their work or leisure time, or they may want to bring something that defines their personality along to your shoot. Such an item could be used as a central prop and could enhance your photograph. It's worth spending time considering what styling you are going to use in your image.

Below: Portraits need not always be the head on, straight at the camera variety. Andy Rumball has created two intriguing portraits that use a different and more creative approach.

'Boom Bip/Doseone' © Andy Rumball

Originally taking its lead from the painted portrait, the photographic portrait confirmed the existence of the individual, but also displayed the status of that person and revealed something of the personality. This is something that you might want to consider when planning a portrait. Often the surroundings of that person can say as much about them as a shot that concentrates on the face.

When you set out to photograph your subject, prepare a list that will focus your mind and determine your approach. Consider the person, who they are and what it is that you find interesting about them. Talk to them and find out what they are interested in; is what they do important to them or not? Conversation often establishes a rapport with your sitter, and a good atmosphere will relax the situation and give you a better chance of capturing the essence of the person. If someone is uncomfortable or posing beyond the requirements of getting the picture, it will show.

Tip
If you can't find an attractive backdrop for your portrait, try using a shallow depth of field to throw your model's surroundings out of focus.

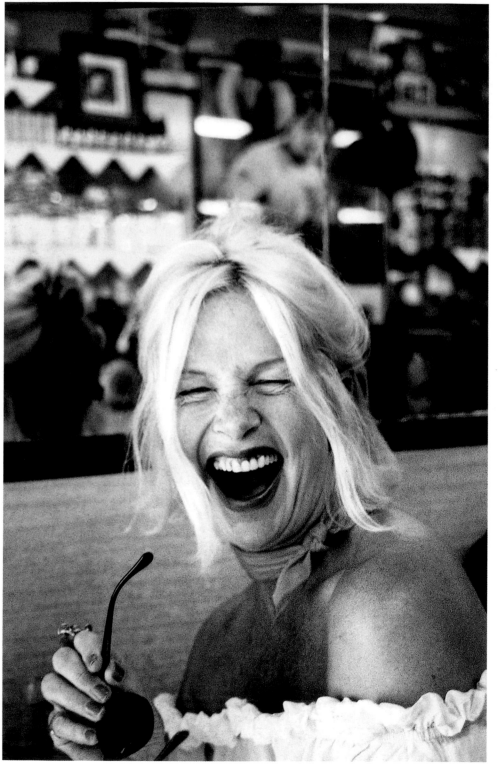

Left: Do spend time talking and making your sitter feel at ease. The laughter emitting from Jibby Beene – a fabulous character from the British art world – is infectious! This is a good example of capturing an impulsive moment because she is comfortable and enjoying herself. Capturing her close-up ensures that she is centred and contained, and shooting against a mirror creates a sense of space and informality.

Right: Black and white can often lend a timeless quality to a portrait. This image of Jude Law has spontaneity to it, and captures an air of playfulness about the actor. Look for characteristics in your subject that you may want to encourage for your shot.

© Helen Drew

Tip

Learn to keep notes on locations and lighting situations that you might like to work with. It is helpful to revisit a situation as it may become your unique style of approach to portraiture.

© Danny Elwes

Above: This portrait of the renowned screen and stage actor, Jonathan Pryce is thoughtful and quite intimate. He is captured here taking a moment for himself, open and at ease with the camera. Without props or make-up we see the the man first and the actor second.

It may be necessary to direct your subject, concentrating on the technical issues, and simultaneously be in control of the creative opportunities that the shot offers. You will find that your subject gives you more if you are firm and direct with what you want from them. Even when taking an informal shot you need to be firmly in control; the subject will assume that you know what you are doing and you should aim to project confidence to reassure them that this is indeed the case! When planning your portrait keep in mind that you should be in a position to see a range of your subject's expressions, once you then start shooting one of the results is likely to be a great photograph. Make the situation as easy as possible; simplify your lighting arrangements and make sure the subject will not want, or be able, to fidget once you start shooting.

Photographing a group can be pretty difficult but you can obtain good group portrait shots if you control and shape the shoot. Consider the varying heights and shapes of people and move them around to make the best composition. Perhaps have some people sitting on the floor or on chairs to create a sense of balance. Make sure that everyone is ready when you are, as the boredom threshold of people is quite low in this sort of situation and you want to catch the mood and look while it lasts. If you follow the simple rules about lighting direction and preparing your subject then you should be able to capture some great pictures.

Consider your lens choice. Remember that a wide-angle lens may fit more into the frame, but can be unflattering if going close-up for a portrait, or there may be a risk of distortion. If you need to use a wide lens, perhaps if working in a tight space, then work well back from your subject.

An ideal lens for portrait shots is 100mm (and upwards). The telephoto lens allows you to get in close and really focus on your subject and you then have the opportunity to perhaps think about the eyes in more detail or catch spontaneous laughter. If you have a 50mm standard lens then this too is also absolutely fine and you can practice your composition skills and consider cropping the final print if you wish to take a close-up. The 50mm standard lens translates into a 75mm on most digital SLRs, which means it is even better for portraits.

A camera on a tripod and with a shutter release will allow you to take a portrait with 'mood'. Often low-lighting need not always mean having to use a flash, and the time of day and angle of the light can create a sense of drama in your image if you use shadow and light with careful consideration.

Right: This portrait of the world famous designer and restaurateur, Sir Terence Conran was composed specifically to reflect the context of the shoot. He was selecting photographs for an exhibition about the weird and wonderful aspects of life, and so was happy to strike an Alfred Hitchcock pose to reflect the mood. He is complete with trademark cigar, but the stuffed crow adds more than a hint of the surreal.

Tip
A reflector can be particularly useful in portrait photography; it creates a softer look by filling in any shadows created by strong light sources.

© Helen Drew

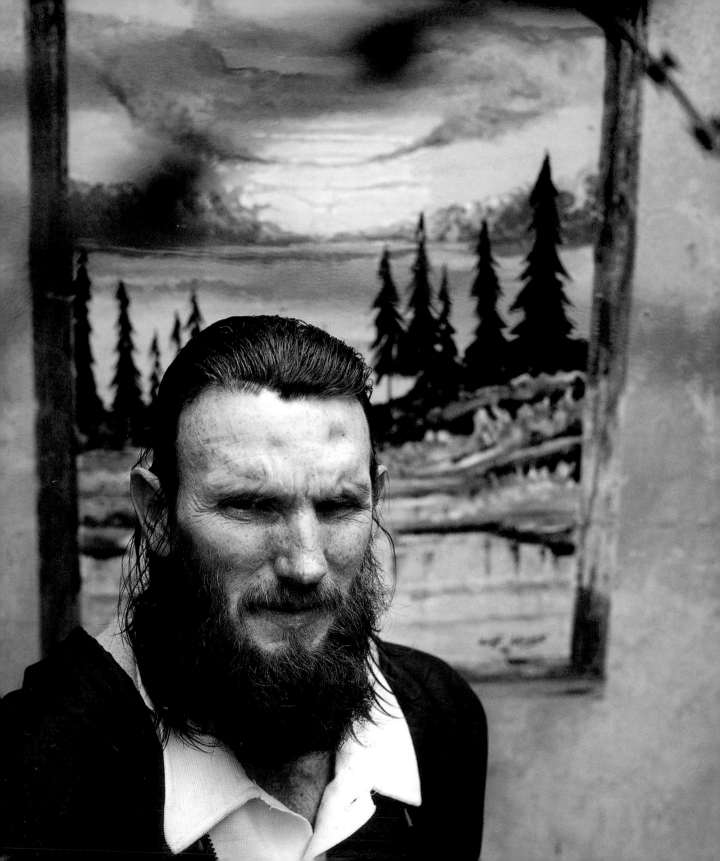

Left: This strong, almost brutal, portrait of a man from The Ark, a self-supporting community and shelter in Durban, South Africa, has a raw and yet compassionate feel. Think about the surroundings of the person to strengthen the composition of your image, and help draw the viewer's eye right into the eyes of the subject.

Right: This image was taken with a slow film using fill-in flash. Shots taken from a lower angle are often thought of as very unflattering, but here the photographer's vantage point actually suits the model's face. The stark crop and strong direct light lend the portrait an intensity and rawness that suit the sitter.

Tip

A camera can often feel intimidating to those that are unfamiliar with them, or not used to being photographed. To resolve this you can spend time wandering around the same space as your potential subject(s), or chatting to them while holding your camera and taking aim around the space you are in. Another good way of catching the uninhibited side of a subject is to use a long lens. This allows you to capture your shot without being invasive.

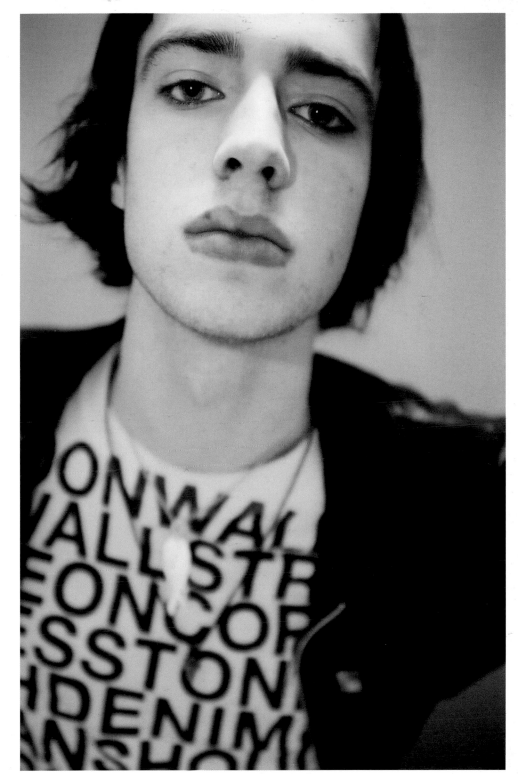

Finn Andrews © Andy Rumball

Ben Elwes is a successful advertising and editorial photographer based in London.

'I had been looking for a subject and theme involving relationships as a basis for a photographic portrait project that I could work on in my spare time and when I had available funds to put towards my own work. Keeping personal work ongoing is essential for one's progress. As well as it being refreshing not to be working to someone else's brief and timescale, it is also a valuable way of developing your identity as a photographer.

Marriage became an appropriate theme and members of my father's generation became the subject. There was an abundance of people, many relations, good friends and acquaintances of my family whom I became keen to photograph; among them a significant number had been married only once and remained with the same partner. This theme of longevity in relationships stood out, and became the portrait project I wanted to pursue.

I decided to shoot entirely on medium format for adequate image quality, using both Pentax and Mamiya cameras and colour or black-and-white negative film. I used a soft box as the main light source, offering an even and complementary light. Natural light was used indoors if sufficient, and no artificial light was used outdoors at all. I always avoid using tripods, as I prefer to be able to move, even if just a little, with the camera.'

The Fundamentals of Photography Genre

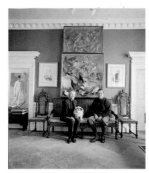
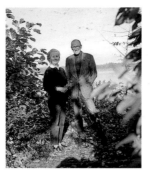

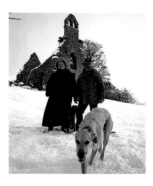
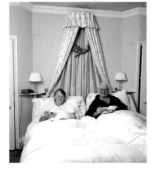
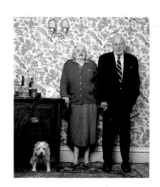

'I would shoot the portrait either indoors or out, determined by the wishes of the subject, and the availability of an appealing setting. I wanted each shot to be a full-length study, keeping the couples close together, thus increasing the emphasis upon them. Their input into the location was always important, as I was keen not to force anyone into an inappropriate situation. By keeping things technically straightforward, and not having too many rules about location, this allowed me to be spontaneous and to concentrate on the 'sitters', most of whom were unaccustomed to being formally photographed.'

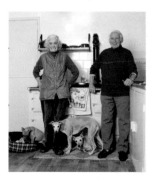
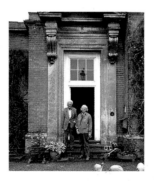

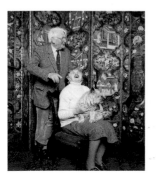
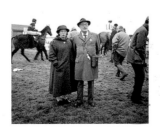

The Fundamentals of Photography Portraiture

fashion

Fashion photography is not just about simply presenting clothes in the best and most flattering context, it's also about capturing a great moment. We live in difficult and complex times and fashion photography can provide a means of escape; as it is influenced heavily by aspiration and art. A good fashion photograph creates a mood and propels our dreams and aspirations of how we want to look, who we want to be and where we wish to conduct our 'perfect' life; all of course attainable by wearing the clothes tempting us from the pages they look out from.

Romance, envy, lust and disgust are just some of the emotions we may feel when we look at a fashion photograph. We can also relate to the fusion of influences that today's fashion photographers reference in their work. Although most models remain the stereotypical size and shape that one has come to expect, some are starting to break the mould; it is not unusual nowadays to see an oversized or older model. 'Real people' are plucked from the street, and novice models can be superstars of fashion campaigns. Take your influences from documentaries, fine art, fantasy or film; it's all in the mix of a 21st century fashion photograph. Informal or unusual framing, close-ups and deliberate blurring techniques are used frequently in, and contribute, to contemporary fashion image. More often than not these photgraphic techniques comment on the subject as much as recording it.

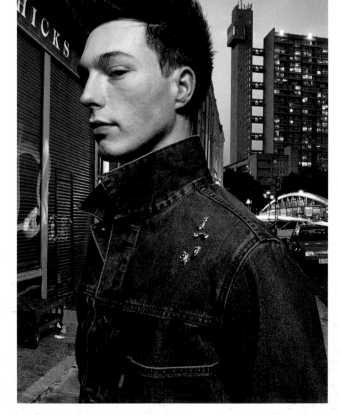

Tip

These days you don't need a fully-equipped studio to create fashion photographs. If you want to shoot fashion on a budget go out on location and go for a candid snapshot approach.

'Night on Earth/Squeeze' © UZi PART B

The Fundamentals of Photography Genre

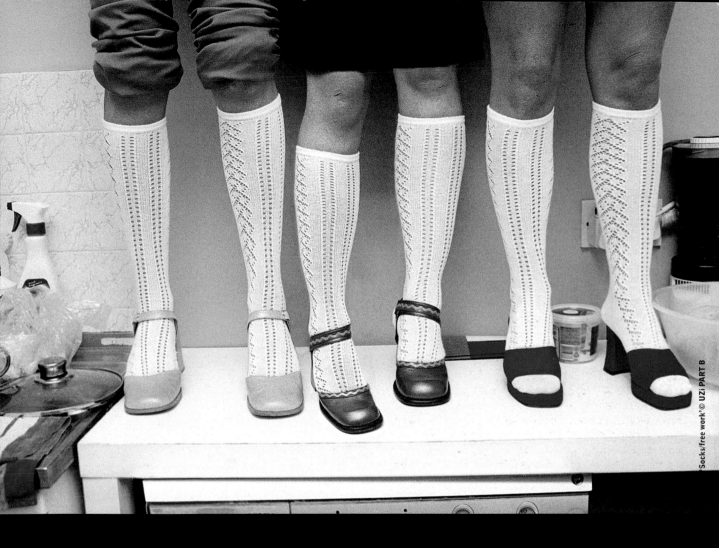

Socks/free work'© UZi PART B

'The greatest fashion photography is more than the photography of fashion.'
Susan Sontag

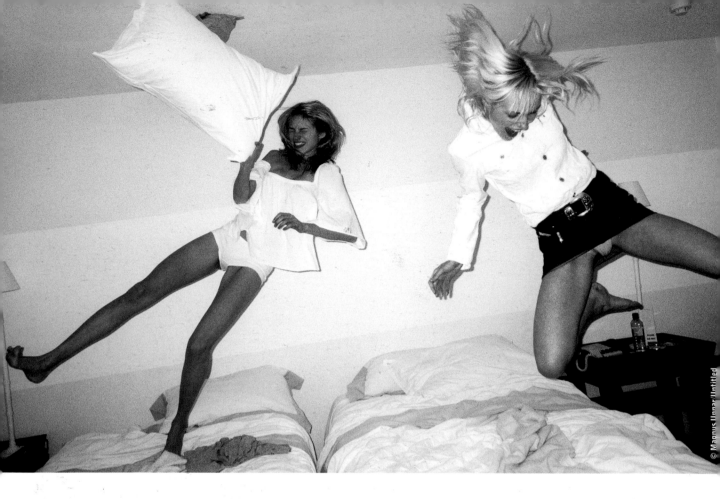

Above: A hotel bedroom was the backdrop for these models who became as famous as the designers dressing them. This spontaneous snapshot feel is widely used as a vehicle in fashion photography to show not only the clothes, but the social status of the model and therefore the lifestyle that is associated with the picture.

Right: This is a fashion photograph that essentially has little to do with the actual garment it promotes. Instead the location and association of the image speak volumes about the item of clothing. If you are interested in fashion photography take note that it is now, more than ever, intrinsically bound up in lifestyle and culture, so think laterally about the shot you compose. Think about the clothes you are photographing and the type of lifestyle that the person who would wear them might lead. The world is your backdrop when it comes to fashion and absolutely anything goes!

In the early days of the fashion industry, illustrators recorded a designer's vision; as the designers wanted to ensure exclusivity and originality. As the decades have gone by, fashion photography has evolved and changed. The fashion industry has witnessed a variety of styles and movements, many of which were a reaction to a previous popular culture or the politics of the time. For example, the 1990s reacted to the glitz, glamour and ostentation of the 1980s with grunge, waif-like models and heroine chic (a movement that provoked widespread condemnation in the media). Models, and the photographers themselves, became celebrities in their own right and an obvious crossover between fashion and art photography was established.

Right: This bright and beautiful model allows her smile to give the clues to her lifestyle and choice of fashion. If you want to plan a fashion shot then think beyond the clothes. On a professional shoot an art director will make suggestions and a stylist will provide the models, clothes and make-up. Consider what approach they might take and as you experiment, get into the habit of thinking beyond simply getting the structured shot. In doing so your ability to take photographs that echo your own style will strengthen.

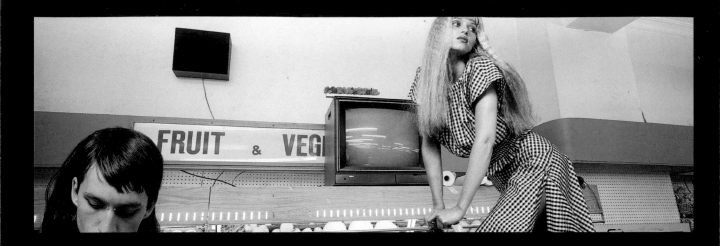

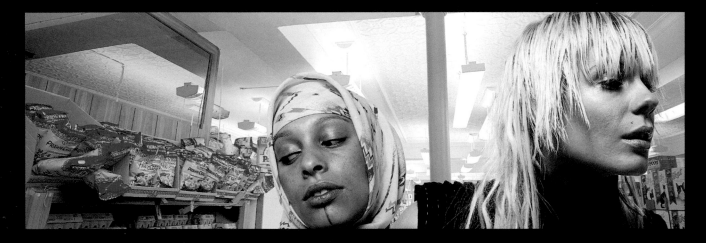

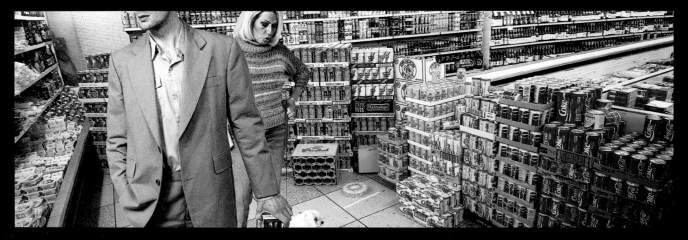

'7-11/Pulp' © UZi PART B

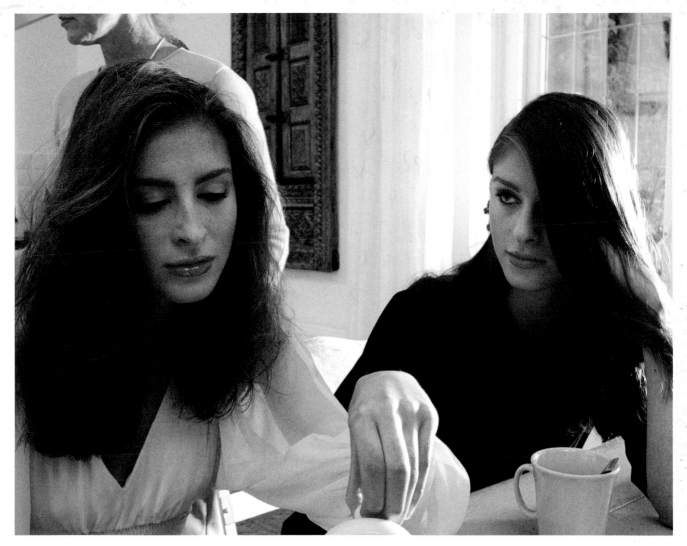

Above and left: Opportunities for fashion moments today – thanks to over half a century of incredible fashion photographers inspired by and reflecting elements of constantly changing global, political and cultural climates – are to be found in abundance everywhere. Anything goes whether in the supermarket, down the café, at the movies or just hanging out with friends.

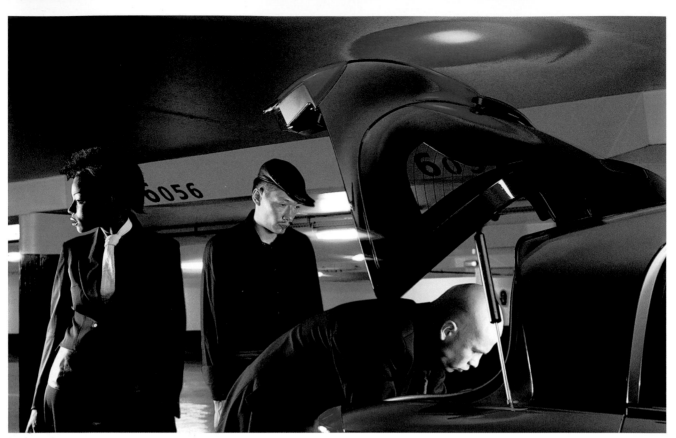

Above: The last 150 years have provided a fantastic visual culture and repertoire, and film sets and stills are no exception. Even though this image was taken from a fashion shoot it could quite easily be a still from a movie. Set in an underground car park with a glamorous and dangerous look, the image allows you to invent your own narrative.

Right: This image of two glamorous cocktail girls could not be further from the fashion photographs seen in contemporary magazines today. Fashion photography in the 1950s often endeavoured to describe the social ambience of the particular house of couture the model was wearing. In this particular instance however, the appeal of the dresses, while fun, is aimed at the mass-market, fashion-conscious woman and while quite daring to use a shocking Schiapparelli pink backdrop, the look is more high street than high couture.

Tip

Coloured backdrops are expensive. A cheaper option is to buy a white one and invest in some coloured gels to use with your lights and change the colour or mood of your images. Tear off a used section of the backdrop and use it to walk on while you position your model and lights, then remove it when you are ready to shoot; this way your functioning backdrop will remain cleaner and last longer.

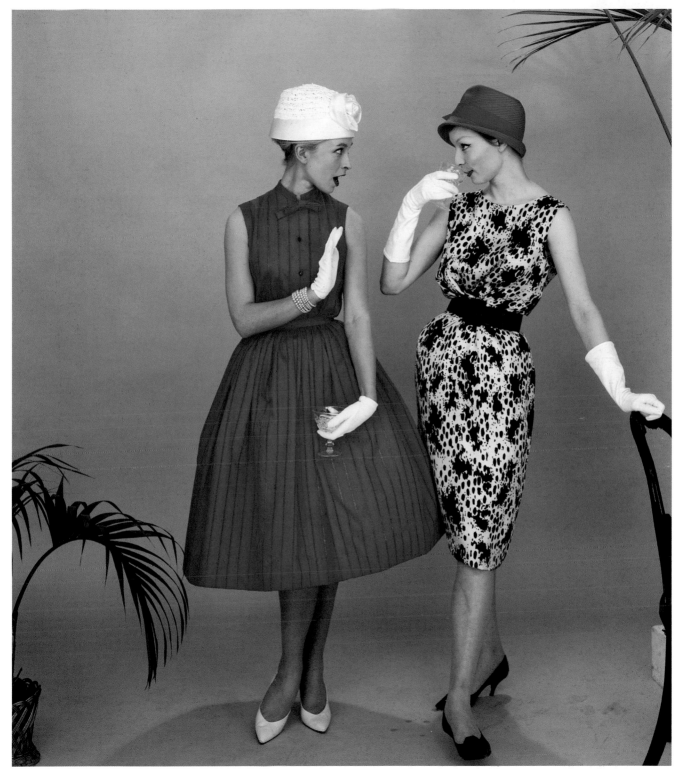

'Cocktail Conversation' © Archive Photos/Getty Images

The Fundamentals of Photography Fashion

the photograph as art

The concept of photography as an art form has promoted continual debate. From the early days of photography's popularity as a medium, it has been argued by its proponents that a photograph expresses far more than simple information or representation of a literal form.

When photography is embraced by artists as a creative tool, both the world and the way in which we view it becomes a spectacularly different place. This contrast is particularly stark when compared to the recorded images of documentary photographers (see page 64).

Following a century of powerful visual appropriation and reassessment of meaning in image culture, the boundaries between the photographic genres and what constitutes 'art' are now very blurred. What might have originally been shot as a simple portrait, a busy street scene or a nude, may now be considered as a 'higher' or 'purer' form of aesthetic, adding a reverence and a value that may be influenced by the status of the photographer or simply by an image belonging to part of a school of styles, which were taken at the right time and in the right place.

The fine-art photographer has the ability to convey something more intense, and often intangible, than what has actually been photographed; the technical skill and sensitivity to light is infused with a creative spirit. The camera in the hands of a fine art photographer will somehow produce more than is seen, as Graham Clarke comments in his essay 'The Photograph as Fine Art', 'the concern with form and light gives to the most banal of objects a magical quality which transcends their literal function'.

The photograph as an art form is a vast, complex, rich and fascinating arena upon which we only touch briefly here. There is a plethora of wonderful books available that are devoted to this particular genre, which I recommend you read as many as you have the time for. More importantly, look at the work of photographic artists as well as group exhibitions to get a feel for how the images look and what feelings they evoke.

The 'art' photograph provides a license to break the apparent rules of conventional photography. In this particular genre blurring, atypical composition, cropping, or under- and overexposing may actually contribute to the strength of the image, as they somehow manage to evoke what the photographer is seeing and feeling, without necessarily recording it in its literal form.

'There are times when the process of photography seems invested in magic, and what it is that makes that photograph truly work in the end is a mystery.'
John Szarkowski

Tip
This particular genre encourages you to break the rules. Experimentation is the key here – whether it is with your composition, technique or even your chosen processing and developing methods.

Left and below: An office block and the corporate landscape may appear to be the antithesis of creativity, but original photography and an open mind towards your approach to it can contribute to original, striking and heartfelt imagery.

© Ty Wheatcroft

© Ty Wheatcroft

Allan Jenkins is a purist and a traditionalist, working only with natural light and using old fashioned, alternative non-silver processes. These methods were first practised in the 1890s and combine ferric salts and carefully exposed UV light, which cooks the images slowly into the fibres of the paper through the density of the negative. Allan's work is dark and mysterious; every print is a curious and beautiful mixture of new and old.

Right: This beautiful, abstract image of a building in New York, one of the most photographed cities in the world, illustrates that thinking laterally when taking a photograph can not only capture what we see, but also the atmosphere of a place or moment. The freedom of creative photography allows for a different kind of record.

'Night Glow' © Ernst Haas/Hulton Archive/Getty Images

Above: A close-up of this military memorial, which is dedicated to all the US soldiers killed in the Korean war, is a subtle but powerful comment on the legacy of a terrible event. The fractured and blurred surface of the memorial captures the reflection of a soldier's image, and renders his face distant and anonymous. This is a thought-provoking image, that perhaps reminds us of the human cost of war.

'Soldier, Korean War Veterans' Memorial' © James Finlay

When the extraordinary photographer Bill Brandt photographed these nudes, he professed to have done so by letting himself be guided by the camera and without controlling what he wished to see and record. These beautiful, anatomical shapes and forms were the result, and indeed are evidence that the camera is so much more than a piece of recording equipment.

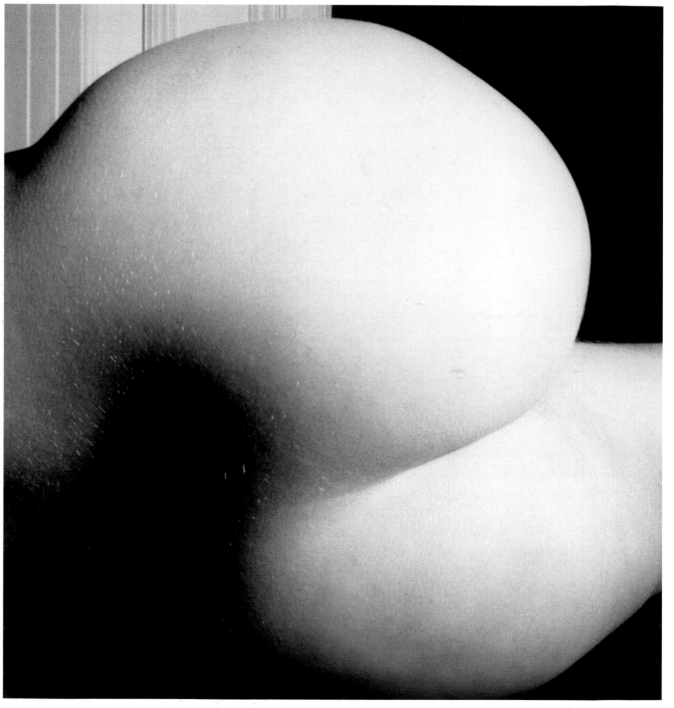

Section 5
Lighting

Lighting *(n.)* *1.* Equipment in a room or street etc. for producing light. *2.* The arrangement or effect of lights.

understanding light

Light is the photographer's chief resource. The word 'photography' derives from Greek, and literally means 'light drawing'. From the brightest light of the midday sun to the fuzzy glow of a streetlamp at twilight, the light falling on the subject of your photograph is what determines the mood of the final image. Adrian Mott, Senior Course Leader at the London College of Communication, comments that lighting forms the crux of a number of crucial photographic principles – 'the use of light and the quality of light are the most important factors influencing the aesthetic success of every picture that you take. The way light falls on a subject totally dictates the physical appearance, how much texture and detail are revealed, the strength and neutrality of its colours and whether it looks flat or three-dimensional. This in turn influences the mood of your picture and the way people respond to it emotionally, so to get the most out of your photograph you must have a thorough understanding of light and how you can use it to your advantage.'

Whilst the volume of light determines the exposure for a photograph, the light itself actually has a colour that is measured by temperature, and this can also affect the picture. The 'colour temperature' is measured in degrees on the Kelvin scale. Imagine the colours of a piece of metal that is slowly heating up; first from red to orange, then pale yellow to white hot, and finally to blue. This is a good analogy for the measurement of light temperature as it increases in strength and brightness. The redder, warmer tones at the lower end of the Kelvin scale are present in the morning when the sun has not fully risen; these would give a temperature of around 3500K. The strong, midday light on a bright, sunny day will be around 5500K, and a sunset would typically be around 2500K. The Kelvin scale allows you to clearly see the weaker or stronger effects of light as the day goes on.

Film is typically referred to as being 'daylight balanced', which means that the colours are calibrated to respond to light at midday on a bright day. If this is not reflective of the conditions that you are shooting in, then colour casts will be recorded. Digital cameras work in a similar way, but have a distinct advantage over film in that they can calibrate themselves to automatically respond to any given colour temperature. This is referred to as Automatic White Balance (AWB). However, it isn't perfect and the further away from typical daylight temperatures the situation is, the more chance there is of a colour cast being recorded.

Artificial light can cause more problems for both film and digital cameras; a typical 100 watt bulb has a colour temperature of around 2870K and a professional tungsten photographic light measures around 3200K. Without filters, in the case of film, or precise white balance adjustment, for digital, pronounced colour casts will be recorded. This however, can be used to your creative advantage.

Tip

To develop a genuine understanding of the variations of daylight colour temperature, find a scene or subject with lots of texture and form and photograph it at first light, again at midday and then again in the early evening. Doing so will help you to make more informed choices regarding when and how you create your photographs.

© Helen Drew

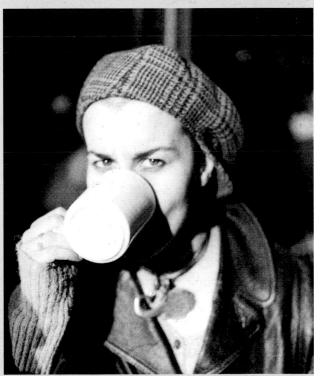

© Ancy Rumball

© Helen Drew

Above: Creatively, there are no right or wrong considerations as to what kind of light you should use; it will depend upon the atmosphere you wish to create.

Right and above right: This woman was caught enjoying a coffee in the powerful midday sun on a winter's day. There is a great deal of contrast in the print, which works well on this occasion.

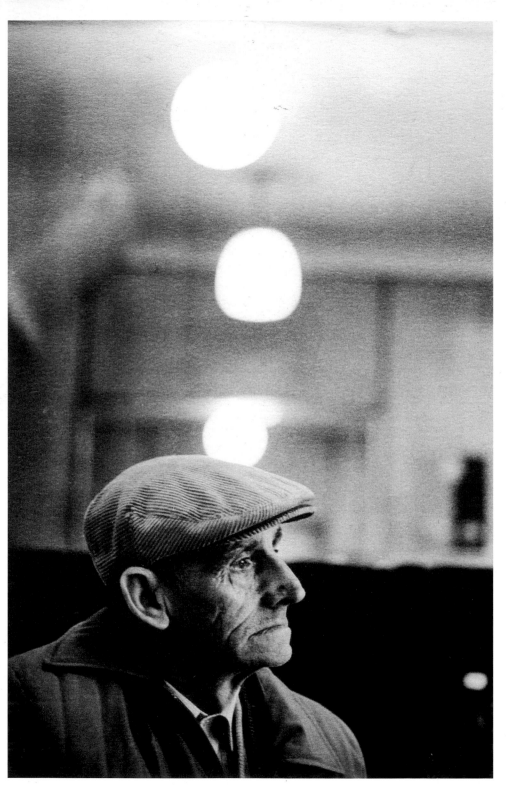

Left: This image has a natural and soft feel to it, as the window light was balanced and soft overhead lighting bounced off all the mirrors inside the café. As such the shot is sympathetic to the gentleman's weathered face. It is a good idea to use all the light-boosting props that are available to you if you are shooting with natural light and remember to consider your light source.

> **Tip**
> Always exercise caution and never look directly at the sun through your viewfinder, as it will be magnified by the lenses. Digital compact users previewing on the LCD should exercise additional caution as the extreme light may damage the CCD.

Right: Shooting a subject from a certain angle can produce dramatic and powerful shapes or silhouettes. You may run the risk of some flare (a lens hood can help reduce this), but if you expose for the background and keep the sun behind your subject you will achieve great creative effects. In this image the photographer has carefully used the shadows to greatly enhance his composition.

© Helen Drew

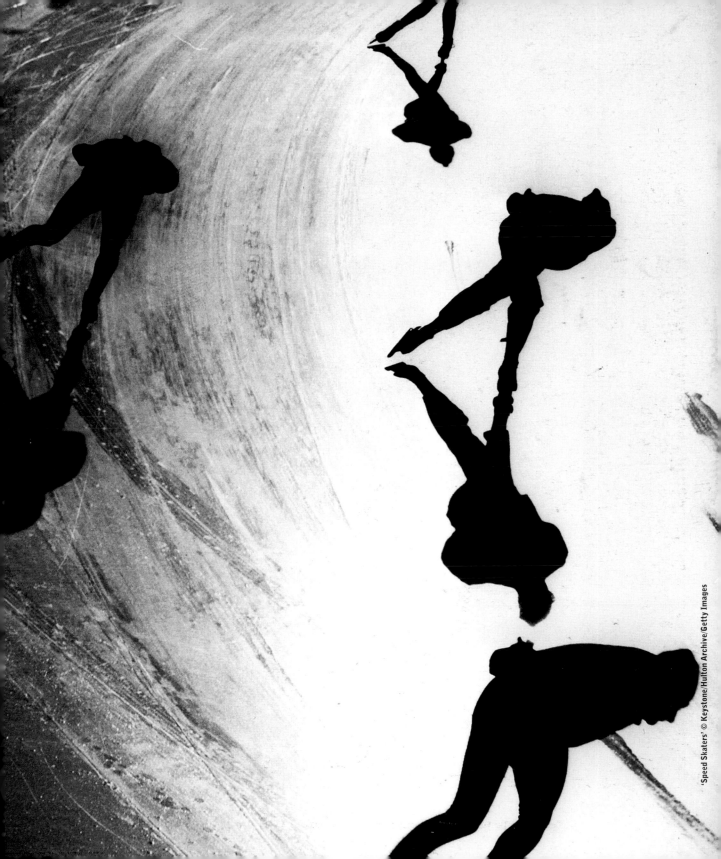

natural light

The intensity of natural light can be controlled, to an extent, by your selection of exposure settings, your technique and your choice of film, all of which can greatly affect your final shot. A good rule to adhere to is: the brighter the light, the higher the f-stop required, the faster the shutter speed needed and slow film should be used. Equally the dimmer the light source is, the lower the f-stop number, the slower the shutter speed and fast film is required.

When shooting outdoors, 'ideal' light will be somewhere between strong sunlight and very weak light. If the light is too bright it can create ugly, dark shadows that can distort your subject; just imagine a face with shadows coming off the nose and eyebrows. This can be remedied through the use of a fill-in flash that will illuminate those areas in shadow, but it is best not to rely on your built-in flash for this as it can't travel very far and so is unlikely to make much difference in strong sunlight. A better solution is to invest in a separate flash, which you can attach to your camera via the hotshoe.

Perhaps surprisingly, It is thought by a number of photographers that an overcast or grey day makes for the best lighting condition for outdoor portraits. You may think that overcast skies will contribute to boring images, but in fact the clouds will act as a giant diffuser over the sun – this is similar to the lighting effect of a softbox and can therefore be very flattering.

The direction in which the light falls on to your subject is very important. Consider the shadows, texture and form that can be emphasised by the light falling in different directions. Move around your subject to see the effects achieved by different viewpoints; experiment in different conditions and analyse your results.

Tips

The colour content of light matters less when shooting in black and white, although the direction and quality remains important as this will affect the contrast of your image.

You can diffuse a hard light by placing a sheet of tracing paper or another opaque material between your subject and the light source. If that source is the sun then the diffuser needs to be close to the subject for it to be effective, whereas if the light is from an artificial source such as a flash or lamp, the diffuser should be closer to the source.

Right: These harvest workers cast long shadows in the late afternoon sun, which is filtered through the trees to lend Bert Hardy's image a real atmosphere. There are many nuances and variations of light, and you will increase your understanding of how to use light effectively the more photographs you take. For example, it is considered bad practice to shoot straight into the light and yet Hardy has used this technique to great effect. This technique is known as 'contre-jour' and can be used with the subject in silhouette as here, or with fill-in flash to add detail to the figures.

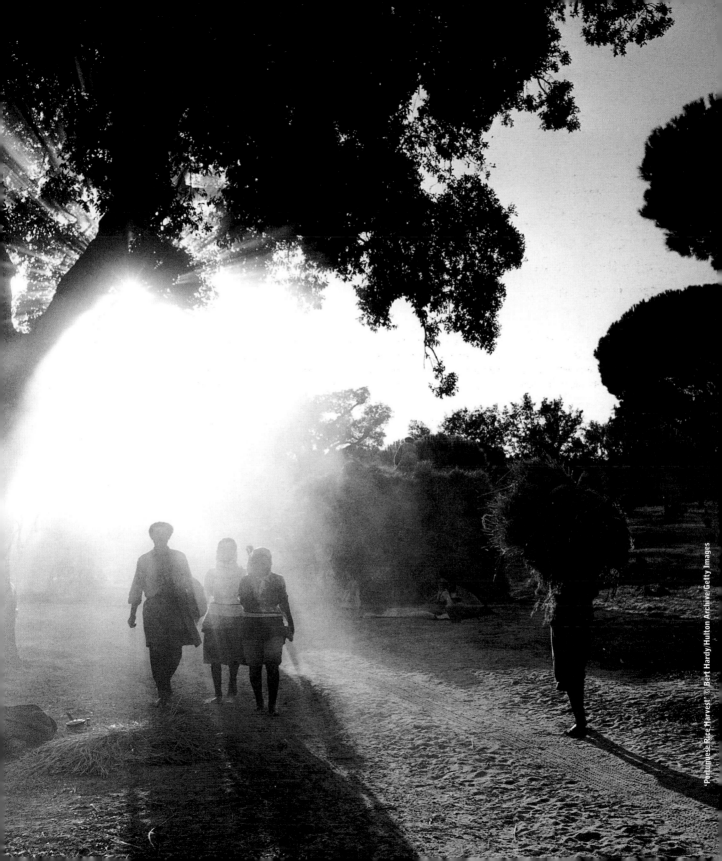

shooting in low light and at night

Taking photographs at night is likely to be dependent on available light and this can present problems, but if successful, the results are worth it. Trying to calculate exposure for a shot in the dark can be tricky, as the meter will pick up on the brightest lights in the scene and the long exposures necessary may give very thin negatives that have too much contrast to make a good print. Digital cameras avoid these problems, but a different one occurs – due to the small fluctuations in light at night, excessive digital noise can occur.

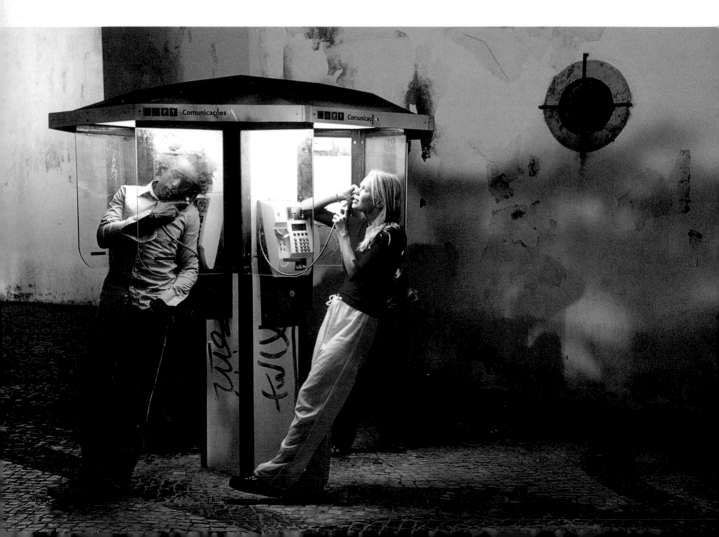

If shooting in low light you are likely to be making exposures for one second or longer by using the bulb or manual setting on your camera. If using this technique you will encounter the problem of reciprocity failure. This means the usual combination of aperture, shutter speed and film speed fails to produce an evenly exposed negative. You can compensate for this by opening up your lens and increasing the exposure, overriding the meter reading. Combine this with bracketing your shots (see page 26), so for each central shot take two or three more with the lens opened up half a stop, and increase the shutter speed by two seconds and so on. There is an element of chance in this and the results may not be exactly what you saw, but you may find your image has gained something else.

Digital SLRs tend to have very long manual settings, so that it can be set for 4, 6, 8, 15, 30 seconds or more. As this is a timed exposure, you can use the timer release, set to a short period of say one second after pressing the fire button. As a guide, begin with a basic exposure of f/8 and four seconds for 64 ISO film and bracket your exposures. Most digital cameras use 100 ISO and actually need slightly longer, so set the camera to f8 and the shutter speed to 15 seconds. Opening the lens just before a burst is launched will capture the fiery streak climbing skyward as well as the burst itself. As long as you can manually control your camera you should capture a great shot.

Below: Exposure techniques for photographing fireworks vary. Expect exposure times to be long, varying from just under a second to more than 15 seconds. The trick is to have the shutter open at just the right time to catch the moment that the firework explodes. Set the shutter speed to 'B' (bulb) and use a locking cable release as you will be making timed exposure.

Left: This image was taken at f2.8 for ten seconds. The shot wouldn't have been possible without the use of a tripod and a cable release, as camera shake would have significantly blurred it.

STA Travel © Andy Rumball

'Battersea Park, November 5th' © James Finlay

Left: These images were shot at night, using only the light that was cast from the bridge. It helps if you take a tripod when shooting with low or no lighting as these shots tend to require long exposures.

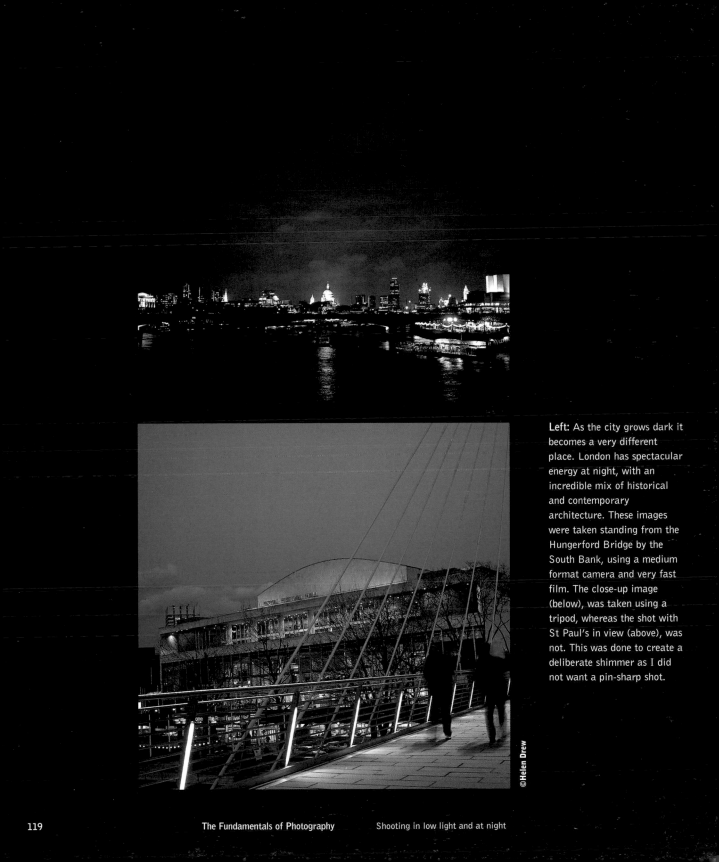

Left: As the city grows dark it becomes a very different place. London has spectacular energy at night, with an incredible mix of historical and contemporary architecture. These images were taken standing from the Hungerford Bridge by the South Bank, using a medium format camera and very fast film. The close-up image (below), was taken using a tripod, whereas the shot with St Paul's in view (above), was not. This was done to create a deliberate shimmer as I did not want a pin-sharp shot.

©Helen Drew

artificial light

When the natural light available is insufficient for your shot, tungsten or flash lights can be employed to illuminate your subject. Often photographers use artificial light to mimic the effect of natural daylight, but it can also be used to great creative effect.

Artificial lighting is continuous, so you can control the set-up and accurately anticipate the results you are going to get. It can be manipulated with a variety of accessories, including 'barn doors' and 'snoots' that will restrict, angle or channel the beam of light. Equally a diffused bulb will offer a softer light, or a spotlight will provide a direct beam for hard lighting and shadows.

Tungsten light, used in conjunction with black-and-white film, can be a good option for portraits; although the beam may seem quite hard, it's actually a warmer light source than flash. Tungsten-balanced film is available when working in colour, which will ensure that no colour cast is recorded. Should you be working without tungsten-balanced film then filters are also available to correct colour cast, but the effects can be variable. If you are working digitally then another option is to scan your image and then add the filter effect via an image-editing program.

As an artifical light source is continuous, it is possible to use the lamps creatively when you require a sense of movement in your image; the light can become very effective and easy to control simply by changing angles and bouncing it. Pulling back from your subject and perhaps diffusing your lamps will create a softer light and more even result, whereas equally you can spotlight and mask-off tungsten to create shadows and greater light intensity.

The advantage of using tungsten lamps for a light source is that you can easily adjust anything with the subject or lighting as you require and this will help ensure that your final shot is realised exactly as you'd planned. If working for a length of time tungsten lamps can get hot and this can be a problem, but you can generally set-up and position your shot with regular overhead lighting, and then work in bursts of artifical lighting, depending on who or what you are photographing.

Tip

When you are experimenting with tungsten move the light around your subject, and see the dramatic effects you can achieve with just one light source.

Right: Man Ray captured this striking image of the surrealist muse and photographer, Lee Miller. Taken in the studio, this picture clearly demonstrates the versatility of tungsten lighting.

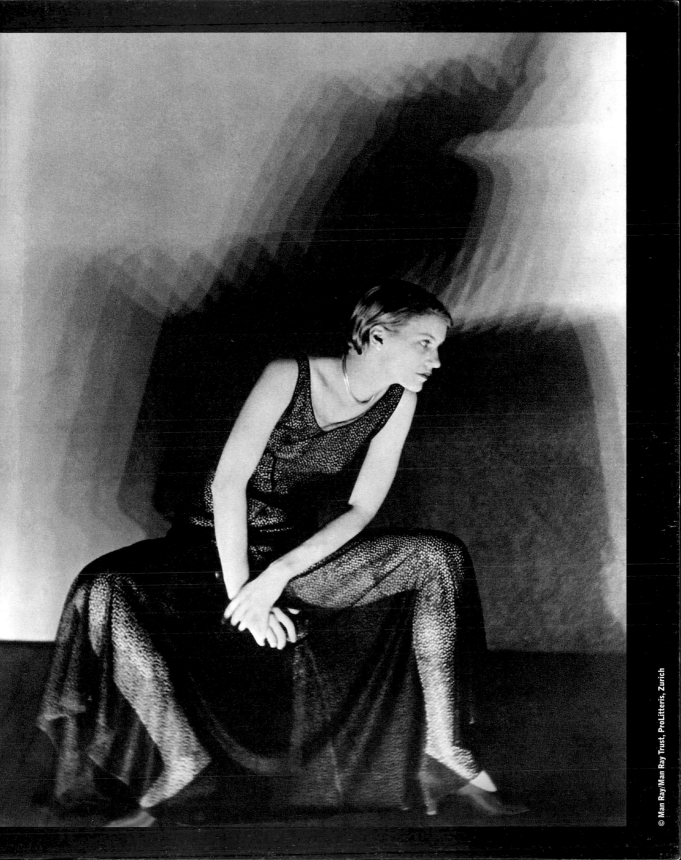

Below and right: These two photographs of American jazz singer Billie Holiday, were taken at the same venue and on the same night. The photograph below was taken using flash; the one on the facing page was taken with the light available (the spotlight on her). Each picture has a distinct mood and look as a direct result of the different lighting used.

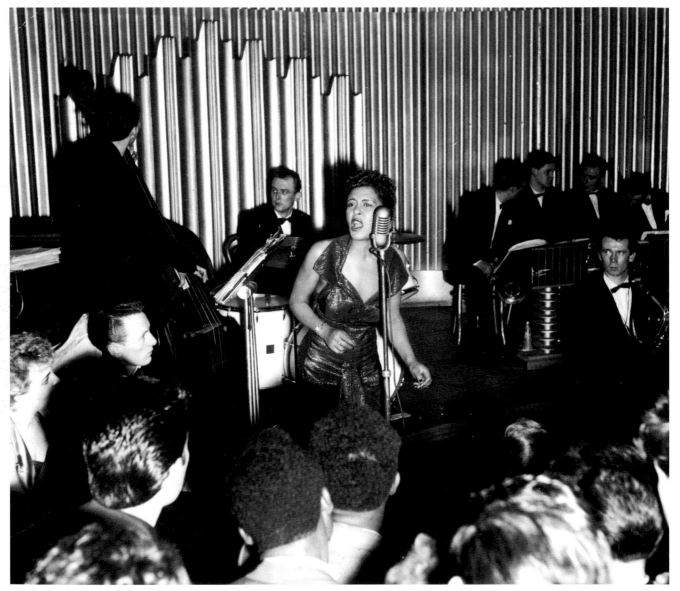

Billie Holiday A © Charles Hewitt/Hulton Archive/Getty Images

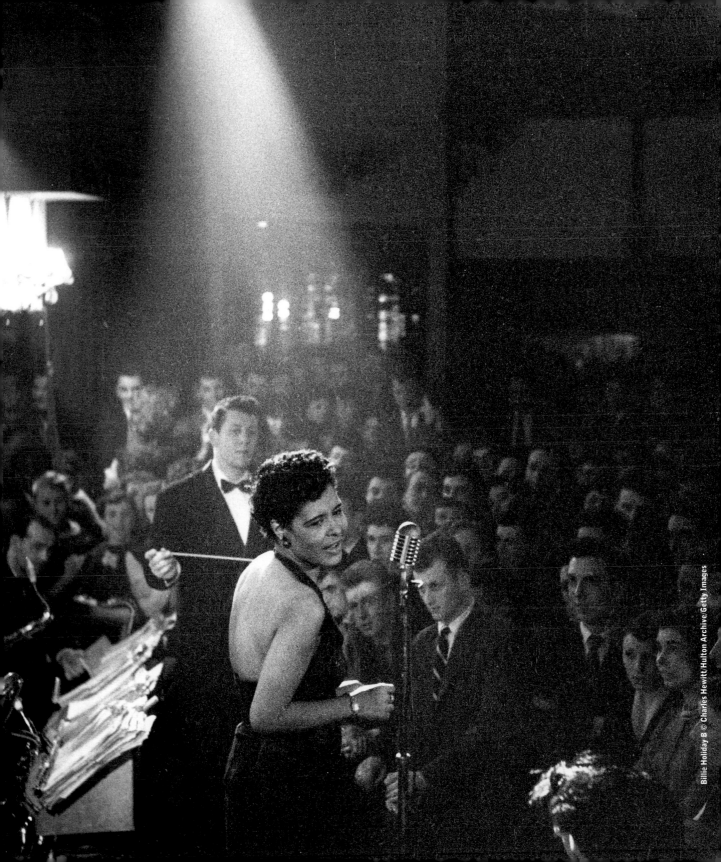

flash

A camera flash is a portable unit that emits a burst of light, which illuminates the subject for the duration of the shutter speed setting. Most modern cameras have a built-in flash, but if you are serious about photography it is worth investing in a separate flashgun or speedlight. Built-in flash can only travel a short distance, usually between 1–4 metres, but a powerful flashgun or spotlight can provide a shooting range of up to 30 metres. Flash is usually categorised as one of two types – 'automatic' or 'dedicated'. An automatic flash mounts on the top of the camera and is universal, so can be used with any camera. It calculates the exposure using sensors, which can measure the light reflecting from your subject. Dedicated units are designed for specific camera models; the flash and the camera communicate to one another via sensors in the camera's hotshoe and the camera tells the flash how long to expose for.

There is probably no type of photography that is more disappointing to the beginner than flash photography. Unlike natural-light photography, where what you see will often be what you get, it is difficult to visualise what the effects of using flash will be. Flash is shut-off until the moment of exposure, and then its illumination is too brief to visually evaluate what it will do to your picture. It is possible, though to approximate your result by calculating the inverse square law – as you double the distance between the subject and the flash, the amount of light reaching the subject decreases to a quarter of what it was. This will often result in the subject being lit by the flash, but the background appearing partially or completely black.

There are ways you can further control the effect of flash, either through the use of reflectors or by holding your portable flash unit away from your camera (but attached by a sync lead). Experiment with the flash by bouncing it off different reflective surfaces to alter the depth and direction of the shadows – the image will appear less flat and contain more information about the background beyond your subject.

Using a separate flashgun will also minimise the risk of your subject appearing with 'red eye'. Red eye is the curse of low-light photography, as it can ruin images. The eyes' pupils are enlarged when they are in dark environments, and they do not have time to react to the speed of the flash. The red you see is the light reflecting off the blood vessels at the back of the eye and travelling straight back to the lens. If you move your portable flash away from the camera and its lens, then the light reflects back to the flash instead and the lens doesn't pick up on it, leaving you with a well-lit portrait. All digital cameras and some modern film cameras now feature a red-eye reduction mode, which works by firing spikes of light at the subject before the main illumination. This has the effect of making the pupil contract thus reducing the potential for red eye.

Left: This image demonstrates the principle of inverse square law. The subject is lit by the flash, but the light has not reached the background. As such the background appears totally black.

Right: This shot is one of a series that was taken for a travel company, and is a refreshing approach to the usual and obvious images of beaches or bars that are normally used in travel advertising brochures. The photographer here has captured his subject close-up and used a portable flash unit in such a way that it perfectly suits the energy of the frisbee player. In this instance, the imbalance of flash light distribution gives the image a bright and edgy feel.

Tip

A reflector is a brilliant, simple invention and an absolute must for your kit. If you are shooting with a flash or with ambient light, using a reflector is an instant way to fill in the shadows and increase the light falling on your subject, from any angle and with immediate effect. Reflectors catch the light and redirect it to where it is needed. Using a reflector provides a softer, more natural light than flash, and you can control the intensity of the light by your choice of reflector. For example, a gold reflector casts a warm light and a silver reflector casts a harsher light. You can use a piece of white card or a sheet for a homemade, but equally reflective surface.

'STA Travel' © Andy Rumball

Bounced Flash

© Helen Drew

Another way of altering the direction and quality of the flash light is to bounce it off a wall, ceiling or a bright surface that is close enough to reflect and spread the flash back over and around your subject. Bouncing the flash produces a softer light, and works well with group shots as it distributes the light more evenly around the subjects and space

Diffused flash

© Helen Drew

By fitting a diffuser over the head of the flash (you can buy one or use an opaque material taped to your flash head), you can soften and distribute the light hitting your subject. This image was photographed with an off-camera flash that was attached to a stand above the left of the skull, and bounced off a reflector to accentuate the round forms of the pears and the graphic symmetry of the skull.

Fill-in flash

It may seem strange to use a flash outdoors in the bright light of day, but strong overhead or backlighting can often result in your subject squinting or having unsightly or uneven shadows cast over them. You can minimise this by using your flash on a deliberately weak setting to 'fill in' those shadows. Take a spot meter reading from the brightest highlight of your subject, and then calculate two stops less than the result. For print film, which has a latitude of around 5 stops, you may want to use three stops less. Remember that you are always underexposing the flash.

Ring flash

© Peter Dazeley

Ring flash is a very popular form of lighting in fashion photography. A circular flash unit is placed as close as possible to the camera lens (or sometimes around the lens itself), and when the shutter is fired the camera produces a flattened image due to the unique circular output of light, which will cast a dark, even shadow, or rim, around the subject. The ring flash also produces an attractive circular catchlight in the eye of the subject. The final image will have an even, haloed effect that reproduces particularly well.

Flash can capture and freeze action as it happens, this enables you to capture something that is in motion with the resultant effect of 'freezing' the subject. Quite simply it will appear that something which was travelling extremely fast has stopped and is suspended in time.

To create this effect 35mm SLR cameras will sychronise with a flashgun at only 1/60th or 1/125th sec; they usually have a symbol or an 'X' on the shutter-speed setting dial to denote this. With many contemporary models however, the camera will automatically complete the necessary calculations, and all the settings are built-in and ready to select.

Once the correct settings have been calculated and selected it is the flash that determines the exposure time, rather than the shutter itself. If a faster speed than the recommended standard has been used, then only part of the film will be exposed to the short burst of light before the shutter planes have fully opened. In this instance the simplest way to calculate exposure is to use the guide number on the flash head. The simple rule for setting your flash correctly follows this equation: the distance between the flash unit and your subject multiplied by the f-stop number required. Remember to set the ISO of the film as this will dictate the exposure setting calculation.

© Helen Drew

Left: This quickstep dancer was 'frozen' mid-move at 1/125th sec, f11 for 3.3m and using 100 ISO monochrome film. Remember it's speed multiplied by distance for the duration of the flash. Go out and experiment with film that you can afford to lose or, in the case of digital, until your batteries run out!

studio lighting

The great benefit of the studio is that the photographer has complete control over the lighting. There are two main types of studio lighting: continuous tungsten and strobe or flash lighting. Flash lighting is more suitable for portrait photography as it doesn't get as hot as continuous tungsten lights.

Unlike tungsten lighting you can use flash lights with daylight-balanced film and without the use of a corrective filter or altering the Automatic White Balance on a digital camera. When using flash lighting it is a good idea to have a modelling light as part of your kit as these will provide continuous light, so you will have some idea of what the subject will look like in your final image.

Cameras cannot automatically set the exposure with studio lights (as is the case with portable or built-in flash), so you either need to use a light meter or be prepared to test, calculate and recalulate until you reach the optimum exposure setting. The advantage of playback on a digital LCD means that you can experiment with impunity and make any corrections as and when needed. There are few obvious differences between shots achieved using tungsten lighting and those achieved using flash lighting. However, tungsten lighting is cheaper than the less powerful flash units and you do not have to synchronise it with your camera (and so can use the camera's built-in metering system). The primary disadvantages are that tungsten lights do get very hot and also create a good deal of glare.

Studio lighting is often perceived as being difficult or complicated, but this is usually not the case. The secret of successful studio lighting is simplicity. Aim to keep the impact of your lighting to a minimum and remember that some of the greatest studio images are those shot with a single light. Softboxes, reflectors and umbrellas are important tools of studio set-ups, and effective use of these will allow you to take more control over where the light falls and how soft that light is.

When in the studio take the opportunity to work with a single light and fully explore all its possibilities. Use it with diffusers and umbrellas and try a variety of angles until you fully understand its capabilities, then add a white-board reflector and repeat the exercise. Doing so will ensure you gradually develop a thorough understanding of lighting.

 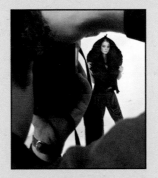

Left to right: A reflective umbrella, students browsing through a model's portfolio and the tutor capturing a shot in a clean, evenly lit studio.

These images were taken from a studio shoot that was held at the London College of Communication.

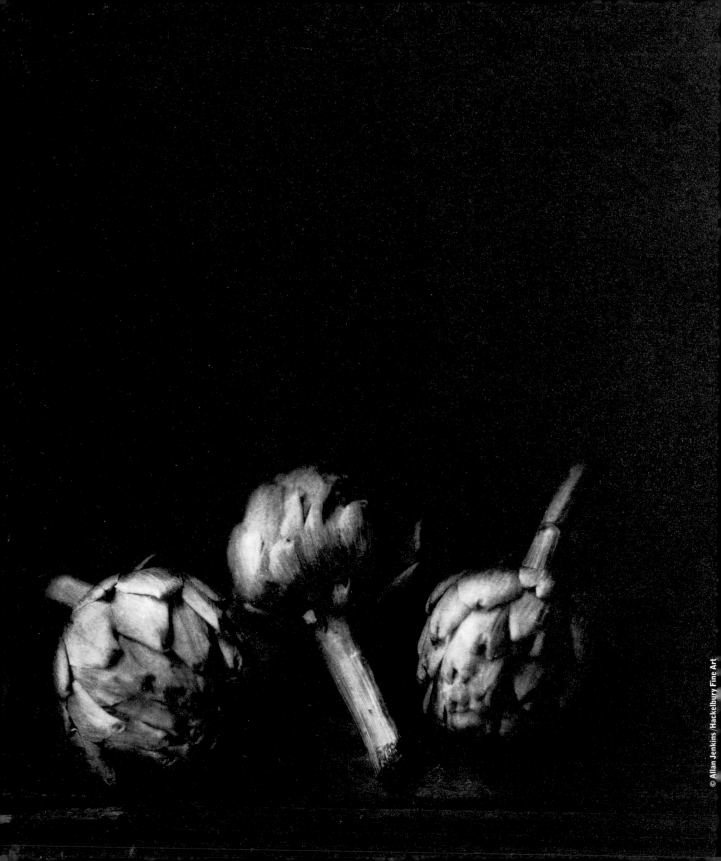

Section 6
Processing and printing

Processing *(n.)* To treat light-sensitive film or paper with chemicals in order to make a latent image visible.

Printing *(n.)* The process or business of producing copies of documents, publications or images.

processing monochrome negatives

Many photographers – including those working at the top of their profession or exhibiting their work at international level – maintain a passionate interest in the aesthetics of traditional monochrome processing. Black-and-white photographs often simplify the scene and can focus our attention on what is happening, while colour photographs can distract. Black and white allows the photographer more creative control, both in taking the picture and also in producing the print – elements such as shape, line, texture, form and tone can be used to create exactly the right look and feel for your image. Black-and-white images also have more of an artistic feel; it is surprising how stripping the colour out of an everyday subject can make it beautiful.

The black and white developing process is less complicated than colour processing techniques, and more suitable for the home darkroom as the chemicals are slightly less toxic. Of course digital technology has made advancements in leaps and bounds and it now seems that there is nothing you can't do with a digital camera or a scanner and image-editing software. Learning how to convert colour images to black and white, enhance them sympathetically and achieve a quality print has become a whole new area to master. However, this technology seems to have inspired a generation of art photographers who want to keep their work as a craft. If you are beginning to shoot using black-and-white film, then it is definitely worth learning how to develop and print the negatives yourself. Processing your own negatives is an exciting aspect of photography when you are starting out, and although it is a fairly straightforward procedure, you must follow instructions carefully and adhere to them. The equipment for a standard processing kit is not expensive but there are strong chemicals involved and it is important to handle them with care. It is possible to process negatives using a small, specially-made bag, but to print from them you will need a small area which is totally light-tight, has running water and is lit by a red safe light.

You will need:

1. A light-tight film-developing tank with one or two spools (or spirals) to load the film on to. This is a specially developed tank that allows you to remove and add chemicals without taking off the lid.

2. A thermometer. This is very important as you will need to check the film-developing tank's temperature, which is crucial.

3. Plastic measuring jugs. You will need a different jug for each chemical that you use to prevent cross-contamination.

4. A reliable clock and, ideally, a kitchen timer that can keep track of seconds and minutes (up to 20 minutes).

5. A film development chart (these come inside boxes of film). It is a good idea to put these on the wall for easy reference.

6. Scissors, cloths and latex gloves.

7. Three plastic trays for each chemical.

8. A set of tongs.

9. A dust blower for spotless negatives.

10. A rubber squeegee.

11. Four or more containers for chemical storage. Dark storage containers are best as most photo-chemicals are light- and air-sensitive.

The chemicals:

1. Negative preserver for your developed negatives.
 Keep these in a clean, dry place.

2. Film developer.
 There are several film developers on the market and the film manufacturer will always recommend you use their own-brand developer, but this is not essential for good results.

3. Stop bath.
 This chemical stops the action of the developer; it also cleans the residue of the developer from the film to stop cross-contamination.

4. Fixer.
 This is an economic chemical as it can be used over and over again. It stops the film-developing process and removes any unused silver from the film, which is what renders it non-light sensitive. Liquid or powder fixers are available; and both types are equally good, but look for one with a hardener as this helps to avoid scratching the negatives.

5. Clearing agent or fixer remover.
 This is important for the longevity of your negatives as any fixer residue can stain and fade both prints and film over time.

6. A wetting agent such as Photo flo.
 This chemical coats a micro-fine layer on to your film, which helps prevent drying spots (these are similar to the marks left on glasses that have not been rinsed properly). This is inexpensive and goes a very long way.

 All of these chemicals can be reused, but read the information that comes with them.

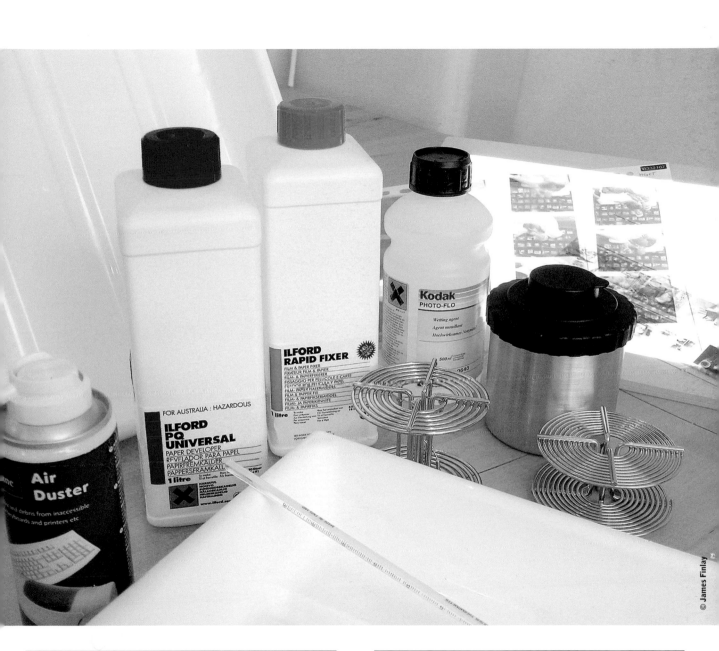

© James Finlay

These next steps must be carried out in total darkness, without even the help of a safelight. If you don't have access to a darkroom, it is worth investing in a light-tight bag that you can use to load the film into the tank. If you do use a pitch-black room it is worth giving your eyes a chance to adjust before starting the process.

To develop your film:

1. If you have never developed negatives before it is a good idea to practice first. Try putting an old or unimportant film on to a spiral as it can be quite difficult and frustrating trying to slot it on in the dark!

2. Once you feel confident, turn off the lights and pull the film from the canister. You will probably need to open it with pliers or a can opener if the film is entirely inside. Feed the film on to the teeth of the spiral and twist the edges of it backwards and forwards until you feel the film loading itself on to the reel.

3. Once the film is wound on to the reel, put it on to the spindle and into the tank. Then close the light-tight cover securely. It will now be safe to turn on the lights.

4. Mix your developer as instructed and ensure it is the correct temperature.

5. Prepare the fixer and clearing agent at the same temperature. Keep a tray or jug of tepid water to hand as this will allow you to top-up the liquid and maintain slipping temperatures.

6. An optional step is to pre-soak your film (again at the same temperature) for around a minute. This is not essential but it will help with even development of your image.

7. Set the timer for developing (again, check your manufacturer's development chart), and pour in the developer.

8. Agitate the film by inverting the tank gently and continuously for one minute, then for 15 seconds each minute until the development time is up.

9. Quickly pour the developer back into a container, then pour in the stop bath in order to neutralise the developer without removing the lid. Again, this can be poured into a container and reused.

10. Pour in the fixer. Again, check the manufacturer's instructions and allow the time as directed. The fixer can also be poured into a container and reused.

11. By this stage your film is no longer light sensitive. You can now wash the film by standing the tank under running water with the lid removed for at least 30 minutes.

12. Before you remove the film, add the wetting agent to the tank and agitate for one minute.

13. Remove the spiral. Carefully unwind your film and squeegee off any excess water.

14. Hang the film up to dry in a dry, dust-free area; preferably in a drying cupboard.

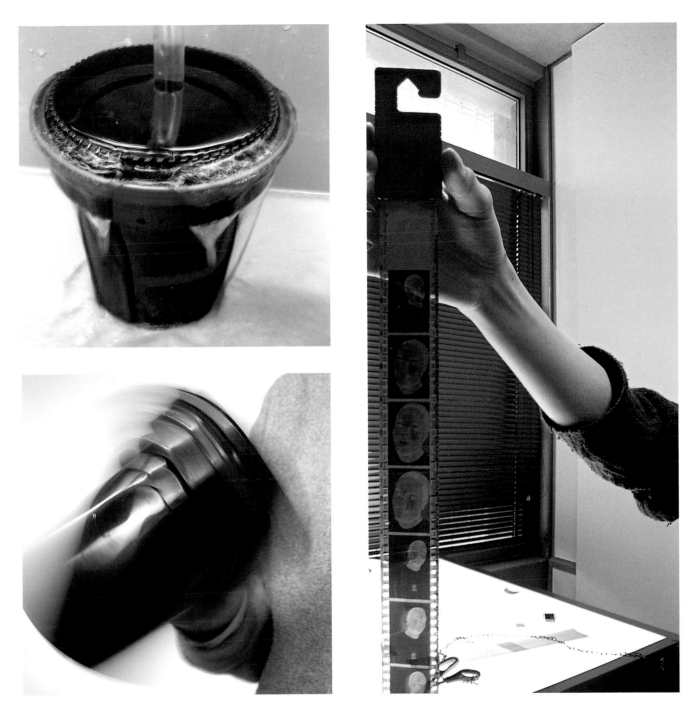

© James Finlay

© James Finlay

Tip
Agitating your film and chemicals will create tiny bubbles. To remove these, gently tap your tank on a bench or work surface.

The Fundamentals of Photography Processing monochrome negatives

paper types

Photographic paper for chemical printing is very similar to film, and totally dissimilar to photographic paper for inkjet printers (see page 160). Paper for chemical printing is coated in a light-sensitive emulsion of silver halides, which convert to metallic silver when exposed to light. As with film, these tiny silver particles collect in clusters and appear black; thus forming the tonal range of your image. One side of the paper is slightly shinier than the other side; the shine is created by a layer of emulsion and this side of the paper will capture your image.

© James Finlay

Just as the growth in photography as an industry, art form and academic and leisure pursuit has boomed, so has the product range available and the range of photographic papers on the market is vast. However, for the purposes of learning the fundamental principles, there are generally two types of printing paper that will cover most of your basic requirements: resin-coated (RC) paper and fibre-based (FB) paper.

Left: There is an enormous range of photographic paper on the market.

Tip
Make sure you get the right type of photographic paper as you cannot develop a black-and-white image on colour paper and vice versa.

Resin-coated paper (RC)

Resin-coated paper is used by most high street photographic labs as their paper of choice. The paper is coated on one side with light-sensitive silver particles that are suspended in polyethelyne. This coating renders the paper-base virtually waterproof, so the process of washing and changing chemicals is much faster than with fibre-based paper. Resin-coated papers have built-in chemicals that serve to speed up the whole process of development. If you are a novice printer this is probably the best paper to go for as it is cheaper than fibre-based paper so it doesn't matter if you make lots of mistakes. However, this type of paper does have a limited ability to convey depth and subtlety in a print and over time it will fade and fog as it has a short lifespan of around 60 years.

Fibre-based paper (FB)

Fibre-based paper is the type of paper that was used for some of the very first photographs. The silver particles in this type of paper are actually embedded into the cotton fibre of the paper. Although fibre-based paper does have a coating of emulsion, it is not coated and sealed throughout like the resin-based paper, nor does it contain the chemicals that are present in resin-based paper. The design of fibre-based paper means that the image actually becomes part of the substrate (unlike resin-based paper where the image sits on top of the emulsion).
The great benefit of this is that the lifespan of a print could extend to hundreds of years. However, as the paper absorbs far more water in the development and washing process, it is also more delicate and requires greater care when handling. Fibre-based paper is the preferred choice of many professional photographers, especially those shooting for the fine-art market. A fibre print is capable of producing a richness, depth and warmth that a resin print cannot convey. The paper contains more silver halides and this greater depth and tonal range can be achieved and manipulated to the best advantage of the image, and viewer.

Both resin-coated and fibre-based papers are available in a variety of different surfaces and weights. Three of the more common surfaces that you are likely to experiment with are:

Gloss

A shiny, reflective paper that can be very useful for highlighting the finer detail in images, as well as intense blacks. Its primary disadvantage is that its inherent shiny quality can detract from the image if viewed from the wrong angle, and may show up surface 'kinks' very easily.

Semi-matt

This type of paper has a mild, satiny sheen. It is useful when blending or hiding small blemishes and defects (such as drying kinks or tiny fingerprints), in the finished print.

Matt

A print produced on matt paper will have a dull glow and has a barely visible, but perceptible, surface texture that impedes the viewing of fine detail. As matt paper has no glare it is very sympathetic to 'darker' images and shadows.

When selecting your photographic paper, remember to take into consideration the distinction between graded and multi-graded paper.

Graded paper

This type of photographic paper is classified within a range of five grades. Ranging from Grade One, which will produce a low contrast, and a softer and flatter result to Grade Five, which will produce a high-contrast and harder finish. This type of classification system is somewhat restricting as ideally you will need to know the grade you require in advance of developing your print.

Multi-graded paper

Multi-graded paper contains several layers of emulsion that react to the different colours of light through the use of different coloured filters. As such it is possible to create different levels of contrast on one sheet. This makes the paper advantageous; not only because you can print a variety of different negatives from the same pack of paper, but you can also achieve different levels of contrast within the same print.

Tip

Before deciding what brand and type of paper you wish to buy ask to see the retailer's sample cards. This will give you an idea of the texture and weight of paper before you make your decision.

Right: This couple was photographed using a fast film rated at 400 ISO, then printed on to a Grade Four paper to make the image a little harder.

The Fundamentals of Photography

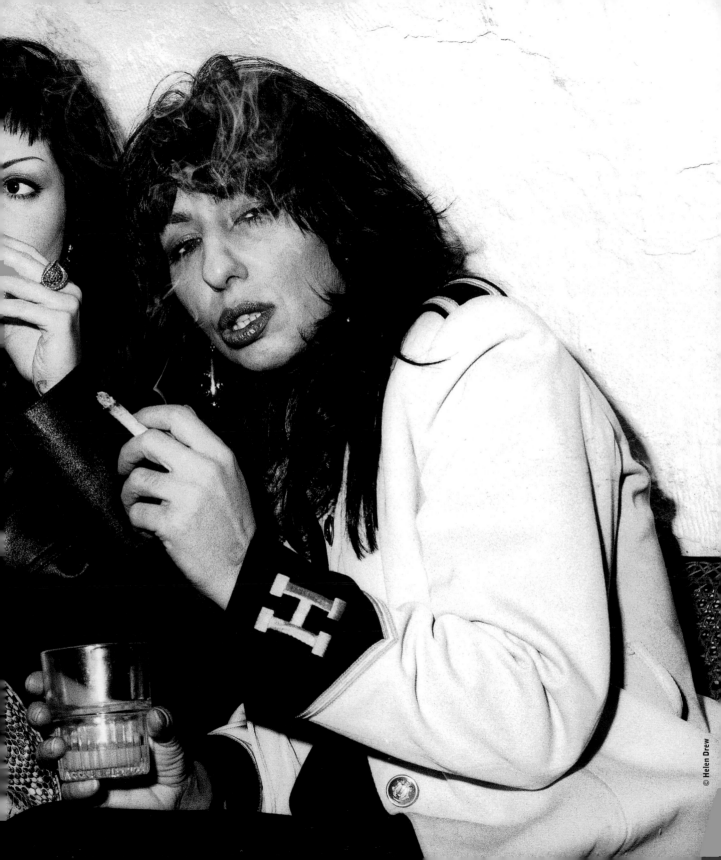

making a contact sheet

A contact sheet is a positive print of the whole roll of developed negatives cut into sections and printed on to one sheet of photographic paper (for digital contact sheets, see page 158). Making a contact sheet allows you to compare and assess your images, is essential for deciding what images to print and also provides a quick and easy reference for future enlargements. This is a highly recommended procedure to start employing as soon as you begin printing your own photographs.

A contact printer is a piece of thick glass that is hinged to a baseboard. The glass may have 'threads' or runners that you can slide your negatives into in order to hold them in place, or simply lay them, emulsion side down (this is the matt side of the film), flat and evenly on the paper to be exposed. The contact must be as close to the paper as possible or your images will not be in focus.

You will need:

1. A contact printer.

2. An enlarger.

3. Print developing chemicals and equipment.

4. Your developed negatives.

5. 10 x 8 inch (25.4 x 20.30cm) medium contrast paper, such as Grade Two or Three, which should provide a fairly even range of contrast.

Right: Sometimes a contact sheet will contain many similar images with great potential (as Bert Hardy's example demonstrates), yet other times only one or two of the images will be good enough. The red markings seen on the bottom right of the contact sheet demonstrate marks that a photographer would make with a chinagraph pencil. This tool is an inexpensive and erasable wax pencil that is used to easily identify the images selected for enlargement. It's a useful habit to adopt, especially if you are printing in bulk or need to quickly identify the negatives you wish to use.

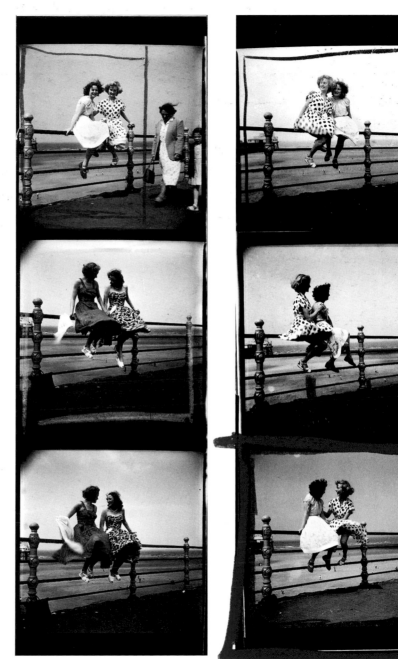

Bert Hardy
Blackpool
Pkt 5358
Box camera
M45327 rec seas promenades

'Blackpool Contact Sheet' © Bert Hardy/Hulton Archive/Getty Images

To make your contact sheet:

1. Set out your equipment in the wet-printing area of the darkroom, and prepare the developer, stop bath and fixer, (diluted as instructed by the manufacturer and at the usual recommended temperature). Pour these into your trays. It is a good idea to set out the trays in the order in which you will work: developer, stop bath and fixer.

2. Raise or lower the enlarger until the light falls on to the entire baseboard, and open at the brightest aperture. Once you have placed the enlarger in the correct position make sure you turn it off.

3. With the enlarger safelight on, position your negatives into the grooves of the baseboard, ensuring they are emulsion side up. Firmly lower the glass on to your sheet of photographic paper, which should also be emulsion side up. Make sure that both the paper and the negatives are tight and flat against one another.

4. Set the timer for ten seconds (a good average), and expose the entire contact sheet. Turn off the enlarger and remove the paper.

5. Tilt the developer tray and quickly slide in your exposed paper (emulsion side up), then sweep the developer back and forth over the entire surface of the contact sheet. This technique is similar to film agitation and ensures even development of the contact sheet. Do this for one minute, which should be enough time for an average contact sheet to develop.

6. Once the contact sheet is developed, lift it out of the tray (using tongs), and drain it for a few seconds. Place the sheet in the stop bath for 15 seconds, and then agitate for a further 15 seconds.

7. Using a different pair of tongs, lift out the sheet and drain it for a few seconds. Then place it in the fixer and gently agitate once more for 20 seconds. The fixer desensitises the paper to the light so you can have a peek at your contact sheet after one minute, but leave it to fix for a few more minutes if you wish to keep it.

8. Wash the fixed print thoroughly for five minutes and squeegee off any excess water before you let it dry off.

(All the times listed here are suitable for the development of a resin-coated paper contact sheet.)

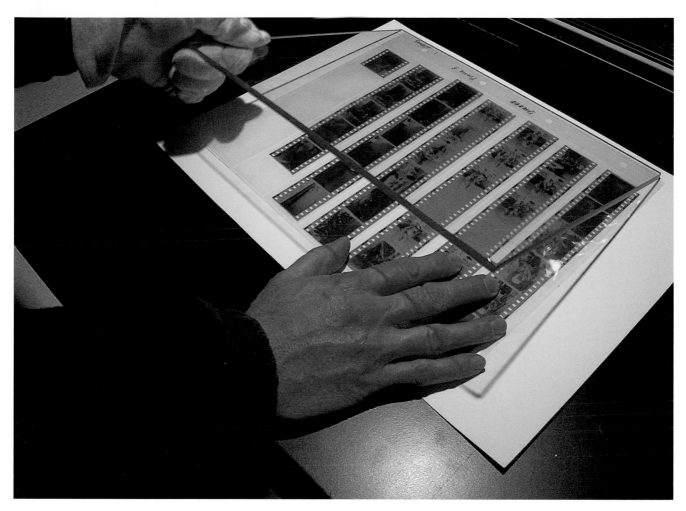

© James Finlay

making a test strip

Once you have created your contact sheet and have selected the image that is to be printed, you will need to develop a test strip.

To make your test strip:

1. Place your chosen negative in the enlarger, and make sure that the emulsion side of the negative is facing upwards.

2. Close the enlarger head, turn on the light and focus the image on to an old piece of paper.

3. Once you have focused the image correctly, turn off the light and securely place a piece of photographic paper on to the easel.

4. Use a piece of card to cover most of the paper, but ensure that a small section remains exposed.

5. Set the timer for two seconds and switch the enlarger light on.

6. Move the piece of card to expose more of the image, and turn on the enlarger light for another two seconds. Repeat this action until you have exposed all of the sheet.

7. Develop the test strip as you did the contact sheet (once it has been in the fixer for two minutes it should be safe to bring into the light).

8. Decide which section looks best — the length of time that the best-looking section was exposed for will tell you how much exposure time you should allow the real print.

Tip
If you don't like the look of any of the strips on your test make another one, but this time narrow the time intervals so you get more specific measurements.

Right: On this sample test strip I have used a full print for clear instruction, but I recommend you use two- to three-inch strips when creating your own. Light-sensitive paper reacts in the same way as film — the more exposure time it receives, the darker it becomes. Try to expose a cross section of tones in each exposure by positioning the piece of card at a horizontal or vertical angle as needed. In this example I have positioned the strip vertically, which means that most of the strips include a section of the background, part of the man's face and part of his jacket — this allows for an easier comparison between them.

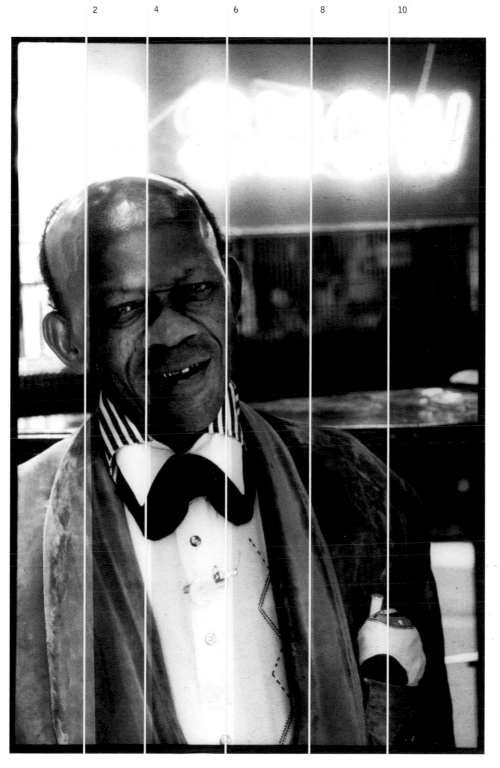

2 4 6 8 10

© Helen Drew

The Fundamentals of Photography Making a test strip

making a print

A test strip should be used as a guide to approximate how long you should expose your print for. However, a test strip is not infallible! Making a print takes skill and practice so don't be too disheartened if your first few attempts aren't quite perfect (for digital printing, see page 160).

.To make your print:

1. Set the timer on your enlarger for the correct length of exposure time (as determined by your test strip). Check that your image is still lined up correctly and has not slipped out of focus. Then place your paper (emulsion side up), on to the easel in the exact place that you had your guide card.

2. If you are using variable contrast paper, then you will need to insert a filter into the enlarger head. There are five different grades of filter; Grade One is low contrast and Grade Five is high contrast.

3. Turn on the enlarger.

4. Develop your image in the same way that you did for your contact sheet and text strip. Fix the print for one to two minutes (the time will vary depending on what paper you are using; fibre-based paper will require more time).

5. Once you have removed your print from the fixer, you must ensure that you remove all chemical residue. The best way to do this is to fix a hose to a tap and into a tray, allowing for continuous overflow. Alternatively you can place the print in a wash tray and agitate. Resin-coated paper will need to be washed for around five minutes, whereas fibre-based paper should be washed for at least 30 minutes.

6. Lift the print using the tongs, squeegee off the excess water and leave it to dry.

Tips

To avoid hairs and white spots ensure your negatives are clean and dust them every time you remove one from the negative carrier.

When printing you may think your image could be better if you lost part of the background or focused more tightly on a certain area. This is where the enlarger can act like Photoshop; you are in control of how much of the image falls on the paper. Anything that goes over the edge of the paper will not be printed.

It is worthwhile taking an image that has a good, even tonal range and printing it in a range of grades on multi-grade paper. This will allow you to see how obviously the highlights and contrast can make or break an image.

Above: A focus finder will help you ensure that your image is completely in focus. It is harder than you may think to judge this by eye, especially in the lightless environment of a darkroom.

Right: This is the print at the end of the washing stage. Having been under a continuous wash for at least 30 minutes (though anything up to two hours can be beneficial for a really thorough removal of chemicals). The print is ready to have the excess water removed and be placed on a drying rack.

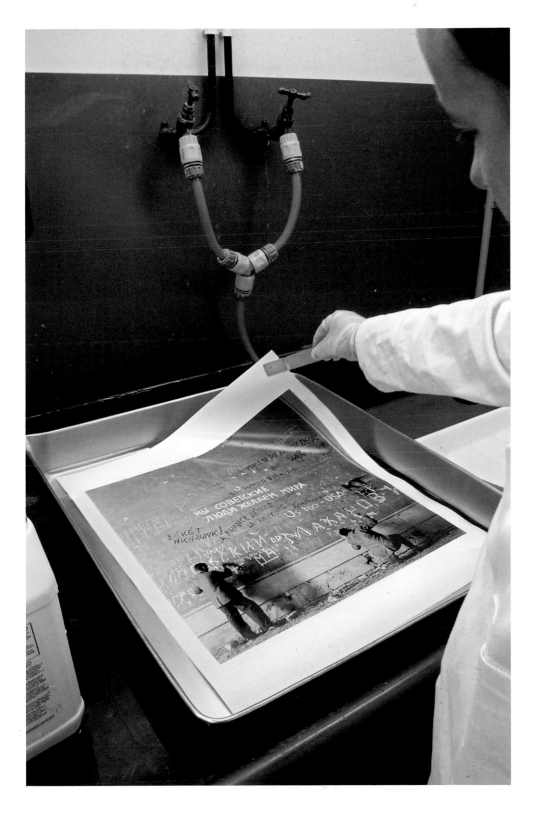

dodging and burning

Professional photographers often resort to 'dodging' and 'burning' techniques in order to produce a perfectly-exposed image (for digital dodging and burning see page 153). These techniques allow the photographer to control how long certain parts of the print are exposed to the light. For example, if a negative has extremes of dark and light, then you may wish to hold back (or 'dodge') the exposure on the dark side and increase (or 'burn') the exposure on the lighter side to create a more balanced look.

To dodge and burn:

1. Create a test strip to determine the overall exposure time for your print and then examine it in the light. You will need to work out, perhaps by creating one or two more test strips, where the work needs to be done.

2. Place your paper in the easel and get ready with your tool (your tool can be as simple as a pencil and a piece of card). Hold the tool about halfway between the print and the enlarger head and activate the timer. Begin to 'dodge' around the area you wish to hold the light back from. It is important that you keep gently moving the tool to avoid creating an obvious change in contrast or a 'halo' effect. Remember you are trying to achieve a gradual change and not a jump in the tonal range.

3. Develop and wash your print as normal, and compare the difference to a direct print with no dodging or burning applied, or the original contact-sheet image.

Right: This portrait of an Inuit elder has been worked on in order to create balance in the final print. On the original shot, the strong natural light coming in from the right created too much shadow on the left. As you can see from the diagram, by holding back (or 'dodging') the exposure on the left of the face, and increasing, (or 'burning') the exposure on the right-hand side of the face, a balance was created. The result is an even portrait that allows the viewer to focus on the eyes of the sitter and not the lights above and around him.

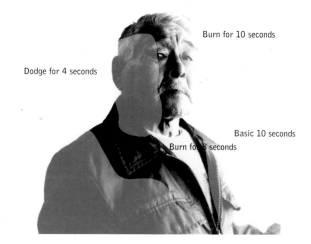

Burn for 10 seconds

Dodge for 4 seconds

Basic 10 seconds

Burn for 8 seconds

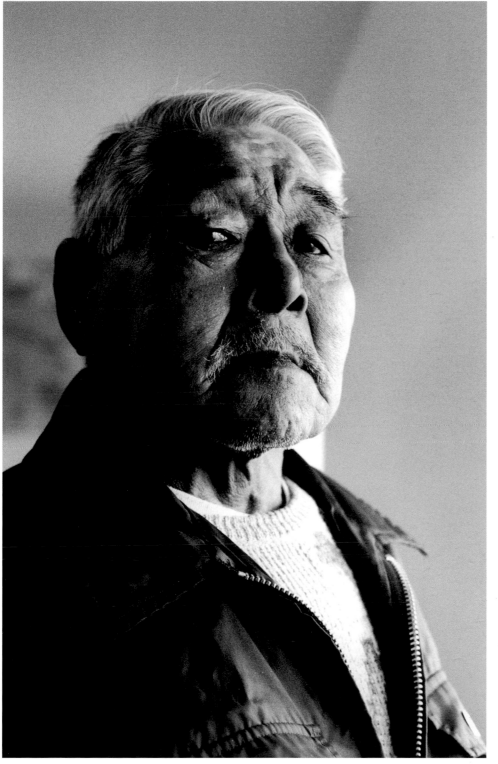

© Helen Drew

Tips

You do not need to buy special tools for dodging and burning. Keep the blank card that comes with your photographic paper and draw around the areas that you will be dodging or burning. You can then cut rough or precise shapes from the card and attach to clipped coathanger wire with masking tape. You can also cut a mask around the shape of the area to burn in, leaving a hole where you want to increase the exposure. The great thing about making your own dodging and burning kits is that they can be custom cut to match the requirements of your print.

This technique can also be applied using image-editing software. The tools on this type software are also called the dodging and burning tools and are utilised by moving them over the affected area.

digital processing

For digital photographers the use of software to enhance or correct images, is as important as the chemical darkroom is to film enthusiasts. Whether that software is simple and inexpensive, or whether it's Adobe Photoshop (considered by many to be the best image-editing package currently available) doesn't matter. What does matter is that digital processing software can be used to add to the overall impact of your image. Equally, for the film photographer scanning their work into the computer, processing software offers the opportunity to benefit from digital workflow advantages.

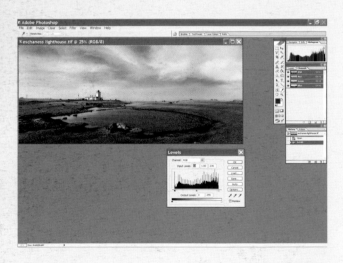

Above: The Levels control can be used to increase the tonal range in the image by moving the sliders, at either end of the histogram, inwards to where the data starts and finishes.

Exposure correction

There are a number of general exposure correction facilities, including the cheap and cheerful Brightness/Contrast adjustment. This control adjusts the brightness and the contrast separately, across the entire image. If your image needs a simple boost, this is the place to do it.

Before that, though, it is advisable to use the Levels control. This control shows a histogram of the tonality of the image from dark to light. The taller the bar at any particular point along the histogram, the more picture data there is corresponding to that level of tonality. If your picture isn't meant to be high key, or deliberately murky, then look to both ends of the histogram. If either end has no data then move the pointer, underneath one end of the histogram, until it points to the start or finish of the current picture data. This will stretch out the tonal range of the picture, giving it more depth and highlights. If the picture is, however, now too dark or too light, move the centre point slider accordingly to set the mid-point of the image correctly.

For more accurate tonal adjustments, the Curves tool is invaluable. A straight line represents the range from dark to light and clicking on the line allows control points to be added. These can then be moved to make that part of the image lighter or darker. A typical adjustment would be to place control points at the 25%, 50% and 75% positions on the line, drag the top-most point to the left and the bottom-most point to the right. This increases the dark and the light areas, giving the image much more punch. If the mid-tones are too bright or too dark, then add a control point in the middle and drag to the left or right accordingly.

Spot adjustments

For areas of your image that are too murky or too light, yet cannot be adjusted by the standard tools without affecting other areas of the photograph, the Dodge and Burn tools can be useful. The Dodge tool makes elements lighter, and the Burn tool makes them darker. Both tools have opacity settings that determine how strong the effect is – 5% is a good default value to use because it allows for subtle retouching. A sophisticated alternative is to create an adjustment layer with a mask; the overall adjustment is applied to the picture but the mask only allows it through to the areas that you want, and at the intensity (between 1–100%) that you require.

Left: The Burn tool is used here at 5% opacity to darken the blue sky and make the clouds stand out more.

Below: The completed image with corrected tonal range and enhanced contrast and colours.

Colour enhancements

Colour casts are a hindrance for all photographers, film or digital. Although digital cameras may have white balance adjustment to cater for indoor or special circumstance lighting, it isn't foolproof. Through the use of the Variations option, a general tint of blue, cyan, magenta, red, yellow and green can be applied to counter most colour casts. Varying amounts of each can be applied or combined so, to a degree, it is the digital equivalent of using filters on film cameras, except, of course, that this is after the image has been captured. The real problem is that the Variations option may correct the colour cast, but affect another colour detrimentally within the picture. An alternative is to use the Colour Balance option. Here, three control sliders allow the balance of cyan-red, magenta-green and yellow-blue to be adjusted. These can be used more subtly than the Variations option, to cancel out colour casts. Another option is to use Selective Colour, which allows the amount of cyan, magenta, yellow or black within a colour band to be manipulated. This is the most subtle and complex method for tweaking a general colour range.

The Hue/Saturation tool allows for general saturation increases where the colours look weak – though more than a +30% adjustment will cause visual artefacts, in digital images, to appear. The Hue/Saturation tool can also be used more selectively by targeting a colour area and then using the colour picker to select a colour out of that area. This selected colour can be increased or desaturated without affecting any other colour in the picture.

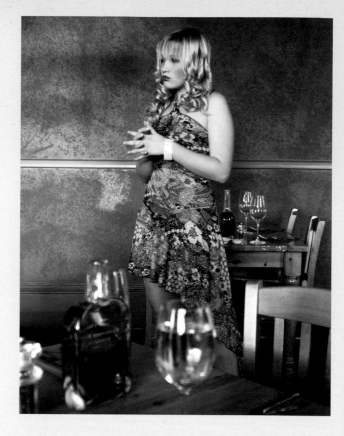

© Duncan Evans

Above: The original photograph is a very vivid scene, but the colours are quite flat.

Above: By simply using the Hue/Saturation tool the colours across the entire image can be significantly boosted.

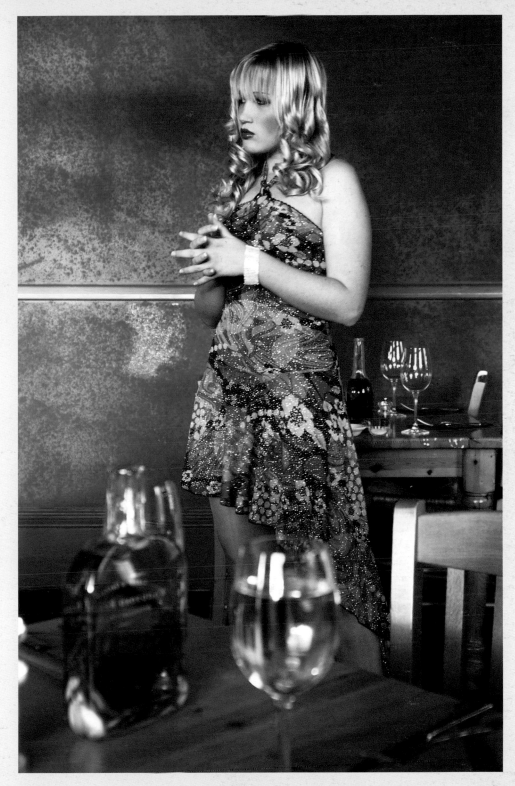

Right: After a minor tweak, the full and rich colours of the original scene are restored to the photograph.

Photo filter

Introduced with Photoshop CS, the Photo Filter does not reside in the Filters menu, but is instead listed as an adjustment. It offers two warming filters (equivalent to 85 and 81) and two cooling ones (equivalent to 80 and 82), with a 25% default density. To make the effect more pronounced the density should be increased. There are also a range of other colours that can be used to influence the general colour tone; their effect is similar to using a filter of that colour on the lens, as opposed to simply overlaying a layer of colour afterwards in Photoshop.

Left: The Photo Filter can be used to add colour tints in a very subtle fashion. Here a Deep Red selection makes the sunset photo have more of a ruddy glow with less blue.

© Duncan Evans

Above: This image of Grobsness on the Shetland Islands demonstrates the impact of adding the Deep Red Photo Filter. The original image is shown on the left and the filtered image is shown on the right.

Shadow/Highlights

The Shadow/Highlights adjustment allows you to correct those images that have underexposed areas, or highlights that are far too bright. The Shadows control allows brightness to be brought back, and detail to be revealed, in the darker areas. The Highlights option does the opposite – it tones down the brightness of the highlighted areas and restores detail, for example, where clouds have been rendered too light. An advanced option of this function allows for colour correction and for the contrast of the mid-tones to be adjusted.

Above: The Diffuse Glow filter has three settings, which control the spread and effect of the glow and texture.

Using filters

Photoshop comes armed with an ever increasing list of filters, some of which are incredibly useful for photographers – most notably the grain filters. Film Grain is held in a separate location from the main Grain filter, but the latter has a variety of options for enhancing your pictures. The most obvious thing about 50 or 100 ISO digital pictures is that they are very clean; whereas scanned film has a very different look to it. Adding some grain or texture can subtly enhance a photograph, or in fact ruin it if applied needlessly. Photoshop offers ten types of Grain, ranging from a regular effect, to clumped and distressed effects, and stripey, heavy effects.

Photoshop also offers lighting effects, which are usually more suited to portraits as they can concentrate the light on the subject and blank out any surroundings of the original picture that had flat lighting. Possibly one of the best filters of all is the Diffuse Glow. This has both texture and glow elements, and works on the whiter end of the tonal spectrum. It can be applied with one or both elements, and when used on landscapes gives an almost infrared or even ghostly effect, and on portraits an ethereal, harsh and grainy, or soft and angelic effect.

Below: This image demonstrates the impact of adding the Diffuse Glow Filter. The original image is shown on the left and the filtered image is shown on the right.

© Duncan Evans

© Duncan Evans

Digital portfolios

While there is no doubting the visual impact of a portfolio of pictures, there is also the time, travel and expense of creating one to be considered. As such, it can be a good idea to create a website that will showcase your digital portfolio and contain your photographic and contact details. For a more professional feel, you could purchase your own domain name on the world wide web. This normally lasts for two years, whereupon it can be renewed or will lapse and be generally available again. This very inexpensive domain name registration can be bought from as little as £0.99p/$1.50 per year. Creating the website yourself can be relatively easy, if time consuming, with one of many software creation packages. Many of these (such as Microsoft FrontPage, NetObjects Fusion and Corel HoTMetaL PRO) feature gallery options that allow an online gallery of photographic images to be displayed.

Above: Creating your website is straightforward with packages such as NetObjects Fusion, which use a visual, non-programming, design basis and come with numerous templates.

Above: The family portrait gallery at www.duncanevans.co.uk in action. Various designs are available to frame each individual image.

Digital contact sheets

The purpose of a digital contact sheet is usually to present a selection of images, perhaps categorised by styles or subject so that they can be viewed easily and a selection can be made quickly. Whether it's to choose a picture for enlargement and print or select a shot that encapsulates a particular style, the contact sheet has myriad uses. Creating them digitally means that the photographs can come from any session, off any camera, and all be combined into one contact sheet. Photoshop has a built-in feature called Contact Sheet II that does just this job.

Above: The best way to start is to gather all the photographs that you want to be on the contact sheet in the same place. This allows you to make selections and discard others upon reflection.

Above: You can select Contact Sheet II under File>Automate. If all the pictures are in one folder use the folder option, otherwise use Browse to select them. Set how large the printed sheet is going to be and what printing resolution is to be used.

PICTURE PORTFOLIO

Classic backdrop full.tif

Classic backdrop head.tif

Classic hollywood 40s.tif

Classic studio b&w.jpg

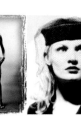

Extreme b&w.tif

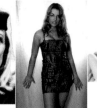

Film star b&w.jpg

Glamour FHM style.tif

Lingerie FHM style.tif

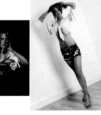

Modern casual location.tif

Modern casual studio.tif

Modern location glossy 1.tif

Modern location glossy 2 ...

Above: Bearing in mind how many photographs you are using, set up the column and row counters accordingly. Another option is to use the file names as captions, otherwise you will have to add them later on. If that is the case it's best to select the Flatten All Layers option. Then simply click on OK and the scripted process does the job. If the layers are left unflattened then fine adjustments can be made.

Storage

Whether you are shooting on film and scanning, or simply using a digital camera, your computer's hard drive will soon start filling up with pictures. Now you can leave them there, in suitably named folders, but it's akin to having your family album stored next to the cooker. All it takes is one accident and it's all gone for good. Back-up storage is a good idea and many software packages can create VideoCD or DVD format discs for you to play back on your computer or DVD player. However, these options are for lower resolution pictures or for display; they are not suitable for any hi-res 6Mp digital pictures. Either the software will resize them or if they are kept at that size they will display slowly. For showing on a television screen, pictures do not need to be any bigger than 1Mp.

Storage then is the key, and images can be placed on Zip disks, CD or DVD. If you only use a lo-res camera for your pictures, then a handful of Zip disks at 100Mb (or 250Mb if you are using the newer format), will keep you happy. Just drag the folders on to the Zip disk and write the contents on the label. Easy, and now your images are safe. For higher resolution pictures, you will need to store them on a CD that offers up to 740Mb storage space, or on a single-sided DVD, which offers 4.9Gb of storage space. CD-RW (rewrite) drives are very inexpensive so you can even delete old pictures if you no longer want them, and DVD writers have come down in price to a more affordable level, so offer a cost-effective solution if you have a large number of hi-res pictures.

Above: Products such as Nero make burning a back-up CD of pictures easy. Picture files can be simply dragged and dropped into the interface.

Above: When the selection of pictures is complete, click on Next, name your disc and start burning that back-up.

colour inkjet printing

With the advent of digital photography, the requirement for a new skill has arrived. Just as many film photographers like to print their own images, the digital photographer can now be in complete control of image preparation and print production on a colour inkjet printer. Unfortunately, each piece of hardware in the digital process deals with colour differently, which can make matching the print to the original picture fairly problematic. Consider even the start and end points of the process. The digital shot, once on the computer, is viewed as an RGB (red, green and blue) image via a light-emitting device – the monitor. The inkjet printer is a CMYK (cyan, magenta, yellow and black) device, which produces images viewed by reflected light. This is where colour management comes in, which is the important process of attempting to end up with a physical print that is a true reflection of the original, digital image. The aim is to make the image as accurate as possible at each stage.

The starting point is the camera, which is an RGB device. RGB, like CMYK, is a colour model. It consists of three channels of colour, each containing 256 shades, which can provide 16.7 possible colours. Within the RGB model area are 'colour spaces'. These are the defined areas of the RGB model that a digital device uses. Most cameras use the RGB colour space, but more modern ones use AdobeRGB 1998, which offers a wider range, or gamut, of colours.

The next step is calibration of the monitor; this sets your view of the colours throughout the rest of the process and until the final print. It is important that the software used to control the printer is set up correctly, and that it is capable of controlling colour management. If it isn't then you will need to take direct control of the printer and any necessary adjustments must be made in an experimental, trial-and-error fashion. Unlike film, where chemicals will respond in accordance with specific film types, inkjet printers offer a very variable printing experience. The best printers will offer fine detail and well-saturated colours across a range of paper types; from matt to gloss, satin and coarse fibre. However, there are also many printers that produce pictures with noticeable dots, poor colours, unconvincing skin tones and take a good deal of time to output an image.

When printing an image you should consider the printing resolution, as well as the image resolution. Image resolution is the amount of pixels in the digital image, with more pixels making for more detail. If you continue to print an image on a larger and larger scale, you will reach a point where the pixel count becomes insufficient. As such the picture begins to lose detail until individual pixels become visible and the image appears very coarse indeed.

The printing resolution determines how large an image can be printed, and this value is measured in dots per inch (DPI). Commercial printers tend to use 300dpi as a standard resolution value, but inkjet printers can produce a fine output with an image resolution between 150–300dpi. The physical size of the print also determines how closely it will be examined. For example, an A4 print will be viewed more closely than an A3 print. As a result a value of 150dpi would be more than acceptable for an A3 print, but it would only be satisfactory for an A4 print.

The actual printing process starts by selecting Print from the menu of your image-editing program. When the name of the printer is displayed there is a box titled, 'Properties' or 'Printer Properties'. Click on this and the options of the printer driver are revealed. The printer driver for each brand of printer tends to be different, though

they have similar features. Within these options you can set the printer resolution and select various colour and monochrome specifications. Don't make the mistake of relating the printer resolution to image print resolution – they are very different values, even though they are tied together in the print process. Within a specified area, a printer will spray ink in microdroplets; the finer the holes in the print head, the more ink it can spray into this area. The printer resolution determines how many ink droplets are used. More droplets will require a longer printing time, but the more droplets that are sprayed into each pixel area, the finer the result will look.

If the colour output from the printer is consistent with the image on the monitor, then no further adjustments need be made. However, if it isn't, then each individual colour ink tank can be adjusted, along with the amount of black ink that is used. This, of course, presupposes that there are separate ink tanks in the printer. The very least that should be considered for photographic output is a printer with three colour-ink tanks and a black-ink tank. The better printers offer six, seven or eight ink tanks, adding brighter colour and in the latter case, a pure red ink, to increase the overall colour gamut of the output.

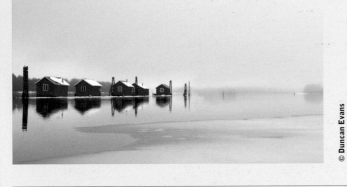

© Duncan Evans

Left: To print this image on a colour inkjet printer requires one with at least six ink tanks, and preferably eight to faithfully reproduce the subtle tones and bright red colour.

Tip

Make a test print before going for the high-resolution output. Set the printer resolution to as low as possible, as this will save on ink but still give you a good enough result to judge contrast, brightness and colour.

Above: By using the Print with Layout command it is possible to set a colour profile space that is specifically designed for the printer being used.

Above: To set your print size in Photoshop you should access the Image Size dialog box. The Resample Image box should not be ticked as this would resize the image dimensions, not the print size. Either the Width and Height sizes can be set at a required figure, with a careful eye kept on the resolution value to ensure it doesn't fall too low, or the resolution can be set to a high level of 300dpi, perhaps for commercial printing, and the width and height sizes either accepted, or noted so that further interpolation can be carried out.

digital monochrome

Unlike film, where a decision is taken to capture a shot in black and white or colour, most digital images are shot in colour, and are converted to black-and-white images during the processing stage. On many digital cameras, there is the option to shoot in a black-and-white mode, but this is not advisable as the result is simply flat. Converting the image on a computer gives far more control over the process and a better image as a result. As such digital cameras offer the advantage of having both a colour original and a converted black and white version of a picture – this is, of course, an attractive prospect for many photographers.

There are a number of methods that will enable you to convert a colour image to monochrome, but what needs to be understood is that they all result in an image that uses 256 shades of black-grey-white (unless it is converted to 16-bits per channel and then manipulated in colour to use the extra colours). A standard RGB image has three 8-bit channels of red, green and blue. Upon conversion to monochrome, this becomes one 8-bit channel, which offers 256 shades. However, the method of conversion does determine which of the shades are used and how punchy the resulting image is.

The easiest method of conversion is to use the Desaturate command, but this gives the worst result of all and is very flat. There has been some enthusiasm for the next alternative, which is to change the colour mode to LAB. LAB stands for Luminance, A and B; A represents red to green colours and B represents blue to yellow colours. To convert an image to monochrome, you simply delete the A and B channels and leave the Luminance channel, which is then converted back to RGB. What results should be an accurate representation of the monochrome image; however this is not the best method of conversion because the Luminance channel only has values ranging from 0–100, as opposed to the 256 greyscale shades on offer in an 8-bit channel.

The best method of monochrome conversion is the most complex, but it does give superior results. It is achieved by using the Channel Mixer, but before you use this it is a good idea to study the individual colour channels to see exactly how the image is represented in each. Once you have developed this awareness you will be able to apply better judgement when using the Channel Mixer.

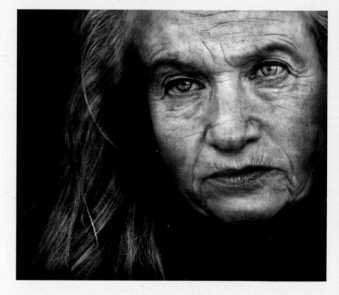

© Andrzej Dragan

Above: This is the original colour image portrait by Andrzej Dragan. Go to the Layers palette and select each channel in turn to see what it looks like as monochrome data.

Left: The red channel is the brightest because of the skin tones. These are the highlights.

Left: Green contains mid-tones and would make a worthwhile image on its own.

Left: The blue channel contains the shadows and would be too dark to represent the image alone.

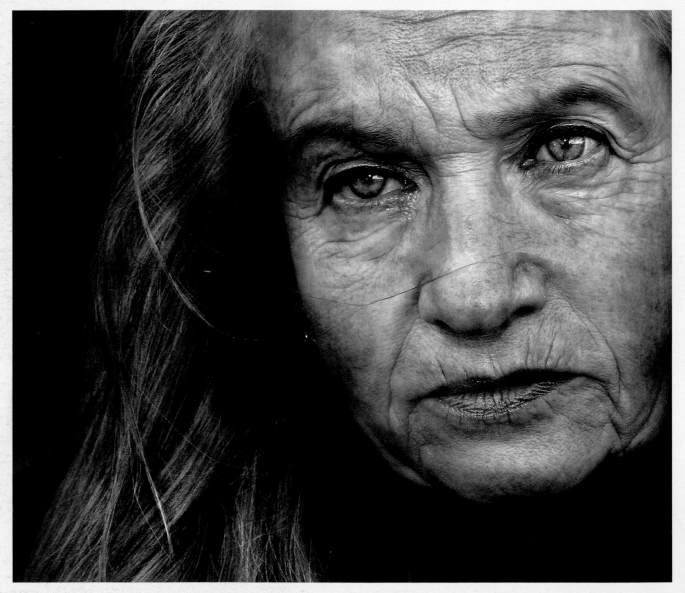

Output Channel: Gray
Source Channels
Red: 30
Green: 40
Blue: 30
Constant: 0
☑ Monochrome

OK
Reset
Load...
Save...
☑ Preview

Left: The next step is to select the Channel Mixer palette and tick the Monochrome check box. Usually, the percentage values would be split between the three channels, but you can alter the weighting to suit both your image and your taste. For this example 40% has been attributed to the Green channel, and 30% for the Red and Blue channels. Usually these numbers should add up to 100% in order to avoid losing highlights, but in some cases you can break this rule.

Below: Here is the monochrome image, which has been converted using the Channel Mixer. This image has a wider range of tones than would have been seen if any of the alternative methods of conversion had been used.

© Andrzej Dragan

Tip

Once converted to Monochrome, use the Levels and Curves commands to increase the tonal range and contrast.

Below: For comparison, this is another monochrome version of the image. However, the method of conversion here was the Desaturate command. The tonal range in this image is less well defined.

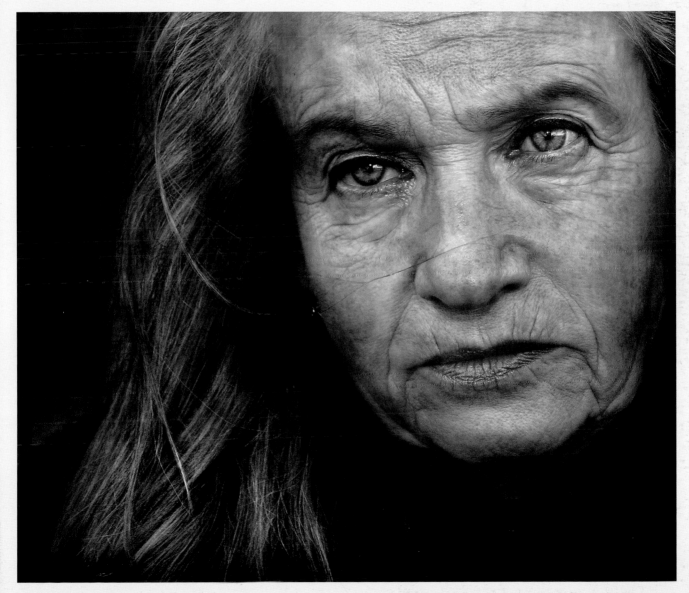

© Andrzej Dragan

digital monochrome printing

It is in the field of monochrome printing that, despite technological advances, traditional techniques retain the advantage over digital and inkjet methods. However, it is possible to produce good quality digital monochrome prints. There are though a number of issues relating to this, and the largest of these is colour casts. It might seem illogical that the primary problem of digital monochrome printing is one of colour, but this is because a monochrome print that is output on a standard inkjet printer will use all the colour-ink tanks as well as the black one.

In commercial print production, the colour-printing process consists of Cyan, Magenta, Yellow and Key, and the Key colour is not a direct shade of black. To print black therefore, requires 100% Key and a mix of the other colours as well. This is mimicked in inkjet printing; instead of Key, an inkjet printer has a dedicated Black cartridge, but the printing process is still essentially CMYK. The use of the other colours adds definition and strength. As the printer is using other colours to generate a black-and-white image, it is possible that it will use slightly too much of one – typically it's the Cyan ink – and produce a colour cast. Worse still, the inks may be perfectly well balanced, but the absorption in the paper means that some will blend better than others, which will also result in a colour cast.

A solution to this problem is to print using only the black-ink tank, but doing so does have consequences. By only using one tank, you are reducing the amount of ink that is sprayed on to the paper, which reduces the density and the resulting image will look coarser and may have a pronounced halftone pattern. Clearly, if the image is meant to be grainy and coarse then this does not present a problem, but if the image is intended to have fine, graduated tones, then it is.

The answer to the paper problem is simply one of experimentation. The printer manufacturer's own paper stocks should be produced with optimum ink absorption in mind, but these stocks are usually calibrated for colour images, not monochrome printing. It is worth trying sample stocks from a variety of sources and testing the results. If you do find a paper stock that you particularly like, and are determined to use all the available inks to ensure the finest and highest resolution print possible, but still get a colour cast then the next step is to try manipulating the individual ink tank output.

As a rule, the printer properties are set to use the complete colour range of inks, but the process of manipulating individual tank output means that colour management is turned off and manual control implemented. Once this is done each ink tank can then be tweaked to increase or reduce its output. A test print should then be done and further experimentation carried out until the optimum result is achieved. At this point the settings should be saved so that they can be used again with this combination of inks and paper.

Tip

To avoid contamination when switching from colour to black and white printing, ensure that you run the printer's head-cleaning routines before printing.

Alternative Inks

In response to the problem of coarse print production when using just the black-ink tank, a number of ink manufacturers have introduced replacement ink sets. These sets contain four black-ink tanks, and each has a slightly different tonal range, which can be used instead. This gives far better results for digital monochrome printing, but does tend to designate your printer for black-and-white image use only. To avoid contamination and endless ink switching, it is better to have one printer for colour and another for black-and-white images.

Left: Ensure that either the specific paper type is selected in the Printer Properties dialogue box. If you are using a third party supplier then select the nearest equivalent.

Left: With the colour management set to manual, the output of each of the individual ink tanks can be increased or reduced in order to avoid colour casts.

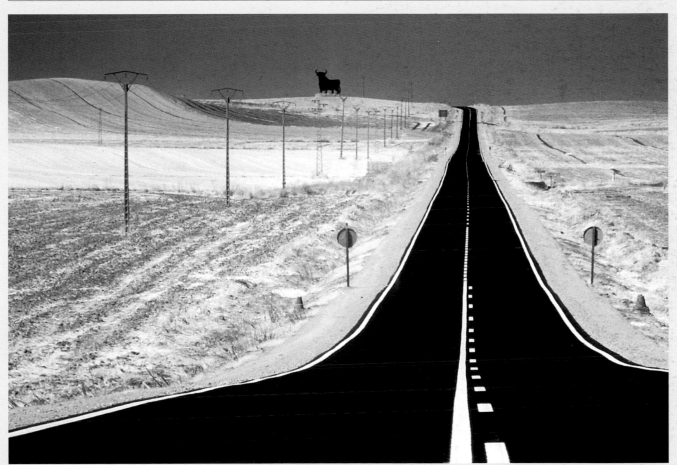

© Felipe Rodriguez

Above: Printing black-and-white images, such as this one called 'September Snow' by Felipe Rodriguez, requires a deep black and high resolution, which only a full range of ink tanks can produce.

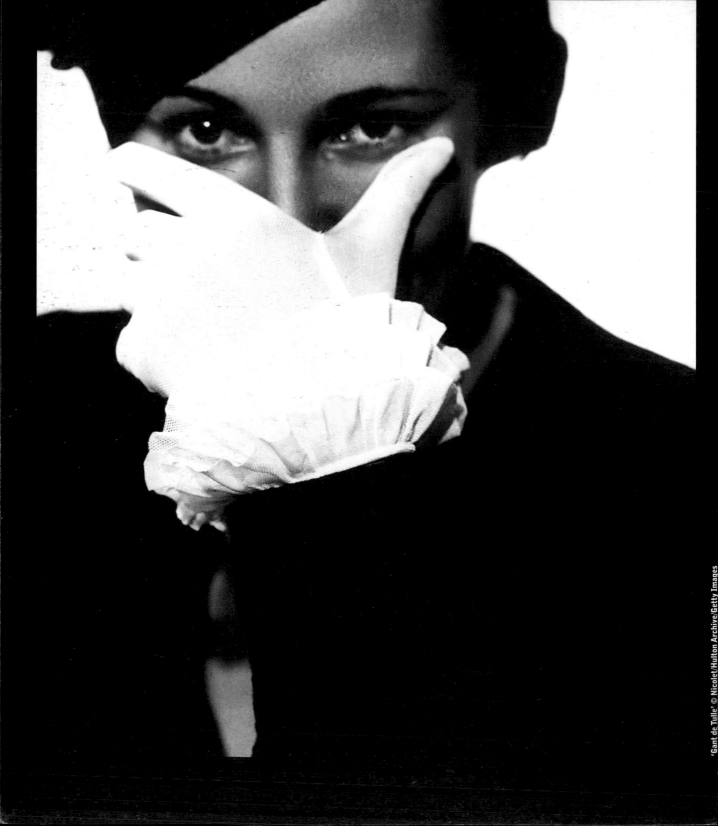

Section 7
Breaking the rules

'There are no rules for good photographs, there are only good photographs.'
Ansel Adams

When we think of photographic technique, particular words that spring to mind may include: method, approach and expertise. Each of the sections in this book have looked at the fundamental principles of photography and have hopefully informed and inspired you to go out and create some great images of your own.

What appears below is a brief, constructed by David Carpenter, which is similar to those set for students on photography courses at a number of academic institutions. Following a brief is a great way to go out and get used to capturing a photograph that relates to a simple idea, and is a chance to experiment with your technique and approach.

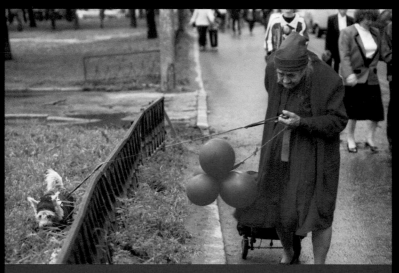

© Ty Wheatcroft

Red

This is an open brief that allows you to be creative and produce an image with the title of Red.

There are no restrictions, but the image should adhere to the title — no matter how loosely. The image can be landscape, still-life, portrait, or abstract — be as creative as you wish.

When you have completed your project make notes about what elements you feel work within the image and why you chose to incorporate them. This will be an important lesson in developing your technique.

The nature of this brief demonstrates that there is no standard or formulaic path to perfecting photographic technique. You will find that you develop your own style and approach to taking photographs, and strengthen and develop your skills and technique as you go. There are many methods to apply in order to create pictures that are powerful, but as we can see from the images over the following pages, these methods and rules need not always be adhered to. Once you have a solid understanding of the fundamental principles, the rules can be exploited, or even broken, to

Above: Using mirrors and reflections in your photographs can increase the illusion of depth and space, as they will divide the image into different focal planes. The repetition of subject and shapes can make a more interesting composition.

Left: This image packs a powerful punch due to the shallow depth of field that the photographer has used. The image is proportionally incorrect, but that's exactly what makes it work.

Working with a shallow depth of field – which can be obtained by using a wide aperture – can create a sharp point of focus and unsharp background, or vice versa. The blurred back- or foreground will add an abstract energy to the image as it hints at what may be, or is, happening.

Left: Think about what can be left out in order to say more in your image.

Below: Experiment with focal ranges for a creative effect. If you want to deliberately capture an out-of-focus shot then bold shapes and colours work particularly well.

Above: Look for opportunities to make a photograph more interesting. The interplay of a woman's cropped leg and the face of the bus conductor, divided by the rail of the staircase, gives this image a new dimension. Cropping an image in an unusual way can add a new dynamic to it

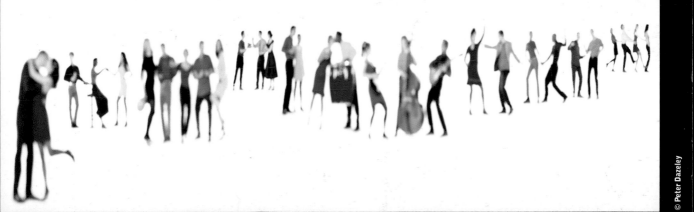

Above: If you remain still whilst your subject keeps moving, and ensure that your shutter speed is deliberately slow, you can capture a real sense of motion. These musicians were photographed at 1/8th sec.

Using a slow shutter speed adds a dramatic, impressionistic feeling of motion. Alternatively, if you read for the correct exposure, set your shutter on a slow setting and 'pan', or move, your camera at the same speed as the motion of your subject. If achieved successfully, the subject will remain sharp while the background will streak and blur as the camera moves across it.

Below: Car trails at night are a very common photographic subject. If you wish to capture a similar type of image it is important to try a fresh approach. Here the photographer has managed not only to capture the car trails but also blur the lights of the buildings along the roadside.

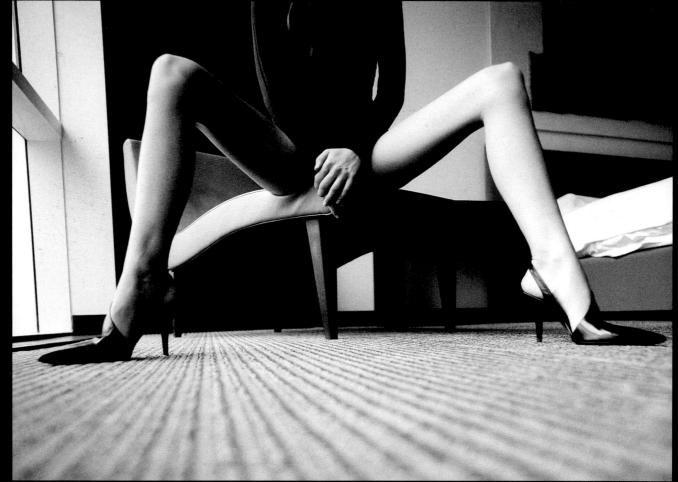

© Helen King/CORBIS

Above: Think about your vantage point when composing your shot, as a different perspective can dramatically enhance your image. Think about elevating or lowering yourself before you shoot, to see how it affects your composition.

Right: If you are photographing in the studio, experiment with coloured gels and backgrounds. A successful, creative photograph will not always require a distinct subject matter. Using colour and shape can produce evocative results, or may lead you to discover effects that you can call upon for future work.

 Images and commentary

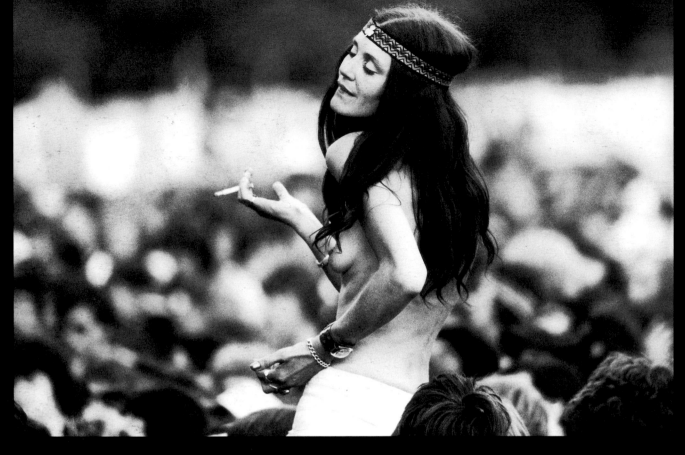

'Happy Hippy' © Evening Standard/Hulton Archive/Getty Images

Above: Clever cropping can redeem an otherwise dull or overloaded image. This woman is one of tens of thousands of revellers at an outdoor festival, and going in close has caught her expression perfectly. It evokes the spirit of the event without losing her in the crowd.

Right: Trapped within such an extensive crowd, this photographer was unable to get near enough to Christine Keeler and Mandy Rice-Davies – seen here emerging from court during the notorious Profumo scandal – for a clear shot. Instead he used the arms of another photographer as a framing device. The result is a shot that takes us straight to the two girls.

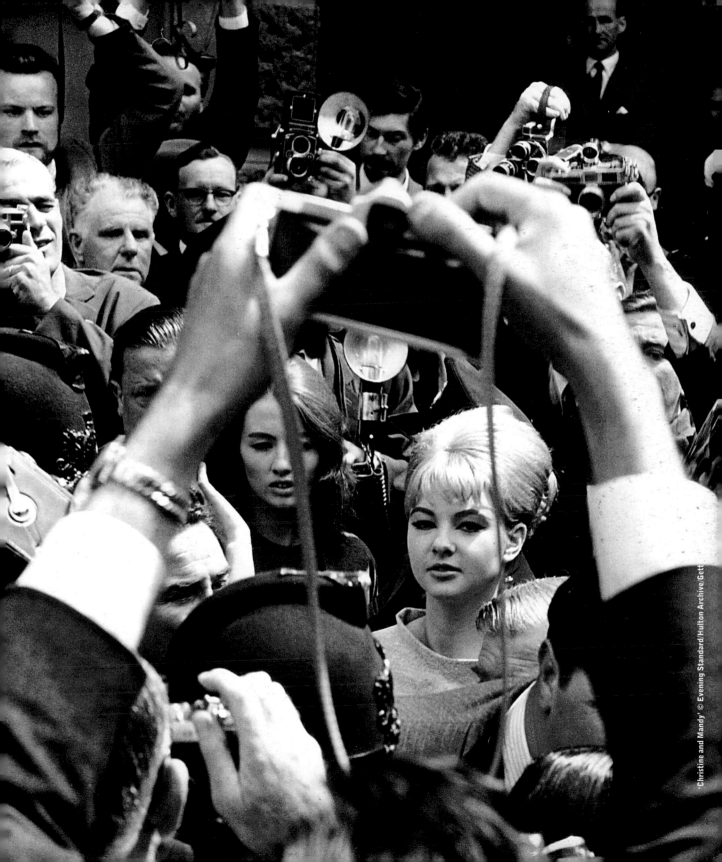

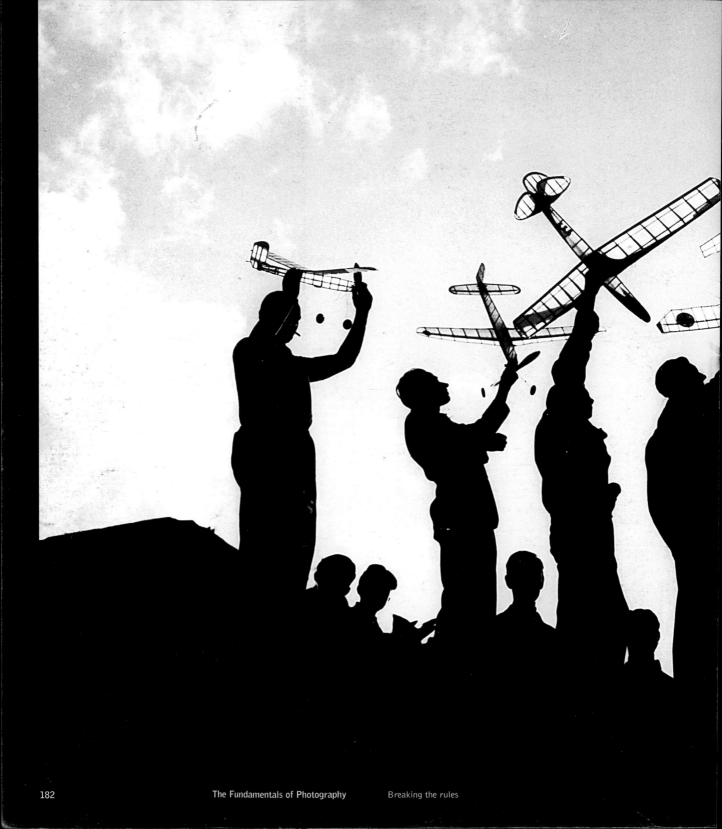

The Fundamentals of Photography Breaking the rules

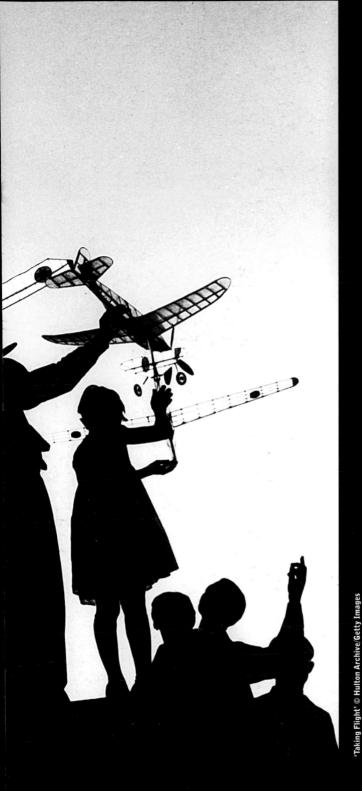

'Taking Flight' © Hulton Archive/Getty Images

Left: These striking silhouettes were created by ensuring that the sun was behind the subjects when the photograph was taken. Look for photographic opportunities to exploit and use them to develop your portfolio of styles and techniques. It will assist you in acquiring a broader range of image solutions.

conclusion

THE IMAGE-MAKING WORLD HAS UNDOUBTEDLY COME A LONG WAY SINCE 1839 WHEN SIR JOHN HERSCHEL FIRST USED THE TERM 'PHOTOGRAPHY'. OUR DAILY LIVES HAVE BECOME IMMERSED IN A SOPHISTICATED VISUAL CULTURE; WE CAN NOW RECORD OUR WORLD AT THE TOUCH OF A BUTTON AND ALTER IT TO ANY STATE WE DESIRE. HISTORY CAN BE RECREATED, SKIES AND LANDSCAPES CAN BE CHANGED AND HYPERREAL FUTURES CAN BE SUGGESTED.

THIS BOOK HAS EXPLORED THE FUNDAMENTAL, BUT NO LESS PHENOMENAL, FUNCTIONS AND CREATIVE POSSIBILITIES OF CAPTURING IMAGES WITH A CAMERA, WHETHER IT BE DIGITAL OR TRADITIONAL. THE BEAUTIFUL PHOTOGRAPHS IN THIS BOOK WILL HOPEFULLY INSPIRE YOU TO SEE THE WORLD IN A SLIGHTLY DIFFERENT WAY, AND INSPIRE YOU TO START SHOOTING GREAT PHOTOGRAPHS OF YOUR OWN. YOU SHOULD NOT TRY TO COPY THE WORK OR STYLE OF ANY OF THE FEATURED PHOTOGRAPHERS, BUT INSTEAD TRY TO UNDERSTAND WHAT MAKES THEIR IMAGES SO MEANINGFUL AND SUCCESSFUL AND THEN THINK ABOUT WHAT COULD MAKE YOUR OWN PICTURES POWERFUL TOO.

I WOULD LIKE TO THANK ALL OF THE CONTRIBUTORS FOR MAKING THIS BOOK SUCH A VISUAL TREAT AND I HOPE THAT THEIR IMAGES INSPIRE YOU AS MUCH AS THEY INSPIRE ME.

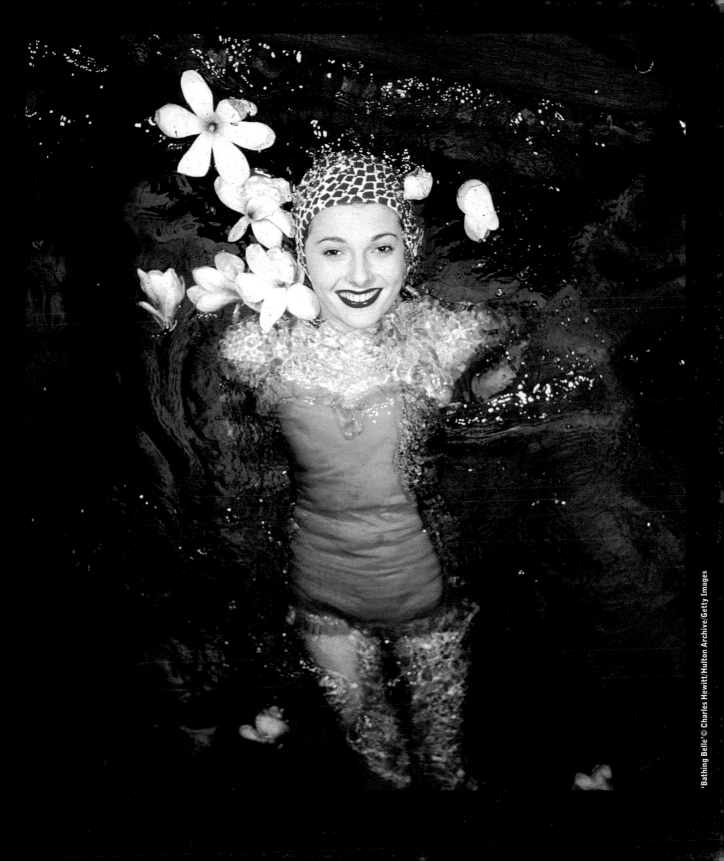

glossary of terms

Aberration
(1) Something that prevents light from being brought into sharp focus, preventing the formation of a clear image.

(2) Lens flaw – the inability of a lens to reproduce an accurate, focused, sharp image.

The effects of lens aberration usually increase with increases in aperture or in angle of field.

Abstract
In the photographic sense, an image that is conceived apart from concrete reality, generally emphasising lines, colours and geometrical forms, and their relationship to one another.

Agitation
During the development of film this is the process of continuous movement to keep the chemicals evenly flowing over the film, or the paper in the trays.

Ambient light
The continuous light available in either an artificial or naturally lit situation.

Angle of view
Also known as the "Field of view", "FOV" and the "Angle of the field of view", it is the extent of the view taken in by a lens. Focal length of a lens, in conjunction with film size, determines the angle of view. Because digital SLR cameras usually have sensors that are smaller than a piece of 35mm film, yet are housed at the same distance from the lens in a 35mm film SLR body, the field of view is narrower and the focal length effectively longer by a magnitude of around 1.5x.

Aperture
A circle-shaped opening in a lens (a hole, really) through which light passes to strike the film or digital camera CCD/CMOS. It is usually created by an iris diaphragm that is adjustable, enabling the aperture to be made wider or narrower, thereby letting in more or less light. The size of the aperture is expressed as an f-number, like $f/8$ or $f/11$.

Aperture priority
A semi-automatic program mode of a camera that permits the photographer to set the aperture and leaves the camera's built in metering systems to determine the shutter speed for a correct exposure.

Archival process
A print that has been processed to remove all trace of chemicals, using a fibre-based paper with the aim for maximum longevity of the image. The American National Standards Institute established a set of standards by which a photographic print must be processed to be considered archival.

Archival techniques
The handling, treating and storage of photographic materials in a manner that lessens their deterioration from aging or from reaction to other materials.

Artificial light
Illumination that comes from a man-made source, such as electronic flash.

Autofocus
Ability of a lens to focus automatically on an object. A number of different systems can be employed to do this from contrast and shape detection to infra-red spotting.

Automatic aperture
An automatic aperture remains fully open until the shutter is released, at which time it closes down to the pre-set aperture size in order for the picture to be properly exposed. An automatic lens has an automatic aperture. The advantage of this is that the maximum amount of available light is sent through the viewfinder whereas with small apertures the viewfinder would be very dim and the image hard to make out.

Automatic white balance
A feature of digital cameras is the ability to compensate for the colour temperature of light. There are preset options to choose from to match specific conditions or to leave it up to the camera to decide, the default AWB can be used (see also Colour Temperature of Light).

B Setting or Bulb mode
A shutter speed setting that allows the shutter to remain open as long as the shutter release is held down. On some cameras the shutter will remain open until the shutter release is pressed again. This is ideal for control over long exposures or trying to create a feeling of movement in a static shot.

Backlighting
A light source that is placed behind the subject, either to provide light for a backdrop, to illuminate the edges of the subject, to provide light for other objects not lit by the main or key light, or for creative effect.

Bit
A binary digit; basic digital quantity representing either 1 or 0. The smallest unit of computer information.

BMP
File format for bitmapped files used on Windows.

Bounced light
Resulting in a softer effect with a less distinct shadow effect than direct light, bounced light is reflected, or 'bounced' off a surface before reaching the subject.

Bracketing
This is a technique used to ensure, typically in difficult exposure situations, that at least one image will be perfectly exposed. The same frame is shot several times at different exposure settings. Many cameras can automatically bracket shots, so that when the shutter is released the camera takes shots under and over the determined exposure. The amount of exposure variance can also be set.

Bromide paper
Photographic enlarging paper; a high-speed paper coated in silver bromide, a form of silver halide, that forms the image when exposed then developed.

Buffer RAM
Fast memory chip in a digital camera. Buffer RAM is used for temporary storage while images are being written to the memory card.

Burning-in
A darkroom technique in printing to give more exposure to a specific part of a print. Now adopted by the digital darkroom, computer software such as Photoshop allows spot burning in with precise user control (see also Dodge).

Burst mode
A feature on digital cameras, usually compacts, whereby the camera can take a burst of pictures, usually at a lower resolution than the maximum available, but at a higher speed than normal.

Byte
Standard computer file size measurement: contains eight bits. Other common units include kilobyte (KB: 1024 bytes), megabyte (MB: 1024KB) and gigabyte (GB: 1024 MB).

Cable release
A cable that screws into the shutter release of the camera; great for long exposures, reduction of camera shake and used when the camera is on a tripod.

Calibration
The process of adjusting a device, for example a scanner, so it captures, displays or outputs colour in an accurate and consistent way. The same applies to monitors and printers.

Cassette
A canister or container for film. Protects the film from handling and light when loading and unloading film.

CCD
Charged Coupled Device. The sensor at the heart of a digital camera that records an image. The CCD consists of diode wells that register light. When the exposure time has elapsed, the light is cut off from the CCD and the volume expressed as a data signal is sent to the firmware that processes the input and determines the image. Overlaid on top of the diode wells is a colour matrix, normally consisting of a red, blue and two green squares in a repeating pattern. As there is only one colour matrix element per diode well the actual, final colour output is determined by the camera's firmware, which evaluates the tonal shapes recorded and adjusts the colours along the edges as it deems necessary.

CD-R
Recordable CD. A useful archiving system. CD-Rs can only be written once and not erased. Also available are rewritable disks/drives (CD-RW), which are more expensive but can be erased and reused.

Centre weighted metering
A metering system that evaluates exposure by sampling zones like the zone metering system, but also takes a reading from the centre spot, like spot metering, and averages the two out.

Cloning
A feature of many image-editing software programs where part of an image can be duplicated over another part. Used to seamlessly 'paint out' blemishes.

CMOS
An alternative to the CCD, the CMOS works in a similar fashion, is cheaper to produce, less prone to manufacturing errors, but produces softer pictures.

CMYK
Cyan, magenta, yellow is the colour printing model used by dye-sub and low-end inkjet printers. CMYK adds black (key) and is used for most professional printing.

Colour bit depth
The number of bits used to represent each pixel in an image; the higher the bit depth, the more colours appear in the image: 1-bit colour provides a black-and-white image with no greys or colours; 24-bit colour gives 16.7 million colours ('photo-realistic' colour).

Colour temperature of light
The colour temperature of light is measured by the Kelvin scale. Light at different times of day, or under different circumstances, has a specific colour temperature. Regular daylight film is balanced at 5500K so that if the light temperature is higher or lower than this, a colour cast will ensue. Snow for example reflects light that has a very high colour temperature (if not a Celsius one) and so will often record as blue on daylight film.

Candlelight has a very low colour temperature and will give the picture an orange or red colour cast. Digital CCDs are also prone to colour casts but have a facility designed to deal with it called Automatic White Balance.

Composition
The arrangement of key elements in the frame. The structure and layout of various points of interest in an image.

Compression
The 'squashing' of data to reduce file size for storage or to reduce transmission time. Compression can be 'lossy' (JPEG) or 'lossless' (TIFF, LZW). Greater reduction is possible with lossy compression than with lossless schemes.

Contact print
A contact print is a print made directly from the negative on to photographic paper without the enlarging procedure. This produces an image exactly the same size as the negative.

Contact sheet
Made from a whole roll of negatives printed in direct contact with the paper. It is used to review what you have shot on your film when selecting images to print, but can look great in their own right as an image. Digitally, contact sheets of any selection of pictures can be put together in the appropriate software.

Contrast
The difference in high and lowlights in print or negative tonal values. Essentially the lightest and darkest parts in an image.

Cropping
Removing parts of the image to improve the composition, either by trimming the print, or omitting areas in the print process. On the desktop, cropping is a simple matter for digital images.

Definition
Fineness in the detail of a print or a negative.

Density
The amount of silver in a negative. A 'dense' negative is dark, with a lot of silver present. A relatively clear negative is 'thin', with very little silver.

Depth of field
This term refers to the space captured in a photograph that appears to be in focus – the distance between the nearest and farthest points that appear in acceptably sharp focus in a photograph. Depth of field varies with lens aperture, focal length, and camera-to-subject distance. Smaller apertures (high f-stops) give greater depth of field and wide angle lenses offer more than telephoto lenses. Compact digital cameras have around five times the depth of field of film cameras thanks to the smaller CCD and shortened focal length.

Developer
The primary chemical that converts latent (invisible) film to a visible image by changing the silver halides into black metallic silver.

Diaphragm
The aperture of the camera or lens, formed by a series of overlapping blades that allow for adjustment in conjunction with the camera settings.

Diffuse
To employ an opaque material to soften the final effect of a light-source on the subject.

Digital zoom
Camera feature that enlarges the central part of an image to give a similar effect to a telephoto lens. Basically an in-camera crop, it usually results in a drop in image quality.

Dioptre adjustment
A feature on the viewfinder of most SLRs and some compacts that allows the image through the viewfinder to be adjusted for the viewer's own eyesight characteristics.

Distortion
The unnatural perspective that can affect the subject when seen through a wide-angle lens. The closer the image and the wider the angle, the greater the distortion.

Dodge
The opposite of burning-in. In the development process parts of the image are held back, resulting in lighter tones. Digitally, it is used in Photoshop to lighten specific areas of the image.

Download
The transfer of files or other information from one piece of computer equipment to another (such as when transferring pictures from camera to computer screen).

DPI
Dots per inch. A measurement of the resolution of a printer or video monitor (see also PPI).

E-6
The term for the procedure used, largely by professional labs, to process transparency/slide film.

Emulsion
A fine coating used on photographic film and paper of silver halides suspended in a gelatin.

Enlarger
An essential piece of darkroom equipment used to enlarge the image on a negative. Using an artificial light source projects the negative on to photograph paper, at variable sizes of enlargement.

EV – Exposure value
This is the actual light reading value that a metering system produces when working out the exposure required. Metering systems assess the light in terms of the exposure value. A typical EV range for a digital camera is 0 to 19.

EVF
Electronic viewfinder. A recent addition to high-end digital cameras. A tiny colour LCD monitor placed inside a viewfinder, which does not suffer from the glare problems of standard LCD monitors.

Exposure
The amount of light allowed to enter the camera and reach the film or sensor. The length of time and amount is controlled by the camera's shutter speed and aperture settings.

Exposure compensation
Expressed as a plus or minus EV (exposure value) number, this modifies the metered reading of the camera. A plus EV number will make the image brighter while a negative one will make it darker. This is a quick and easy method of adjusting exposure (see also Bracketing).

Exposure meter
A device that reads reflected light and calculates what aperture and shutter speed are required to produce a balanced, well-exposed image. This can be built-in to the camera or used as a separate piece of kit, though this is normally for medium or large format cameras (see also Spot Metering, Centre Weighted Metering and Zone Metering).

Extension tube
An accessory that fits between the camera body and the lens, making the focal length longer and allowing the camera to zoom further into the subject. Used in macro work.

Field of view
The maximum view that can be seen through the lens.

File
Used in computers to describe a single document (i.e. a digital photograph) stored on a disk.

File format
The way information in a file is stored. Common file formats include JPEG, TIFF, FlashPix and GIF.

Film
Light-sensitive material, formed from a flexible base (made from cellulose and polyester), coated in a gelatin emulsion.

Film plane
The flat bed or plane built into the back of the camera where the film lies across during exposure.

Film speed
The sensitivity of film or digital sensor to light, determined by the ISO number. The greater the number, the more light-sensitive or 'faster' the film. Film works by having larger grains that respond more quickly to the light falling on them. Digital works by lowering the volume threshold at which light falling in diode wells triggers the signals that record as pixels.

Filter
A transparent piece of gelatin or glass that modifies the light passing through a lens. Can be used to correct colour imbalance in film, reduce reflections or creatively alter the density of colour and tonal range. A huge range is available for special effects or subtle changes to the subject at hand. The two most useful are the Polariser and the Neutral Density. Also used in conjunction with photographic paper at printing stage, to change the contrast of bromide and resin paper.

Fixing
The third stage in development of film or print. Using the chemical fixer solution, the actively light-sensitive silver halides are removed to render the emulsion insensitive to further action of light.

Flare
This washed-out or patchy effect is caused by scattered, unwanted light near the edge of the picture or lens; light is reflected within the lens, creating circles of light on the recording medium.

Flash
An artificial (electronic) light source of great intensity that falls on a subject for a short duration of time. The colour temperature of flash is matched to 5500K – the same as standard daylight, so film or digital does not need any colour adjustment to use it.

Flash memory
A type of fast memory chip that remembers all its data, even when the power is turned off (see also Removable Media).

Focal length
The distance between the centre of the lens and the film/CCD. Because the CCD/CMOS chip in a digital camera is smaller than the size of 35mm film, but is placed at the same position, it only uses the middle portion of the image that the lens delivers. This is then represented as the full size image. The effect is the equivalent of extending the focal length by a factor determined by the relative size of the chip – it's usually around 1.5x. Thus a 300mm lens on a film SLR gives the equivalent field of view and closeness of a 450mm lens when it is used on a digital SLR. The three types of lenses are normal or standard (around 50mm), wide-angle (below 35mm) and telephoto (greater than 70mm). A zoom lens is capable of variable focal lengths (see also Prime Lenses).

Focus
Adjusting a lens so the subject is recorded as a sharp image on the CCD. There are three types of focus systems used in digital cameras: fixed focus (focus-free), autofocus and manual focus.

Format
The size of the negative a type of film camera can produce, and the camera itself. Also means the alignment of the image, i.e. landscape (horizontal) or portrait (vertical).

Frame
The general image-area seen through the lens – the picture 'in the frame'. Also a device used in composing an image.

Gelatin
A natural protein used to suspend the silver halides and used to create emulsion.

GIF
A graphic file format developed for exchange of image files (only supports 256 colours).

Glossy
A smooth, high-shine photographic paper surface.

Grain

The tiny black metallic silver particles that form your image on the surface of film or print. The faster the film, the courser or 'grainier' your negative. Some photographers love this effect, for others the deterioration of details is a problem.

Grey scale

Can be used in card form as a useful guide to correct exposure, a set of tones representing minimum to maximum density. The 18% grey card is meant to represent the mid-tone that exposure meters work from – a reflected light reading is taken from the card to represent the value for the perfect exposure. However that is where the scene is an average one in terms of tonality. Scenes with lots of white (like snow) or lots of dark areas, do not correspond to 18% grey so the meter reading would lead to underexposure and overexposure respectively.

Guides and grids

Function in the camera LCD monitor that helps you achieve straight compositions. Also found in software for much the same thing.

Guide numbers

The numbers on a flash gun that indicate the correct settings required for the flash gun that will correctly expose the subject, used in conjunction with the film speed setting and simple calculations of the distance of the subject from the camera.

High key

Where the tones in an image are predominantly bright it is referred to as a high key image.

Highlights

The darkest parts of a negative that will correlate with the lightest, brightest parts of the subject in a positive print.

Hotshoe

A fitting generally located on top of a camera to which accessories (such as a flash unit) are attached.

Hue/Saturation

An RGB image can also be defined by Hue, Saturation and Brightness, where Hue is the colour and Saturation the 'strength'. Hue/Saturation controls are useful for altering colours without affecting overall brightness or contrast.

Image manipulation

Once a digital image has been transferred into a computer, image-manipulation software allows the individual pixels to be altered in many ways. Colour corrections, sharpening, photomontage and distortions are all forms of manipulation.

Incident light

The actual light falling on the subject. An accurate incidental light reading can be taken by turning the meter toward the camera, close to the subject, instead of the reflected light. This will give you the exact light reading but you must also take heed of how reflective the surface of the subject is as this will affect how that light is reflected to the camera.

Infinity

The farthest possible distance a lens can be focused on.

Interpolation

The process of increasing the resolution of an image, based on comparing adjacent pixels and working out an intermediate value. Interpolation tends to lead to softer edges in an image.

Inverse square law

Where the light hitting the subject's surface is inversely proportional to the square of its distance from the light source. Therefore half the distance then the intensity is fourfold.

ISO

International Organization for Standardization. The ISO sets and regulates standards for film speed ratings for global usage. Digital cameras use the ISO rating to specify responsiveness and what quality the sensor will offer.

Jaggies

The jagged, stepped effect often seen in images whose resolutions are so low that individual pixels are visible.

JPEG

A file format that stores digital images in a very space-efficient way. Used by virtually all digital cameras, JPEG uses a form of 'lossy' compression to reduce file sizes at the expense of fine image detail. The level of compression (and thus the loss of quality) is varied, and this forms the basis of digital camera settings.

Kelvin (K)

This is the unit used by scale to measure colour temperature.

Large-format cameras

These cameras are based on very old fashioned principles and generally take pictures with negatives of 4 x 5 inch film or larger. The large negative can produce great detail and is often used in advertising photography as a result.

Latent image

Directly after exposure the image is still invisible and this is the latent image. It is the following chemical procedure which renders the image visible.

Latitude

The ability of the recording medium to still reproduce a full range of highlights and shadows despite the exposure being incorrect. Print film has a very great latitude whereas digital and slide film have a much smaller latitude, making it very easy to overexpose and lose the highlights.

LCD – Liquid crystal display

A colour display found on the back of digital cameras allowing photos to be previewed (usually on compacts), or reviewed after capture, and to allow navigation of menu items.

Lens hood

A simple accessory in the form of a circular shield (usually made from plastic or rubber) that protects the lens from excess or side light that could cause flare.

Light meter

Literally used to measure light; a simple and brilliant device used to measure light and convert it into the correct exposure settings for the camera.

Lossless

File compression that involves no loss of data and therefore no loss in quality. LZW is a lossless compression system used in TIFF files. Lossless compression produces lower space savings than lossy.

Lossy

A type of compression that involves some loss of data, and thus some degradation of the image. JPEG is a common lossy system.

Macro lens

Capable of taking detailed shots at close-range, maintaining optimum (ideally life-size) reproduction quality. Macro lenses are referred to with ratios that indicate the size of reproduction of the subject. A 1:1 lens is a true macro lens that will reproduce an object at exactly the same size on film as it is in reality. A 1:2 lens will reproduce the subject at half the size, a 1:3 lens at a third of the size and so on. Because compact digital cameras have very short focal lengths they can focus at incredibly close distances to the subject.

Masking frame

The adjustable frame attached to an easel which, during printing, holds the paper down. Also used for cropping, and leaving a white border.

Medium format

Cameras which offer a larger film reproduction area than 35mm, but in consequence are bulkier and suited more to landscape work where the pace is slower, or studio work where it can be mounted on a tripod most of the time. There are three types of medium format – the smaller versions at 6x4.5cm, the square size at 6x6cm and the largest at 6x7cm. Medium format cameras use 120 roll film, rather than 35mm film, and offer fewer pictures per roll, but much better quality.

Megapixel
A term meaning a million pixels, used to describe the resolution of a digital camera. Calculated by multiplying the horizontal and vertical resolutions of an image produced and then rounded off. Hence, a camera with the resolution of 2400x1800 would have a 4.3 megapixel resolution. Written as Mp for short.

Mode dial
This dial is found on the back of a digital camera and holds a selection of functions, including recording, playback and movie modes.

Modelling light
Continuous ambient light emitted from an electronic flash unit enabling the photographer to assess where the light and shadows will fall.

Monochrome
The general term used for black and white photography.

Montage
A composite image made from several exposures or combined prints. In Photoshop terms a montage is an image made up of several elements.

Negative
This term is used for the most widely used film type in photography for both black and white, and colour. When this type of film is exposed to light in the camera, the emulsion captures the light in opposite wavelengths from the actual scene (i.e. light tones are captured as dark, and vice versa). Once processed, the negative image looks reversed from the actual scene when viewing the negative.

Neutral density filter
One of the most useful filters, the Neutral Density or ND, comes in two forms and numerous strengths. One form is the graduated (from clear to grey) filter, which is invaluable for digital and slide film users as it allows that part of the scene which is very bright, to be toned down so that the camera can record the entire tonal spectrum present, whereas otherwise highlights might be lost or half the picture might be considerably underexposed. It is usually used to tone down bright skies. The other form is an even, solid grey which does not affect the colour, rather just blocks light. This is useful for slowing down shutter speeds for creative effects with water and motion.

Noise
Unwanted electrical interference that degrades analogue electrical equipment. In digital cameras, this most often occurs in very low lighting or shadow areas as pixels of the wrong colour appearing at random in dark areas.

Optical resolution
The maximum resolution possible without resorting to interpolation. Also describes a digital camera's true CCD resolution.

Panning
A technique used to create the impression of speed by moving, or 'panning' the camera while exposing for and shooting a moving subject. As a result, the subject looks relatively sharp while the background looks blurred.

Photoshop plug-in
A small piece of software that adds extra features or functions to Adobe Photoshop or other compatible applications. Common uses are to add new special effects (such as filters).

Photosite
A single photosensitive element in a CCD which translates to one pixel in the resulting image.

Pixel
PICture ELement. Smallest element of a digitised image. One of the tiny points of light that make up an image on a computer screen.

Polarising filter
A very popular lens accessory used to minimise reflections, light bouncing off and obscuring shiny surfaces or intensifying the blue of the sky, by reducing the amount of light reflected in a general view. It blocks light of certain wavelengths, and is most effective when 90 degrees to the ambient light source.

Positive
This is the term used in photography to describe when the lightest and darkest parts of an image correlate with those of the original subject, whereas the negative describes the opposite to the original subject.

Power-up time
Measure of a digital camera's speed of operation, showing how long it takes from turning the camera on until it is ready to take the first picture.

PPI
Pixels/points per inch. A measure of the resolution of scanners, digital images and printers.

Prime lens
One with a fixed focal length. Although lacking the flexibility of a zoom lens, the prime lens offers better quality which benefits macro and landscape work.

Pulling film
Rating the film at a lower ISO or reducing processing time.

Pushing film
Rating the film at a higher ISO and increasing development, to generally improve contrast and increase speed.

Rangefinder
An optical device within the camera which assists the photographer to assess distance and accuracy of a subject. The subject is viewed via different viewpoints that align a semi-transparent image.

Reciprocity failure
Occurs during long exposures as the film cannot accurately record the available light using the metered shutter and aperture settings. Usually leads to under exposure so that the longer the exposure, the more positive exposure compensation needs to be applied to the metered reading. Digital also becomes variable at longer exposures but not in the same way. Here, much more digital or coloured noise is produced as the result of variations in the light source.

Recovery time
The time delay during which a new picture cannot be taken on a digital camera, while waiting for the previous one to be saved.

Reflected light reading
A meter reading of the light bouncing off the subject. This is how the metering system built into a camera works.

Reflector
Sheets of reflective material used to bounce light into shadow areas.

Refresh rate
In digital camera terms, how many times per second the display on the LCD preview monitor is updated. A refresh rate of under about 15 fps (frames per second) will look 'jerky'.

Removable media
Small memory chips that store the captured images. The two main formats are Compact Flash and Smart Media – Compact Flash cards offer higher capacities, but Smart Media cards are smaller. Other types of removable media used include Multimedia/Secure Digital (MM/SD) and Sony's Memory Stick.

Resample
To change the number of pixels in an image. Upsampling uses interpolation to increase the number of pixels, while downsampling throws away pixels.

Resin-coated (paper)
A high-speed plastic-coated photographic printing paper. Absorbs fewer chemicals than other papers.

Resizing
Changing the resolution or physical size of an image without changing the number of pixels, e.g. a 50 x 50mm (2 x 2in) image at 300 dpi becomes a 100 x 100mm (4 x 4in) image at 150 dpi. Often confused with resampling.

Resolution
Measure of the amount of information in an image expressed in terms of the number of pixels per unit length (i.e. pixels per inch). Camera resolution is usually defined as the actual number of pixels in an image i.e. 640 x 480 (see also DPI and PPI).

Reticulation
An irregular clumping of silver on the emulsion, usually happens when the film has been exposed to sudden or severe temperature changes.

Reversal film
A photographic film that produces a transparent positive image, or a slide.

RGB
Red, green and blue. TV sets, monitors and digital cameras use a mix of RGB to represent all the colours in an image.

Ring flash
A circular, electronic flash unit that is placed around the lens. Produces a flat light, with a fine halo effect around the subject.

Rule of thirds
A photographic rule, largely applying to landscapes, in which the photographer is advised to split the scene into one third sections, horizontally and vertically, and try to compose the image so that the areas of most interest are on the points of intersection or on the lines themselves. For example, the horizon should be positioned at a third of the way from the bottom of the image, or a third from the top, not the middle.

Safelight
A darkroom light, usually in red or orange, or a disc of glass of that colour that can remain on in the darkroom without affecting light sensitive materials.

Saturated colour
A strong, bright, pure colour free of any mixing or dilution with grey or white.

Saturation
The amount of grey in a colour. The more grey there is, the lower the saturation.

Serial transfer
Connecting a digital camera to a computer via the serial ports in order to download images.

Shutter
The curtain-like camera mechanism that, when set and activated, determines the duration of exposure, or light falling onto the film. Works in conjunction with the aperture.

Shutter lag
The delay between pressing the fire button and the camera actually taking a picture. Most notable on compact digital cameras, where the camera has to switch from providing a picture to the LCD, meter the scene using any preset options, reset the CCD and open the shutter. Earlier, and currently cheap, models were very poor in this regard.

Shutter speed
The time for which the CCD or film is exposed during an exposure. High shutter speeds (hundredths or thousandths of a second) prevent camera shake and can freeze motion in photos. Slow (long) shutter speeds allow exposures in low light.

Slave unit
Primarily used in the studio in a multiple flash-lit situation. When the main flash light fires, a photo electric cell in the slave detects it and activates its own flash.

SLR – Single lens reflex
The SLR camera gets its name for two reasons. The first is that it has a single lens – the term comes from an era when dual lenses were common. The second is that what you see through the viewfinder is the light coming into the camera and that which will be recorded when the shutter is fired. The light is reflected up to the viewfinder by a mirror; when the fire button is pressed the mirror drops flat, allowing the light to hit the recording medium instead.

Softbox
A lightweight frame with a soft, white diffusing material stretched across it. Placed over the head of a light (usually studio flash), it gives a soft, even light on the subject.

Spot metering
A two degree spot circle in the centre of the viewfinder where the metering system reads the light, ignoring all other elements in the picture. The value from the spot is used for the exposure.

Stop
The f/number for an aperture setting. On a camera or an enlarger lens in the darkroom a photographer will 'stop down' to reduce the aperture.

Stop bath
Chemical used to neutralise the developer and completely stop the development stage.

Super zoom
A general term for a zoom lens with a very big range of focal lengths. A 28-300mm zoom would be an example.

Sync lead
The lead, or cable used to synchronise the camera with the flash unit.

Telephoto
Lens with a long focal length and a smaller angle of view, giving a larger image of the subject without the photographer having to move.

Test strip
A thin strip of sensitised material used to assess correct exposure times.

Thumbnail
A small, low-resolution version of a larger image file, used for quick identification or showing many images on a screen.

TIFF
Standard file format for high-resolution bitmapped graphics.

Toner
Chemical used to change the tonal range and colour of a black and white photograph. This is available in a huge range providing the slightest hint of a change to whole areas of strong colour.

USM
Unsharp Mask. A tool in many software image editing packages, and a vital one in digital imaging. It makes photos appear sharper by giving more contrast to the boundaries between colour areas.

UV filter
A colourless filter used over the lens to absorb ultra-violet rays and, to some extent, general haze. Many users fit screw-in UV filters to expensive lenses to prevent any chance of scratches or damage.

Viewfinder
The scene, or view or subject range, seen from the camera.

Wetting agent
A detergent type chemical, greatly diluted to reduce surface tension of water on film. Used in the final stage of development prior to drying to help prevent drying marks.

Wide-angle lens
A lens with a short focal length but a wider angle of view than a standard lens.

X
The symbol on the shutter setting and/or flash sync socket that signifies the setting for electronic flash.

Zone metering
The default metering system in many cameras. The more zones the metering system assesses, tied to an in camera interpretive procedure, the more accurate the metered result. More sophisticated systems use depth detection in combination with straight zone reading for greater accuracy.

Zone system
This is a method devised by the great American photographer Ansel Adams, to identify eleven zones of the tonal range in black and white.

Zoom lens
This lens allows the focal length (therefore image size and subject) to be altered, while the focal plane remains the same.

contacts

Allan Jenkins Photography
Tel: + 44 (0)8 8348 6900
Email:
allanjenkins@btconnect.com
Web: www.allanjenkins.com

Andrzej Dragan
Komandorska 8
62-502 Konin
Poland
Tel: +48 504 266 344
Email:
photography@andrzejdragan.com
Web: www.andrzejdragan.com

Andy Rumball
und_ photography
Boxhagenerstr. 89
10245 Berlin
Tel: 030 4208 5659
Email: andy@rumball.de
Web: www.rumball.de

Arild Sleire
Fossumberget 24
N-0983 Oslo
Norway
Tel: +47 91862672

**The Association of
Photographers**
81 Leonard Street
London EC2A 4QS
Tel: +44 (0)20 7739 6669
Email: general@aophoto.co.uk
Web: www.the-aop.org

Ben Elwes Photography
Tel: +44 (0)7973 174538
Email: ben.elwes@ic24.net

Bill Brandt Archive
Tel: +44 (0)20 7792 0132
Email: info@billbrandt.com
Web: www.billbrandt.com

Corbis
Rights Managed
Tel: +44 (0)20 7644 7644
Email: sales.uk@corbis.com
Royalty-Free
Corbis
Tel: +44(0)2.7644.7407
E-mail: intsalesrf@corbis.com
Web: www.corbis.com

Danny Elwes Photography
Tel: +44 (0)7721 386114
Email:
dannyelwes@hotmail.com

Duncan Evans
East House
Grobness
Voe
Shetland Islands
ZE2 9PY
Email: dg@duncanevans.co.uk
Web: www.duncanevans.co.uk

Felipe Rodriguez
Plaza de América, 1
41840 Pilas
Sevilla
Spain
Tel: +34 954 751 703
Email: felipe@beatusille.net
Web: www.beatusille.net

Getty Images
101 Bayham Street
London
NW1 0AG
Tel: +44 (0)20 7267 8988
Email: sales@getty-images.com
Web: www.gettyimages.com

Hackelbury Fine Art Limited
4 Launceston Place
London
W8 5RL
Tel: +44 (0)20 7937 8688
Email:
katestevens@hackelbury.co.uk
Web: www.hackelbury.co.uk

Heard Design
4 Underwood Row
London
N1 7LQ
Tel: 44+ (0)20 7253 6688
Email:
Emma@hearddesign.co.uk
Web: www.hearddesign.co.uk

James Finlay Photography
Tel +44 (0)20 6675 8471
Email: james@jamesfinlay.com
Web: www.jamesfinlay.com

**The London College of
Communication**
Elephant & Castle
London SE1 6SB
Tel: +44 (0)20 7514 6562
Email: info@lcc.arts.ac.uk
Web: www.lcc.arts.ac.uk

Magnum Photos London
5 Old Street
London
EC1V 9HL
Tel: +44 (0)20 7490 1771
Email:
magnum@magnumphotos.co.uk
Web: www.magnumphotos.com

Man Ray Trust
Tel: +1 (516) 938 7373
Email:
information@manraytrust.com
Web: www.manraytrust.com

Melvin Cambettie Davies
Master Mono
11b Printing House Yard
15 Hackney Road
London E2 7PR
Tel: +44 (0)7763 243515

Paul Barton Photography
Tel: +44 (0)7799 062012
Email: Info@moto-racer.com
Web: www.moto-racer.com

Peter Dazeley
Tel: +44 (0)20 7736 3171
Email: studio@peterdazeley.com
Web: www.peterdazeley.com

The Pro Centre
5-6 Mallow Street
London EC1Y 8RS
Tel: +44 (0)20 7490 3122
Email:
procentre.ec1@hasselblad.co.uk
Web: www.procentre.co.uk

Silverprint, London
Tel: +44 (0)20 7620 0844
Email: sales@silverprint.co.uk
Web: www.silverprint.co.uk

Tom Craig
Tel: +44 (0)7801 367169
Email: Tomcraig1@hotmail.com
Web: www.tomcraig.com

Ty Wheatcroft Photography
Tel: +44 (0)7883 308354
Email:
tywheatcroft@blueyonder.co.uk
Web: www.lomohomes.com/
tywheatcroft

Untitled, London
Tel: +44 (0)20 7434 3202
Web: www.untitled.uk.com

UZi PART B
Tel: +31 204 868 733
Email: uzi@uziphoto.com
Web: www.uziphoto.com